reGeneration

jeremy p. tarcher/putnam a member of penguin putnam inc. new york

generation

telling stories
from our twenties

edited by
jennifer karlin
and amelia borofsky

Most Tarcher/Putnam books are available at special quantity discounts for bulk purchase for sales promotions, premiums, fundraising, and educational needs. Special books or book excerpts also can be created to fit specific needs. For details, write Putnam Special Markets, 375 Hudson Street, New York, NY 10014.

Jeremy P. Tarcher/Putnam
a member of
Penguin Putnam Inc.
375 Hudson Street
New York, NY 10014
www.penguinputnam.com

For further discussion, color images, and contributors' links,
check out www.regenproject.com.

Library of Congress Cataloging-in-Publication Data

ReGeneration : telling stories from our twenties / edited by
Jennifer Karlin and Amelia Borofsky.
p. cm.
ISBN 1-58542-214-2
1. Youths' writings, American. 2. Young adults—Literary
collections. 3. Young adults—United States. I. Karlin,
Jennifer, date. II. Borofsky, Amelia, date.
PS508.Y68 R43 2003 2002028706
810.8'006—dc21

Printed in the United States of America
10 9 8 7 6 5 4 3 2 1

This book is printed on acid-free paper. ∞

BOOK DESIGN BY MEIGHAN CAVANAUGH

For Dorine Karlin and Ruth Borofsky,

who live liminality to the fullest,

and for anyone who has ever wondered

about their place in between.

our acknowledgments

Hundreds of people helped make this book come alive and, more important, have been a pleasure to work with. Every contributor shaped our ideas and created this anthology, whether or not their submission is in the final printing. Many others have provided assistance along the way. Specifically, we love our art editor Laura Plageman for her keen sense of beauty and connections. Frank and Brian Lichtlin made our website accessible. Jill Morawski, Nina Pesut, Michael Ellsberg, Lindsay Shaw, Diana Glanternik, Rene Tillich, Richard Slotkin, Mary Henderson, Margo Simon, Catherine Black, Gregory Cato, Elisabeth Benjamin, Meg Cain, Shannah Handel, and Lauren Borowsky all did content editing at the most crucial moments. A warm hug to Danielle Jatlow, Carol Doumani, John Driscoll, Tom Radko, Andy Gold, and Lawrence Schimel—you were all surprises and gave much-needed support along the way. We appreciate Gail Ross for her help in negotiating the contract and for being honest with us. At Tarcher, we are endebted to Allison Sobel for her detailed edits and perpetual reassurance and Kelly Groves for his astute sense of how to get the word out there.

jen's acknowledgments

I dedicate this book to Dorine Karlin for her living reminder that reality is whatever we choose to see; Dad for teaching me the importance of letting Jersey diner conversations linger over stale coffee; Nana for your

unquestioning faith; Mark and Aleris for calming my worst early morning fears; Jason for relentlessly telling me that "Life is good, Aunt Jenny"; Pilar for reminding me how happy I was as a four-year-old; all of my fun, dependable roommates in the last three years (Laura, Diana, Maggie, and Rudey—if only I could get you guys all on the same coast); Brian for your unquenchable love and for being so soft and so smooth; Margo, as usual, you help me figure out exactly what I am trying to say; Zaks for knowing me instinctually; my "Top 10"—you should know who you are by now; Joseph Manzare, Mary Klingbeil, Eva Dienel, and the Health Law Unit for doing your jobs so well; and Amelia—you have brought with you the warm breezes of the Pacific and have taught me more than you will ever realize.

amelia's acknowledgments

I dedicate this book to Dr. Ruth Borofsky for teaching me not to give up and showing me how the seagulls fly over Glouchester; to my mom for the cow trough and unconditional love, and my father for teaching me how to talk about feelings. Robyn for being the kind of rich and varied political activist and thinker that this book aspires to cultivate. The entire Borofsky clan for being family, therapists, and willing to forgive. Friends are endless inspiration and magic. Laura Starr for putting up with me; Ilana for dancing late into the night and skewing normalcy; David (thank God for airplanes); Sepideh for grace and the moment that night ends; Sara for music, music, music; Catherine for that card and sharing Hawai'i; Erica for sticking with me since we were five; Rudey for flopping around on a surfboard and being the kind of person who sends lemons; Wendy and Becky for a Manoa home; Dorine for living yoga, strength, blossoms, and wisdom; and Jen, Jen, Jen, thank you for your easy laughter and fierce determination.

honorary acknowledgments

Many contributors have shaped our thinking and this book dramatically, but their work could not make it into the final printing of the book. Out of 450 contributors, these talented people deserve special mention.

WILLIAM ABBOTT	WILL COMERFORD
GREG AMES	TRISTA CORNELIUS
CHRISTINA AMINI	DEE AND TINY OF *POOR MAGAZINE*/
AMY ARENA	POOR NEWS NETWORK (PNN)
BEN ARNOLDY	KELLEY EVANS
ERIN BEALMEAR	JORDAN FLETCHER
AARON BEBEE	MAUREEN FOLEY
ALEXANDRA BLAIR	ERIK FONG
MATT BLOWERS	JOHANNA (JONES) FRANZEL
JASON BORUM	JENNIFER FURSTENBERG
CLAIRE CARPENTER	JEFF GARITO
ERICA CARPENTER	EVAN GOLDSTEIN
KATE CARROLL	JACKIE PEREZ GRATZ
GREGORY CATO	ZOHAR GREENE
ARSHAD CHOWDURY	TAMMY GREENSTEIN

Noah Grey

Joyce Hsu

Aaron Jorgensen

Josh Krist

Martin Lijtmaer

Alexandra Lopez

Sara McKay

Brenda Miller

Johannes Miller

Kyle Mizokami

Craig Morse of Culture
 Subculture Photography

Amy Neevel

Miranda Nell

Kim Nichols

Beth Ortner

Rachel Ostrow

Christopher Otto

Laura Elizabeth Pohl

Rodney Reid

Joelle Renstrom

Irina Reyn

Dee Rimbaud

Amy Riter

Jaime del Rosario

Joshunda Sanders

Andrea Scher

Lawrence Schimel

Roddy Schrock

Brian Shabaglian

Deborah Siegel

Reid Spice

Justin Silverman

Felicia Sullivan

Tony Tiu

Rene Georg Vasicek

Emily Weinstein

Alia Yap

Weston Yap

Gregory Yates

contents

Part 2
Working

Part 4

Dreaming

reGeneration

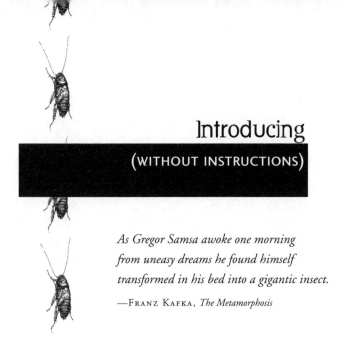

Introducing
(WITHOUT INSTRUCTIONS)

*As Gregor Samsa awoke one morning
from uneasy dreams he found himself
transformed in his bed into a gigantic insect.*
—FRANZ KAFKA, *The Metamorphosis*

For the two of us, waking up in our twenties is like finding ourselves transformed into Kafka's infamous insect. Peering from newly formed shells, the outside world looks like a different place. The room we are lying in seems overwhelming, filled with bizarre possibility. Our compound eyes see everything simultaneously in all directions while our feelers span out, sniffing for a familiar odor to remind us of permanence. Stepping out of bed, our six feet seek out stable ground. As we start to explore past the privacy of the room, we are met with a barrage of questions: who/where/what are you? We do not want to answer any of these questions, fearing that doing so will harden our exoskeleton. Instead, our mouths start muttering something quasi-intellectual about transformations and regeneration, while inside our heads thoughts knock around between traditional self-inquiry, anxiety about the dire state of the world, lines from our favorite new parody about the genre of pop culture that parodies pop culture, and skepticism about everything. Although Gregor Samsa's metamorphosis made him a social outcast thrown out with the trash at the end of the short story, our transformation does just

the opposite. We have acquired an increased responsibility to figure out how to live within this expansive and pulsating world.

This dramatic first paragraph represents the series of conflicting metaphors, genres, and images that infiltrate the daily lives of many twentysomethings today, making it difficult for us to settle into one particular thought or course of action. The twentysomethings who have created this book are an unstructured group living during a disorienting time, a perfect subset from which to gain understanding about how people adapt and survive within a hyper-evolving world. We twentysomethings know that there is always more information to be learned and another method of understanding just beyond our grasp, and thus we spend a lot of time questioning our questions, never fully solidifying our skin. We are living in a state in between, on the threshold of marked categories and realities, and we can shed light on the boundaries used traditionally to define us. According to a Google search, cockroaches reach maturity only after about six or seven molting phases. In each molting, their outer shells split, their appendages scatter, and their soft underbellies emerge. Aligning ourselves with Kafka's insect ties us to a long tradition of asking existential questions, although we view these metaphorical cockroaches of today as a continuously molting breed. The character sketch that emerges from this book is a person in his or her twenties who moves around a lot, job-hops, forms diverse relationships, and believes in relativity more than ultimate truth. Resisting static definitions and singular identities, we have fragmented ourselves into millions of pieces to exist. Some body parts ended up assembled here, others can be found way over there near the border to the next location, and some are in cyberspace just hanging out. Together, the scattered appendages form new, adaptable, flexible, innovative bodies.

Thousands of e-mails, four hundred and fifty submissions, and many conversations came together to create *ReGeneration,* an anthology about the questions people in their twenties are asking and, even more important, the answers they are generating. For three years we collected the manifestations—in prose, poetry, photographs, sculpture, painting, and architecture—of the process of our peers finding something to believe in during an exciting moment of struggle and opportunity. All the contributors testify that it is impossible to tie this

group down to a single thought or course of action. Our call for submissions brought a dynamic group into our living rooms, and now into yours.

The art and stories in this anthology are arranged according to the actions that we perform most often: navigating, working, relating, and dreaming. The tie that binds the stories together is the everyday process of living out youthful ideals in a world of questionable merit and of learning how to reconcile what *is* with what *can be* in a world where *what is* is always being challenged and expanded. In this anthology, you will see how a person decides what to compromise, how they move beyond definitive categories, and why it is of the utmost importance to see this messy process. Understanding and creating are not found in the totality but in the choosing and linking of fragments and thoughts. Within these pages is the insanity, creativity, privilege, responsibility, and possibility of a group of young, educated people growing up at another fin de siècle in history.

However, today is not like any other time. So much of who we are depends on how we communicate with others, and our access to collective knowledge has never been as expansive and accessible. This is even more poignant for those who remember a time without this technology, and twentysomethings today stand legs wide open, feet breaching the before and the after. Today, we

To: jkarlin@hotmail.com
From: nlee@aol.com
Subject: tuesday's summer heat

Don't know if you got my e-mail message sent to your last account (just saw this address on the top of Lauren's message). Do you know how she's doing by the way? I get these forwards but never get a chance to hear how *she* is doing. It is hot, hot, hot here, and I am sitting in my underwear getting ready for the beach. A cool dip. I'm still waitressing my bum off, seeing my therapist, and working for my dad and my side internship. A little too busy for my liking, but it seems that is what the world has to offer. I don't know how I feel about the work world. I am starting to like just thinking in my head of possibility. I like the dreams rather than the reality of actually doing anything or going anywhere. Decided my goal for the year was to have a cute cozy studio that I can afford. That is it. No other expectations of myself. No settling down, no needing to get some grand this or that.

Not yet. But damn, Central America also calls my name.

are the group who are aware of how cyberspace has changed our notions of possibility—we believe it to be a place where anything can happen. The technological changes in the way we communicate subtly change who we are. From fantasy baseball to cybersex, the Internet provides a medium to form new relationships, exchange information, and become whoever we pretend to be. We do not even have to put on makeup and wigs to look different; we simply tinker with our digital image, ready to remake ourselves at any moment.

E-mails are a perfect example of how technology changes who we perceive ourselves to be. These cyber correspondences are rapid extensions of ourselves. Like twentysomethings, they are transformative because they are transitory—they have dislocated qualities due to their disregard for formal structure. Forgetting traditional salutations and punctuation, e-mails get down to their real business—their content—as quickly as possible. At once settled and located, e-mails leave our minds/bodies behind and stretch out as active participants within a world where information is key, and location irrelevant. We all know the routine: sitting down to write an e-mail, we instantaneously type out words intended to express our feelings at that particular moment. Without thinking, we simply click and send those thoughts out into a void to be read—possibly seconds later—by a friend who, probably sitting demystified at work, quickly replies. And, on the other end, we wait for those responses, those little beauties to pop up on our screens. In an instant, we have moved across time and space. And the beauty? E-mails can be oh-so-easily cut and pasted, stripped from their progenitors, edited, linked

To: aborofsky@yahoo.com

From: ztoplis@netware.org

Subject: a response

Why am I confused? Because I feel like I am stuck in a system that I have no control over. Because it is set up and is so strong that everyone buys into it. I now think the fun is going to be finding ways to get around that, doing what I want, and trying to change the world in ways I think are important. But it seems that everyone else is either giving in or giving all of themselves to fighting. I can't do either. I have realized that I need to stop comparing myself to other people.

into thematic structure, and portrayed as cohesive narratives to say whatever it is we want to say. That is what the e-mails in this book do: As an introduction to the book, and as epigraphs for each part, the e-mails that pop up throughout this book are linked, telling their own stories about our technological, communicative, and personal transformations.

The free-floating yet networked confusion you find in these pages largely belongs to the contemporary educated class. This experience does not necessitate higher education; rather, education predisposes us to the condition. Even though not all of our contributors attended college, they all belong to an educated group with access to technology. Only comprising 30 percent of the U.S. population, college graduates are far from the majority. Yet, by virtue of the "meritocracy" we live in, this group is likely to be in positions of power and give voice to our future. It is this group, perpetually searching and unsatisfied with their accomplishments, that are of interest to us.

While all of our interactions occurred over e-mail, the majority of our contributors live on the coasts of the continental United States, and most of the submissions flew in from New York City and San Francisco. We received the most contributions from college-educated, white women. We then selected and solicited the most intriguing, diverse, and just plain ordinary sub-

To: regenbook@hotmail.com
From: laurenbo@yahoo.com
Subject: automation

I am glad you wrote. I was starting to think you might be upset with me. Honestly. I was going to write and ask. I know you are busy, but I just miss you and my feelings of being disconnected from your life turned into insecurity. We are all just so busy. I think it is because of everything we can do. We are connected to the world through our keyboards. We never even have to leave our homes if we don't want to. We can work, order food, order stereos and videos and whatever other kind of entertainment we want from baby toys to porn on the net, and we keep in touch with our friends all from one chair in one room. And we can do it all faster than we could before, and thus, we can do more of it, and, as a result, feel the pressure to do more of it. How do we develop community, how to balance work and play, independence and companionship, computer screens with compassionate hugs? I think I am just missing your arms around me.

missions. Throughout the book, the term "twentysomething" does not refer to all people in their twenties, but to this small coterie. A reader need not come from this geographic, class, or age background to enjoy the submissions, though those from this group will likely find resonance within.

ReGeneration takes the private, individual stories of everyday people and throws them out into the public domain. In a multi-world that includes multimedia, multitasking, multinationals, multicultural, multiphrenic,[1] multiphobia, multisexual, multimillionaire, multifaceted, multilingual, multigendered, and multiplexes, this anthology is our response: not a dialogue, but a multilogue. The stories in this book are an open-ended conversation with one another, with history, with us, and with you. Each essay in this anthology has tentacles that stretch beyond the words and images in these pages, reaching out to and pulling in a large and diverse audience. We hope this anthology will offer room for you to inspire, differentiate, and activate your own story.

the twenties in general

Conversations about coming-of-age, which usually revolve around whiz kids and generation-X/millennial-generation hoopla, only contribute to our

To:	jkarlin@hotmail.com
From:	aborofsky@yahoo.com
Subject:	. . .

Okay, so all of a sudden you are twenty-three and you notice that you are still fighting off living the life you are "supposed" to live. You know, you don't show up to work exactly on time and you don't have monogamous boy-girl relationships. You are still dreaming the big dream. You are still young, and it is still okay to be idealistic. But then you start noticing all these older people who you always thought of as complacent are still living life to the fullest. That's when you realize that thirty is not too far off and complacency is only a state of mind.

[1]"The condition of being oversaturated with conflicting images, messages, and relationships that causes an array of oughts, self-doubts, and irrationalities." See Kenneth Gergen, *The Saturated Self: Dilemmas of Identity in Contemporary Life* (New York: Basic Books, 1991), 79.

sense of isolation and self-consciousness. Rarely do we focus on the friction-laden processes of aging—the learning, frustrations, dreams, and compromises of actually growing up. Instead, we use marketed, hyped-up generational labels to create blanket characteristics, as in The Greatest Generation, The Lucky Generation, The Baby Boomers, Generation X, and Generation Y. These categories tend to focus on what a group was doing during their twenties. The Greatest Generation is composed of men and women who were in their twenties during World War II. Generation X is twentysomethings who couch-surf, and drink–sniff coke. While these categories are helpful as quick ways to organize the past, they are oversimplified, named from the outside, and choose a select group to define everyone. These categories therefore cannot define a group of twentysomethings today and do not adequately describe growing up.

Our twenties is a pivotal time because we have to establish ourselves in the world. When we turn eighteen years old, the government deems us adults—we are no longer legally tied to our parents, we can vote, and we can join the army. Logistically, questions need to be answered: Where will I live? With whom will I make a family? How will I support myself? We try on different relationships, places to live, and work projects until we come into a

To: jkarlin@hotmail.com
From: dgoo@yahoo.com
Subject: Still not giving in

Me? I am feeling very much the product of a postmodern, liberal arts education. I feel too high even when I am not taking substances; or rather, at what point do we define a substance? I just need to start meditating or doing tai chi, or something because I am in such a learning and gathering phase that I cannot process it all. Do you ever feel like that? When you learn something every time you move or breathe or see someone, or talk to someone, or see someone move, or watch the sky, and everything is stimulus and everything *means* something. But then when you try to write or talk about it, it all seems jumbled up and just too much. And then people call what you write "rambling." It isn't. It is just that you are trying to explain something that feels unexplainable. It makes me so happy to have friends that love to ramble because I think it is important. I think that so much about how our generation gets along is through the processing of information because we are giving so much. So, I think that some ramble helps us process, and I think it is healthy and fun.

skin that feels right and functions for the moment. There is a lot of uncertainty (at times debilitating amounts) and much experimentation. As one contributor wrote, "I think that I am like most people in their twenties—an unsure experimenter."[2]

In some ways, going into our thirties sounds like a relief and, in other ways, sad. Youth (and this is where we toot our own horn some more) is a powerful force. We have time, energy, questions, and few responsibilities. We want to push the envelope, resist compromise, lead revolutions, and turn the world upside down. Because we do not yet know quite how to be, we have not settled and will not let the dust settle around us.

Moving through our twenties is about learning when and how to compromise. Many of us have spent a good portion of our lives thinking that we can be everything to everyone, and we have been fortunate to be allowed to dream big—everyone should have that opportunity. Now we are in the process of grounding those dreams to see what we can and cannot accomplish. It takes much patience (which is hard for people who have grown up with instant-world at their fingertips), dedication, and persistence. We are slowly learning that we cannot take on the whole world.

Amelia and Jen started this project at the age of twenty-two, and we will

To: aborofsky@yahoo.com

From: jkarlin@hotmail.com

Subject: everyday's science times

I read this article in *The New York Times Magazine* about the plasticity of placebos awhile ago and read another article today about Dr. Steven Weinberg, a prominent physicist who thinks that he is about to discover a "final theory" explaining all of nature's forces and matter. I cannot believe that people still believe in absolute truths. Dr. Weinberg has no patience for any suggestion that the "truths" of science might be constructed. As for spirituality, Dr. W thinks it is a waste of time and only recalls a history of religious persecution and war. You know me, I am no religious zealot, but I wonder if Steven understands that a final theory about the world is only the placebo treatment for having a God complex.

[2]Alexandra Blair, "*Lattetechonomic* Fever."

release the bound copies at twenty-six. Over that time we have lived in many different cities, found and lost lovers and friends, and had *many* different jobs. We have evolved along with this project and are different people because of it. Some contributors wrote their stories three years ago, while others are recent additions. The questions themselves evolve but never disappear. As we age, life will not get easier; the issues and questions will simply change. As you journey with the contributors through this book, you will notice a subtle shift in the intensity of questioning as contributors span ages between twenty and thirty. You will notice hubris tempered with humility, dreams with understanding. Our hope is that we will balance somewhere within the matrix of possibility, passion, and practicality.

the twenties now

Is this process of cacophonous transformation just part of everyone's aging experience? Our elders remind us that we are not the only people to have felt uncertainty during our twenties. On a show about the topic of a contemporary "quarterlife crisis," Oprah Winfrey mentioned that rereading her journal from her twenties reminded her of how volatile she was then. However, based on conversations we've had with our parents and grandparents, we realized that ours are markedly different from theirs. Certainly, the information boom, the "triumph" of capitalism, and the accelerating fast pace have contributed to the dislocation, saturation, and creativity of our twenties now.

Ideals of progress may have led our parents' generation down a known

To: aborofsky@hotmail.com
From: bowden@mail.com
Subject: long lost e-mail

I hate when that happens. I just wrote you a really long e-mail, and it was brilliant and everything (like everyone thinks their mind ramble is). But then, when I went to send it, without having saved any of it, this message came up saying time ran out and so the message is lost to cyberspace. Uggghhh . . .

path through their twenties, but we find ourselves in the midst of progress, yet unsettled. Technological innovation and capitalism have triumphed, and the drive ahead continues at remarkable speeds. The United States is about the American Dream that everyone can have material goods and climb the class ladder, that everything keeps getting better, that everyone should strive to be on the forefront of the NEW and the NEXT. In this atmosphere, we feel burdened by the limitations of the present and anxious to be innovative and successful for the future.

Since we have so much freedom to create and redefine ourselves, figuring out who we want to be takes a long time. Whereas our fathers may have gone straight into a job at 21 and stayed there for forty years, that idea seems unusual now. Getting married during our early twenties is also less common. Statistically, the median age for a first marriage has increased to 25 for women and 27 for men. The number of never-married twentysomethings has increased to 77 percent for 20- to 24-year-olds and 45 percent for 25- to 29-year-olds.[3] This is up 25 percent from 1980, and is certainly higher than it was back in 1950. Women typically have fewer children, and more young adults are spending time obtaining a higher education rather than raising children.[4] An increased life span—from 68 years old in 1950 to 76.5 in 2000—also contributes to additional time for youthful deliberation.[5] Not rushing into anything, we hope not to waltz through life and wake up one day in midlife to realize that we went about it all wrong.

While spending a lot of time on the individual process of "figuring out our shit" before jumping in headfirst, we tend to be cynical of our cultural inheritances and larger structures. Access to information and a post-Vietnam legacy have made us a disbelieving, critical group of individuals. We hope that some beliefs and dreams will be considered authentic, but these become

[3]Median age of marriage 22 for women/25 for men in 1980 increased to 25 for women/27 for men in 1998 (U.S. Census Data, 1999). The average number of "never married" people increased to 77% 20–24-year-olds and 45% 25–29-year-olds in 1998 from 50% 20–24-year-olds and 20% 25–29-year-olds in 1980 (U.S. Census Data, 2000).

[4]The number of enrolled college students ages 20–29 almost doubled from 1970–2000. There were 7,814,000 enrolled in the year 2000; 6,872,000 in 1990; 5,934,000 in 1980; and 4,150,000 in 1970 (U.S. Census Data, 1999).

[5]U.S. Census Bureau Data, 2000.

compromised when we see heroes (Einstein, Gandhi, Dali Lama) on billboards selling iMac laptops. It is not a surprise that unfair elections occur, that democracy is often for sale, that we criticize the "progress" train that we're on, and that everything "should" have "quotation marks" around "it." Many people in this group have seen and experienced the gross inequities that exist at a national as well as an international level, scrutinizing the fact that everything is only one variable of many conflicting ones. Jen's grandmother remarked at dinner, "I do not understand you, you have been so lucky, so fortunate compared to what my generation went through, and yet you complain about this country more than anyone." In response, a contributor puts Grandma's observation into the context of a liberal arts education: "It's a self-fulfilling prophecy: make the sociology student cynical of the institutional structure of capitalistic America and then send them out into the world without any tools and skills to be active citizens in the democratic machinery, THUS forcing them to spend hour upon endless, unemployed hour seething and reflecting about what's wrong with it all."[6] We are aware of the problems in everything, but not the solutions. Necessarily, we participate within the American Dream's contradictions daily—a tension serving both for confusion and, if we are able to focus our seething, for change.

In some ways, we live in the shadow of the changes that happened during the sixties and seventies. It is the most recent example of a time when radical questioning and restructuring of national ideals took place. The extremity and outspokenness of public concerns forced people to choose a side. From our vantage point, we look back on the sixties as a time when twentysomethings were at the forefront of the most important issues: fighting *for* or *against* the Vietnam War and all its domestic eruptions, or demanding civil rights for all people alike. How many times has one accidentally muttered, "I wish I was young in the sixties"? A soldier currently stationed in Hawaii remarked that being a soldier seemed to mean more back in the sixties, and a black activist stated that the demands of black activists were both clearer and more important then. Both of these examples show that we tend to look to the past as a more cohesive and exciting time.

[6]Jennifer Furstenberg, "GOAAAAAALLLLLLLLLL."

Today, just as many weighty issues are on the table, yet we steer clear of recognizing our common experiences. We have been taught under the doctrine of relativity and believe that everyone has his or her own unique and valuable experience that we can never fully understand. Sharing the desire to be seen as unique individuals, we negate the ties of our common history and reactions beyond disorientation and cynicism. Every contributor, however, has been affected by a laundry list of intense events: the AIDS crisis, which brought with it the radical notion that sex can kill; the Persian Gulf War, the Oklahoma City bombing, the terrorists attacks on the World Trade Center; the rise of public-school shootings; and the increasing globalization of American capitalism of products and ideas. Contrary to reactions to other historical events, we twentysomethings have not yet organized into a massive, cohesive front about these shared experiences.

Maybe it is just the retrospective analysis that makes us feel more decentralized than past "generations." Nonetheless, rather than the perceived notion of culture/counterculture, twentysomethings today are met with a feeling of exploded options. Even something as simple as buying toothpaste is an experience in too much choice—there are more than twenty-five brands (go and count yourself). Who hasn't stood at the counter trying to decide if there are any differences between them? We have to-do lists that conflate everything: buy groceries, take ten deep breaths, save the world.[7] But this kind of choice and inability to prioritize is just the beginning. Neil Howe and William Strauss, authors of *13th Gen: Abort, Retry, Ignore, Fail?*, contrasted what they called the agoraphobia (the fear of open spaces) of some current-day twentysomethings with the claustrophobia, or consistency, of their parents growing up in the fifties and early sixties. For those of us with this paradoxical fortune, the feeling of having so many options makes it difficult to make decisions and can paralyze our ability to actually decide on anything. Dr. Barry Schwartz, a professor of social theory and social action at Swathmore College, refers to this as the "tyranny of freedom," explaining that "the proliferation of options in American life is often felt as a burden . . . we have a choice of where to live, what kind of work to do, when to marry,

[7]See www.todolistmagazine.com.

12

whether to marry, when to have children, whether to have children, whether to be straight or gay, but when there are 100 options out there, you have no one to blame but yourself if you choose badly."[8]

Simultaneously, we "information processors" are desensitized to world affairs because of our ability to tune in and out. On one of our sixteen split screens, we can skim CNN news headlines scrolling on the bottom of the screen while the newscaster relays the most recent updates. Even war has become a removable blip on the screen that we can turn off at our remote convenience. Although it is quick and cheap, television does not allow adequate time to grasp issues in depth. Personally, we consider ourselves well educated, yet, when asked, we can give only a bare review of the Iran-Contra Affair, even though it occurred during our lifetime. We know the trivial and the easy-to-swallow details, like Monica Lewinsky giving our president a blow job and how many times Tom Cruise and Nicole Kidman have broken up. The fact that less than 25 percent of us twentysomethings[9] read any newspaper (this is down from 49 percent in 1972–1975) shows that we do not always participate outside our own immediacy and that it is overwhelming to try to process and act on all the information to which we are privy.

Ultimately, some of the tensions in this book are not just an age-specific experience, but rather part of being an American during the twenty-first century. The film *American Beauty* deeply affected the public and won an Academy Award by speaking to a void, a desire to fill life with something beyond work and money. Self-admittedly, the United States is a nation of perpetuating consumption—we never have enough. All around us, people keep asking, Where is the heart in a market-driven economy? Books like *Affluenza: The All-Consuming Epidemic,* by John De Graaf, have even given a name to this contemporary malaise: "*Affluenza* (noun): a painful, contagious, socially transmitted condition of overload, debt, anxiety and waste resulting from the dogged pursuit of more."[10] We may be able to make fun of

[8]Erica Goode, "In Weird Math of Choices, 6 Choices Can Beat 600," *The New York Times,* January 2001.
[9]William Frey, Bill Abresch, and Jonathan Yeasting, *America by the Numbers* (New York: New Press, 2001).
[10]John De Graff, David Wann, and Thomas H. Naylor, with Redefining Progress, *Affluenza* (San Francisco: Berrett-Koehler, 2001).

ourselves on behalf of capitalism's benefits, but the United States has most certainly reached some kind of famine in civic meaning and social responsibility.

It must seem surprising to people in other countries that U.S. citizens can be a rather miserable lot (just look at the number of therapists, gurus, drugs, and Prozac prescriptions). We crave meditation and panic medications to help us focus; ourselves the vectors to medicate the world that we have created. Alexandra Robbins and Abby Wilner, authors of *Quarterlife Crisis: The Unique Challenges of Life in Your Twenties,* are of the same mind, calling upon us to recognize a psychological crisis that might occur as early as our twenties. The modern world, despite all its comparative advantages, is not an easy place to reside in psychologically as we become fast moving, hyperaware, and highly anxious. But we resist the idea of a "quarterlife crisis" defined by "antidepressants, boredom, financial struggles, and office politics."[11] We do not really believe in the idea of a crisis at all, since history has taught us that growth and change rely on loss and repair. In response to the *Quarterlife Crisis,* Rick Marin in *The New York Times* reminds us how definitions can always be reworked. He writes, "Dr. Jolkovksi pointed out that the term 'midlife crisis' was coined by the Danish-born psychoanalyst Eric Erikson to mean not an emergency but a watershed moment."[12] A watershed is a crucially important factor, time, or event. We see the twenties—both the age and the century—as a watershed of possibility.

regeneration

ReGeneration focuses on the people who would categorically fall between GenX and GenY, the people who do not look for labels. By looking at those who would fall inbetween, we start to understand the limits of rigid bound-

[11]Alexandra Robbins and Abby Wilner, *Quarterlife Crisis* (New York: Tarcher/Putnam, 2001), excerpts from topical index.

[12]Rick Marin, "Is This the Face of a Midlife Crisis?" *The New York Times,* 24 June 2001, sec. 9, p. 1.

aries, and why definitions can only superficially describe people and experiences. We aim to talk from the inside of this process of aging to obscure the most often used generational categories. Sick of nouns and descriptive forces, we use regeneration as a form of activity, finally resting upon a verb that does not define us but allows us to define it through our actions.

Our title uses the word "ReGeneration" to embody an active and engaged view of ourselves at the brink of possibility. The Latin root of regeneration is *palingenesis,* meaning birth-again. In biology, the term "regeneration" refers to the repair of structure and function, from the continuous replacement of dying cells to the regrowth of limbs and appendages. It is not such a simple process of breaking and replacing lost parts; rather, regeneration occurs with a reversion back to form an identity-less lump of cells. Damaged cells must first dedifferentiate to form a clump of embryonic cells. Only then can they redifferentiate into new types of cells. These new cells take on specified function and form. In this manner, non-bone tissue can actually turn into new bone tissue, completely new in form and structure. As we age, we are continually in the process of regenerating ourselves, at moments, turning back time, while the future awaits our transformations to see what we can become next.

Hope rests in our legacy to be creative and to continually reinvent in ways that allow us to believe in our cultural inheritances and ourselves. Today, an answer to our dislocation lies in mixing and matching categories and definitions, in combining the old with the new, in creating less divisive alliances. The 2000 census revealed our fluid vision of identity, at least in terms of ethnicity. The census recognized that an ever-increasing number of people are unwilling to identify themselves by a single ethno-racial category. The following example exhibits this fluidity in terms of sexual relationships. A male friend of ours has had the following love life: dating women and men in high school, only dating men in college, falling for a female friend after graduation, and currently dating all genders. When asked about his sexuality, he may say he's gay or bisexual or straight, but he defines himself by his potential relationships; he loves to love, he says. As new technologies and cultural openness increase, it seems that we can be feminist, half-man/

half-woman, gay, cyberdorks, or corporate golfers spending weekends fighting the WTO.

Twentysomethings today mirror the rupture of society, not being able to fit into neat categories, they can offer multi-dynamic solutions to multi-dynamic problems. Our goal is that we will remake definitions and structures that will allow us to believe in something larger than our individuality, like international community, balance, social democracy, past stories, and a sustainable environment. It is international networks toward which we lean: occupations, meetings, telecommunications, ethics that cross borders and have broad ties. There are remedies for the difficulties faced in the twenties, like listening to others and noticing the overlaps. Knowing that the ground we walk on is never truly stable, we are always on the lookout for more combinations and knots that bind us to shared purposes.

Individuals in this anthology revel in their fragmentation. It is only in relationship with others, however, that overlaps exist and through juxtaposition that we begin to understand ourselves. We all share an ability to regenerate—to transform and to activate. In regeneration, things change yet they remain the same. Even though Gregor Samsa lived his last days in the body of a gigantic insect, his metamorphosis was the only way to obtain his freedom as an individual—he had to transform in order to leave his frustrated life behind. In form and situation he was completely different, but he always lived with the memory of his past. Every morning we all wake up a bit changed—dreams, gene translocations, cell mutations, breaths, neuron firings—even after being asleep we are essentially reformed, each piece of ourselves regenerated. And every passing day brings even more transformations.

To: regenbook@hotmail.com
From: lee@aol.com
Subject: much thanks

Hey, Amelia, Jen, thanks so much for your kind words :) I think the regen project is really a wonderful community-building kinda thing to do, and I hope it inspires a lot of people, young and old alike. I think it will. Your feedback has helped me to vastly improve my story, and I think it's made me into a better writer overall. I can't express my gratitude enough. Keep it Up!

part 1

(Amani Willett)

avigating

Finding a home during our twenties today is about movement and
change rather than about permanent settling. From setting out in search of
their ancestral roots to taking trips on Greyhound buses, the contributors in
Navigating depict the various journeys they have had while learning where
and how to create a home. These pieces elucidate what happens to the

children of immigration, migration, and geographical freedom: we traverse landscapes, cities, and apartments until we learn to create bridges with the past and live securely in multiple places.

In these submissions, there is a prevailing tension between the experience of movement and a yearning for roots. Many of us in our twenties try to recall a time when we belonged to a particular location: the trees, the pungent and sweet smells, the familiar faces and street names, but we know that within this country, our families have not stayed in one place for seven, five, or even two generations. Now, even within one life cycle, the people with whom we grow up are rarely the same ones with whom we grow old. Radames Oritz's two poems, *Runaway* and *Down in d' Med Center,* together juxtapose the desire for endless linear movement with the necessity of located place to create community. In establishing home, it may be possible to create a sense of belonging without having to delineate borders. These poems make a larger comment about how, if our definitions change, home can be railway tracks, waiting rooms, and wherever we throw our clothes on the floor. The problem is not necessarily that we cannot *find* home but that we may too narrowly define it.

Many of us do not think of home as placed in one state or country. Part of what drives our search for home is that Americans come from many places, so many countries represented within the nation. At 56 million, the number of foreign-born residents and children of immigrants has reached the highest level in the country's history.[1] For some, the twenties feel like displacement, but what we are trying to do now is tie ourselves to some type of lineages and sense of place. Lauren Kesner photographs people and space to document her feeling of absence, her lack of ties to history and to any lineage. This same absence is Emmeline Chang's driving force to return to her family's birthplace, Taiwan. She hopes to gain some understanding about her relationship to Asia and what it means to be a Taiwanese versus a Taiwanese-American. Traveling with these contributors in their search for history, a reader notices how young this country really is and how all of us age with it.

[1]U.S. Census Bureau Data, 2002.

Not simply put, those of us in the mobile class wonder where to go even while we sit still. Like many in search of something (gold, hedonism, discovery, opportunity, or finding the lost city of Atlantis), Amelia and Jennifer headed off to California in their twenties. Amelia sat at *Lonely Planet Publication*'s computer researching on the Web during the day, and dreamt of other countries at night. After a two-year stint in Northern California, we went our separate ways to México, New York, and Hawai'i. All of the moves were inspired by conflicting pulls since everyone we love, as well as our love of mobility, could not be easily gathered into one place. In deciding where to go, family, history, friends, romance, jobs, adventure, and money all weigh in with dissonant gavels.

And so these twentysomethings keep moving. The 1999 Census shows that 32 percent of 20- to 29-year-olds moved within the year, compared to only 10 percent of 45- to 54-year-olds. Three-fourths of all twentysomethings moved within the last five years. Contributors in this part explore geographies as diverse as Tennessee, New York, California, Brazil, Hawai'i, Thailand, and England. Submissions flew in from as far away as China, Micronesia, and Antarctica. Even sections of this book were written on an airplane somewhere in the clouds.

Even if we decide to stay in one place, those around us are likely to be on the go. One friend who is always on the move remarked that she would not own a couch until thirty, maybe forty. Two contributors, Christina Amini and Rachel Hutton, created a zine about their transition out of college called *Before the Mortgage,* the title self-explanatory. Our personal address books are filled with pen/crossout/pen/crossout. With many friends moving every year, our loved ones scatter to different places. It seems that some of the contributors were sick of crying in the last scene of *St. Elmo's Fire;* they sent more than a few stories (and even an architecture drawing) about having lost, and then trying to create, a home with friends. Others, like Jig Wiley, want to leave friends and move beyond the previously known. Jig Wiley in his *Summer Solstice* stands on the precipice of a familiar landscape: the night of college graduation before everyone scatters like leaves.

Jumping into today's global, rapidly moving world, little keeps this

group still. The technological changes that have made both virtual and physical travel easier carry with them an obligation to try everything possible. Like sleuths slipping from location to location, we walk across bridges and move through virtual borders. An idea zaps someone's lightbulb, and then innovation suddenly propels us forward. Although the earliest written record shows mighty King Etena of Babylonia featured on a coin from 3500 BCE flying on an eagle's back, not until the 1700s did hot-air balloons finally get off the ground. And from there, it was just a matter of tinkering before there evolved fixed-winged aircrafts and spaceships. The speed at which some of us can now travel is thrilling, from horse-and-buggy and railroads, to fast cars, supersonic airplanes, and high-speed modems. Why let our minds sit still when we can go coast to coast for $99 when we can surf the net and see the world and outer space?

Of course, not everybody can and does participate in this mobility. Mobility is class based, and, more often than not, many don't actually get to choose where they go. As Taigi Smith shows in *No One Knows My Name,* gentrification means that some people moving into a neighborhood forces other people out, separating those who have a choice about where to live from those who do not. For everyone across the class board, however, it is an awareness of motion that contributes to an itchy-pants syndrome: wherever you are, you could theoretically be somewhere else. Advertisements assault the senses—glossy pictures of island retreats, fancy cars speeding through the desert—making us wonder about other places and spaces. At some point, almost all of us search and long for a setting glossier than the unextraordinary existence most of us lead.

Even when not experiencing it for themselves, consumers expect nonstop movement of our material products. The United States imports natural resources and goods from around the world and exports American capitalism. Dulce de leche and green tea ice cream line the aisles of the supermarkets next to the vanilla. From Nicaraguan coffee beans to clothes made cheaply in Indonesia and Bahrain, consumers buy products from the most remote and cost-efficient places. Ideally, globalization allows all of us to intertwine economically and exchange ideas, but other countries remind the United States that international relations require mutual benefits. Marcelo

Ballvé's *Copacabana Beach* looks at the explosion of American twentysome-things who try to find something more real and authentic outside of the United States, perhaps in a developing country. He reminds us that people from other places do not belong in our pockets to collect like objects. All of these travelers remind us that travel necessitates honesty, probing, and hu-mility. When we travel, it is difficult to forget that we live in a superpower and that that brings about some amount of accountability.

All the pieces in this part show twentysomethings searching for creative and meaningful ways to make their homes through various moves. Con-tributors arrive at more or less the same conclusion: home is not a place so much as a continuous discovery whether we are stable or moving; home is a verb. This part begins with *The Sky Is Big and Full of Shit* to set up the over-all theme in the book about balancing between possibility and limitations. Shannon Peach reminds us that it takes leaving before you can possibly know what you have. Jig Wiley's *Summer Solstice* brings us to the precipice of possibility, the point when we are ready to move out into the great wide open. *Copacabana Beach* then takes us to the connections we make while searching for magic and realness abroad. This part turns away from twen-tysomethings looking outward toward their looking back at history. Both Lauren Kesner's photos and Emmeline Chang's essay show how these con-tributors understand their homes through architectural and familial past. The final essays in this part talk about the search for stability and meaning in the places where we live out our days and rest our eyes at night.

This part closes with Laura Plageman's photos about memory. The series starts on the flap of the book and continues with images in this chapter. Inspired while her grandmother suffered from Alzheimer's disease, Plage-man explores the relationship between an external perspective of illness and her grandmother's fading memories. Her grandmother's keen awareness of childhood, while losing most other cognitive processes, led Plageman to re-visit her grandmother's home and possessions with a childlike view. What emerges from this exploration is an imaginative space where real and make-believe blur and become inseparable.

Maybe as part of "globalism's mutant progeny" this group of twenty-somethings are hybrid rabbit-turtles who race around, carrying our homes

on our backs wherever we go. Along the way, we find our own geography or sink into the rhythm of movement itself. All of our inhabited geographies and experiences travel with us however we go. Home is wherever we fall in love—with the buildings, the history, the memory, the family, the newness, the people, or the wide-open space. Now grab your map and compass, or just leave them behind. Either way, here we go, go, go . . .

The Sky Is Big and Full of Shit

SHANNON PEACH

Every word in this office mocks me. My coffee mug, snidely advising me to *Carpe Millennium*. When was the last time I *carpe*ed anything? My computer screen restates "lusty, hedonistic fruit bomb" in twelve different fonts. I write about wine in order to receive a paycheck that pays the rent for a room I don't particularly like. The older women in the office are practical. They drink decaf. There is talk of my promotion, because I can write things like "lusty, hedonistic fruit bomb" with seemingly boundless enthusiasm. But the faith is gone; the promise equates only more work for me. It's a dirty trick.

Alone in the office, I go online to compulsively check the Nashville Sky Cam. I figure if lusty hedonism is to be found anywhere, it must be in the sweltering poverty of the American South. I envision a land of perpetual barbecue, bare feet, and big hair. Blue eye shadow. My mom always said I had my dad's feet. I think she meant tough. I give thanks for an e-mail from Paul, my only Nashville contact. He used to play bass for the Judybats and now runs a record label called Disgraceland. He sent me a tape of his new band, the Nevers, which convinced me that all the best music is coming out of Tennessee. Is Nashville not the Music City? I have it all figured out: there are three places to run to in this country. If run one must do, then run thou shalt. If to be an actor, to Los Angeles; if to be a writer, to New York; and if to be a musician, to Nashville. That is the way.

I am none of these things.

After work, I find myself purchasing a ticket. Looks like today was my last day. I let them know via e-mail. It doesn't escape my attention that this is a landmark occasion, for I have found a new way to quit.

go, go greyhound

A crush is something to do. I decide to develop one before leaving the downtown bus station. I find someone tall, blondish, and scowling. He has admirable taste in pants. His name could be Jeff. Two of the five Jeffs I have known have been blond. I spend most of the time en route to Los Angeles dreaming of ways I might approach him. "You are far too attractive for this bus," I could say. Or simply, "I like your pants."

At a rest stop near Bakersfield, he begins walking straight toward me. My face advertises shock and horror. He veers sharply to the left. A close call for both of us.

He collects his bag and disappears at the L.A. terminal. I join the snaking coil of people in line for the next connection. An Apache offers me a dollar to save his place in line, peels a dollar from a huge roll of bills, and disappears. "I should have asked for a twenty," I mutter, and the fellow in front of me agrees. He has plenty to say on the subject of bus travel, and I suddenly, inexplicably, become social.

When the Apache returns, we are at the front of the line. We perch atop our luggage and make disjointed conversation. My new friend in front offers me his headphones along with the challenge to identify the music. It sounds like Pantera. It feels like a headache. This kid reminds me of the preteen brat in the movie *Welcome to the Dollhouse*. He wears a backward cap over his surly face, and a wrist brace peeks out from under the sleeve of a sloppy flannel. He tells me he works at Discount Tire, looking as if he expects me to have heard of it. I'm politely dodging the Bible verses the Apache is slinging my way. He tells me I will make some man a good woman one day. I don't know what to say about that, and tell him so. I in-

sist that it's sexist in some way but can't really prove how. The tire kid is highly amused by this.

It is quite late at night and the tire boy slumps in the seat next to me, declaring, "I don't wanna sit next to no one else." He tells me his name is Jeff. He has already discovered my name by slyly inspecting my ticket. He sleeps curled against my shoulder. Whenever he is jolted out of sleep during the night, he snatches my hand and rubs it vigorously between his. I wonder where he picked up this strange habit. Was it something his mother used to do to comfort him? His hands are dry and scaly. This is a place on my path to self-discovery where I can finally ask myself, "Am I the sort of person who fondles strangers on dark buses?"

taste the heritage

Morning in Phoenix is a brilliant orange. I stumble off the bus and see Jeff waiting for his bag a short distance away. I give him a childish wave, a curling and uncurling of the fingers. He shakes his head slowly and I nod, turning away in search of coffee.

Phoenix is seething with shifty-looking characters. I run into the Apache again. Sober and sickly, he introduces himself as Ernest and immediately begins talking about how he was kicked out of his sober-living home. He's going to see his sister in Houston who doesn't know he's coming. He thinks he has important lessons to teach me. "Honesty is the best policy," he's been saying ever since L.A. When we reboard, he takes the seat next to me and wants to keep talking. I make an effort to stay awake, but really my attention is focused on the scenery outside the window. Arizona is stunning to look at. Far from being desolate, about a million alien varieties of plant life are gracing the landscape, and enormous pink boulders balance delicately atop one another.

Ernest captures my interest when he begins speaking of sweat lodges. He chants quietly, beating a soft rhythm against his thigh. He translates for me, *I walk in beauty, I talk in beauty, I sleep in beauty, I dream in beauty, I sweat*

in beauty, I pray in beauty, I live in beauty, I die in beauty. I doubt it, but I admire the philosophy. He tells me about his travels back and forth across the country, working as a day laborer here and there, picking up and leaving whenever he gets the urge. This I can relate to. I tell him about quitting my job and going to Tennessee for no particular reason. He thinks it is incredible that we have met, two wandering spirits crossing paths at a bus station. He expects an affirmation from me, insisting we must have met in a previous life. I concede that it's possible, yet I'm sure that people like us, people with no tolerance for responsibility, comprise a heftier portion of the population than he seems to think. Each bus, after all, is overloaded.

Among the assortment of things that he carries with him, including an Ernie doll of Sesame Street fame and a huge bottle of women's lotion that he manages to spill on me, a sage plant is folded into a square of leather. He plucks off a couple of leaves and offers them as a token of friendship. I think karma requires me to offer something in return. Ernest then says that "friend" is not a word he uses lightly, because a friend is someone you'd die for. "It's in the Bible." I decide against finding a reciprocal gift.

Ernest leaves me in El Paso. It's 107 degrees, the water tastes terrible, and the coffee comes foaming and sugary from a machine labeled "Cappuccino." Someone has written on one of my bags, "10-31-74, El Paso, TX." And here I am.

I wonder if Texas means anything to me. I have relatives buried here. My dad was born in Lubbock, same as Buddy Holly. The first movie I remember seeing is *The Buddy Holly Story,* at a drive-in. I slept through most of it. And I sleep through most of Texas. There are a few interruptions, from border patrol and some cops who want us to leave our bags on the bus while a dog sniffs at them. I actually have a knife, but it doesn't get me in trouble.

I'm appalled by the quantities of food people are consuming. At every stop, even if it's only fifteen minutes at a convenience store, they are ordering elaborate meals of cheeseburgers with fries, chili dogs, nachos, gallons of soda, and ice cream. They're bored, I guess. A severe young man in fatigues is murmuring quietly in the dark about his travels in military training. He is

talking about families in Brazil and how they don't have any American sense of materialism. They eat beans and drink Coke and are happy to eat and drink together.

In Odessa, I watch the feet trudge by. Velcro sneakers, a fuchsia muu-muu swishing above white pumps, some filthy cowboy boots. I notice my feet have swollen to freakish proportions. They resemble two peeled potatoes wrapped in sandals, just like my grandmother's. A sign points toward a meteor crater.

The landscape gets exciting again come Arkansas. I am seeing the country unravel beside me in all of its glorious forms, countless shades of green, trees I can't identify. I think that if I could reach through the window and stretch out my hand to the line of trees bordering the highway, they would brush my palm in a gentle, comforting way. My love for the country rises like heat, and without a way to let it burn, I sit in agony in my narrow little seat wondering if I can make it to the end of the road without screaming.

might as well get mad

It all comes down to this: the heat that I'm constantly burning. It is caused by the friction of my fantasies clashing with what is commonly believed to be reality. Maybe my fellow bus-goers haven't spent their whole lives buried in books, but I know they watch movies and TV, more TV than I do. Maybe they can accept the ugliness; maybe they all have a program built into them that lets them distinguish the differences. Why should they be allowed that survival mechanism, while all the hideousness is revealed to me in Technicolor?

Nashville. Finally, Nashville. It is late, and the skyline is luminous with neon. I'm alarmed by the size of it. I stop to write inside my bag with a purple Sharpie, "9-9-99, Nashville, TN." Today is my half-sister's birthday. She is nine. I barely know her.

I cross the highway to a busy place called Piccadilly Cafeteria. Several

elderly gentlemen advise me to get to the front of the line before "this band of old coots get in your way." People here are so friendly. I eat warm gumbo and drink real coffee.

With a couple of hours to kill, I smoke and read from E. M. Cioran's *On the Heights of Despair.* I feel smugly superior to have my dissatisfaction validated on the pages. I have become quite agitated, and I think I know why. Something about the way people are calmly going about their lives is infuriating me. People are all around me, doing things, coming home from work or school, filling their cars with gas, meeting friends, preparing meals, having conversations, planning futures. How can they do such things?

I check into the Heartbreak Hotel and hand over almost $50 to a polite young man with a thick Mississippi drawl. He tells me that this is the cheapest I will find. Gone are the days of $19.99 Motel 6 rooms, I'm learning. I figure this will be my last night of pure indulgence, and the name alone is worth it. I salute a higher being for inventing showers and mattresses. Perhaps things are not as grim as they seem.

It's only 9:15 when I get to the club in Murfreesboro where the Nevers are playing. I sip a beer and try to feel as though I'm not exhausted. By the time I'm looking for a second beer, I'm ready to feel human. The bartender engages me in chatty conversation, and I extend it to a few people around me. This chatter is, after all, what it's all about. I recognize Paul and his band as soon as they come in and decide to give them some space. I don't feel like introducing myself in front of the whole band as an aimless fan with nothing better to do than sit on a bus for two and a half days just to see them play. At this point, I don't know why I should care. It is becoming clear to me that I do not belong here. No matter how friendly people are, I'm just passing through—and that puts me on the outside as much as anything.

Dave, the drummer, is a stone-cold fox.

I go outside to skulk on the porch and overhear the Nevers debating whether or not they're actually going to play. Something about people not paying, or them not getting paid. The storm cloud around me is growing darker by the second.

Later, I walk to the bathroom and Paul passes by, finally free from the pack. I wait for him to come out, and then tell him I had heard a rumor that they weren't going on. He tells me that they decided to play after all. "That's great," I inform him. "Because I came all the way out from California to see you guys, and I'd be very disappointed if you didn't go on. . . ." He says he saw me glaring at him on the porch looking as if I might kill him. I don't know what to say to that. I don't know what to make of the whole thing. He graciously hugs me and begins making promises that the band will suck. He has allergies, he says. He is an old man, he says a bit later.

Well, then.

The band does not suck. They even manage to get people dancing, though these people seem to be friends of theirs. For a while, I am happy, and when people comment on the band, I tell them offhand that I had come all the way from California just to see them play. They are doubtful. The situation defies further explanation. Had I really been secretly fantasizing about the glorious world of Disgraceland, envisioning work I might do for the label, even becoming famous for painting album covers? But these were my fantasies, and this is just a bar. When Paul asks me if I'm experiencing culture shock, I tell him no. He tells me that I could be in any bar in any state. Sadly, I am.

Back at the motel, I leave a written request for a wake-up call at the deserted front desk. I've had plenty of water with my four beers, but my head feels heavy and something inside me is breaking. I began to wish that it would all be over and that sleep would restore some feeling of serenity that I hadn't experienced in a long, long time. But sleep won't come, and I spend the few hours until morning restlessly tossing and hating.

What is wrong with me? I'm finally where I've wanted to be for so long. I have nothing to do but anything I want. I can't think of anything I want. I think I want peace, then reject that idea.

It suddenly occurs to me in the middle of the night that I don't have to stay and continue the trip. The sameness of people and cities all across the country has broken me. I might as well save the rest of my money and go

back to where my bed is. Home, I decide, is wherever I throw my clothes on the floor.

if you don't love me, can i at least have a bbq pork sandwich?

I learn from a Greyhound rep that I can use my return ticket, even though it's dated two weeks from now. My bus doesn't leave for three hours. I resign myself to that regrettable bus station coffee and a paperback nonsense by V. C. Andrews. To commemorate the trip, I buy a Nashville key chain and a tasteful terra-cotta mug. I have a long trip ahead of me, and I have already begun feeling the days, hours, and minutes wear on me like a slow grind.

I have to say that Tennessee does not disappoint. It is here like it's supposed to be, stretching long green arms along each strip of highway, innocent and unassuming. I have my eye on that line of trees. Leaves that seem to be stained with silver, some beginning the changes that fall demands of them. Instead of stretching my hand through the window, this time I want to crawl into the underbrush, feel myself enclosed by branches and brambles. That was why I had come all along, I realize, to find solace in the lush, green South. I wanted those soft Southern accents to surround me and whisper promises of home. I wanted big space and music, music all around. I remember a song that the Nevers had played about "you have a friend in Music City." I don't though. All I have is a key chain and a coffee mug.

I've noticed several billboards along the way, billboards that I'd never seen in the West. They offer a number to call for information on vasectomy reversal. This can't be a good idea. Why ruin a good thing when you have it? I ask you.

RADAMES ORTIZ

Down in d' Med Center

Down in d' Med Center
near Tito's Motel II
I sit next to a young nigga
rapping beneath his breath.
His black fist pounding
d' hell out of wooden benches.
Urban beats connecting us
like jewelry around our necks
and this ain't no P-Diddy shit
but a world being built
in d' canal of his throat.
My head, involuntarily,
bobs up and down.
Choking on rhymes.
Digging inner-city rhythms
that grow over cities
like foliage, like flowers,
shrubs, and trees.

Straight-up aggression.
Silent revolutionary
hip-hopping through
aisles of america
on wings of war
on sirens rising up.
He pumps primitive
screams thru nights.
Honesty
Courage
—a new type of Langston.
He decorates streets
with 5th Ward sadness.
This ain't no dream, bro.
Somewhere wings
of butterflies
spread wide as oceans.

—*for Anthony Francis*

Runaway

 through steamed windows
the weather-rotted faces
of working men and women
look down as I pass by.

Weary of the nightclub district
I roam el centro
where calloused hands grab firm asses
and brimming cups of cheap beer
rest on wooden bar stools.

 Dry, starless, the night
 wedged into cracks of brick wall
 as buses spew smoldering exhaust
 into neon liquor sky.

I give myself to the freeway,
to the cement snake that sheds
gray skin on streets
 and stubble grass.

Wandering carelessly,
pasando alfalfa fields
and Baytown refineries that
breathe steam, fogging
 window panes of houses
near ditch banks and streetlights.

With hooded sweatshirt
and wide-bottomed jeans,
I skim this ruined city

for a mask
 innocent, golden.

In rain-gutted side roads
dreams of Hollywood
and hand-rolled cigarettes are locked
into soil of sweaty palms
of bar managers and fast-talking pimps

who promise children like me,
all over the world, that light gleams
at the end of curving roads,

that skies turn blue
like crystal mountains in Tampico
while families reunite
 consoling, talking
like friends never separated.

Summer Solstice

JIG WILEY

It's time. I meet my parents in the main campus courtyard. I'm dressed in the typical graduation garb, black robe and funny cap. My parents are another story. My dad looks good. He wears a traditional suit that makes him look even stockier than usual. I like the way he looks today—educated, decent, but still able to break your kneecaps. I am glad I am taller than he is, but I wish I had his build: legs for forearms, shoulders that spread out to guard the neck. My mom has put on a few pounds. I can tell right away; she is my mother after all. She still looks pretty with the same gentle face and sweet smile. Her eyes are a bit old, but that is expected given the life she's lived. This may be hard to believe, but I do not know much about my own mother. She is a mystery to me and probably to my father, too. What I do know is that she hasn't seen her parents and siblings in ages. They had some sort of falling out, and since then, a thick distance of many miles and years separates them. It must be hard on her, though she never shows it. It's not her way. You'll never see her spilling her guts on some wanna-be therapy talk show. Today, she looks good except for her outfit, some god-awful bright-pink monstrosity that makes her look like a rose on steroids. She has changed her hair again, this time sporting some poofy style. I wish she looked like she did the last time I saw her, with a short bob and a stylish silk suit. Still, she is my mom, so I swallow my embarrassment.

Right away my mom and I start fighting. My dad just laughs, having seen it all a thousand times. She is unhappy with my decision to leave the country and live overseas. She does not understand my desire to become a man of the world and wants for me what mothers want for their children— a better education, a good job, a secure future. She also wants to brag to her friends about her son's education and wealth. A son living in a poor country doing development work doesn't provide an easy outlet for outdoing the Joneses. She says, "You'll be wasting years of your life." I quit talking to her, my silence a shield. My dad looks at her sternly and says, "Now why did you have to say that?"

This is the first time they have visited in the four years I have been here; not once before have they seen this school. I take my parents across the gardens to the old observatory where I introduce them to my boss, Ruth; she is more of a second mother and a mentor than a boss. I like to think of her as a distilled version of my mother—removing the anger, bitterness, and sorrow while leaving the strength, purity, and goodness. Ruth once heard my thoughtless reference to a female professor as "that girl" and then enlightened me as to why a woman who is nearly forty, highly educated and responsible, is much more than a "girl." It did not matter that I meant no disrespect. I said it and the words were sloppy, falling like loose change out of my mouth. With Ruth, however, there was no arguing, no fighting, and no need for such theatrics. She blended a potent solvent of logic and humor to wipe clean my ignorance. Just knowing Ruth was worth the price of tuition. After small talk, she hugs me and tells me to take care. I hear her voice crack a little and feel her grip tighten. I joke with her that she'll never find a worker like me again. She says that's true. I tell her I will miss her. This is the first time we acknowledge our bond. Though years older and smaller in size, Ruth made a person feel safe, her counsel an amulet against the curses of fate. She says good-bye and returns to her work.

I am alone with my parents again. My mom and I have an uneasy truce. We're not fighting but we're not talking either. My dad ignores the tension, hands me a piece of paper, and says, "Congratulations." I look at the thick paper and see a stock certificate. Chuckling to myself, I think, "how appropriate." Nothing sentimental from my ol' man, just something to get me on

my way. I am amazed that he actually parted with some cash. I look again and notice that the shares are for a small company, not one of the prized holdings in his portfolio. I appreciate the gift but cannot help wishing that the certificate read "Microsoft," "AT&T," or some other name that translates into easy money on Wall Street. Have I become a capitalist like my parents? I smile and start to say thanks but stop when I see him crying, almost whimpering. When I see this, my body becomes weightless and hollow. I have never before seen my father cry or look vulnerable, suddenly old and fragile. In the next few seconds, I expect him to tell me that he is dying of cancer, something to explain this oddity of character. He stuns me by telling me how proud he is of me. I resent his words, thinking this is not how one should show pride, angry with him for confusing and scaring me. Months from now, I will tell this story to a girlfriend and she will coo and think it lovey-dovey. She will not understand my horror. She will not understand that in my family emotions are always read between the lines, like adjusting your eyes to a dark room. Any flash of feeling blinds and dazes.

With my friends, we laid emotions bare. As expected, a few nights ago the campus erupted into a saturnalia of relief, sadness, and ecstasy. After finals, my friends and I planned a last hurrah—just another party, of course—but more emotional since we will soon go our separate ways, pretending that we will always be just as close. Eric comes to see me, which is quite a surprise because Eric does not go to see anyone. We start out with some typical chitchat or other but soon turn philosophical. We talk about our lives and where we are going the way others talk about politics or sports. I know Eric is a bit down, more than the usual melancholy that gives him his sense of mystery and pathos.

He asks me if I look down on him for quitting school, if I think he's failed in some way. This feeling of not living up to expectations weighs him down. Shortly after he dropped out of college he visited me and seemed joyous, quite out of character but a pleasant sight. The next day he returned to see me again but looked depressed, and I learned that he had been high on cocaine the previous day. He tells me that he's been shooting coke lately. I'm surprised not by his use of drugs, which so many of my friends dabble in, but rather by learning that it's possible to shoot coke. This little piece of

knowledge upsets my beliefs about the pantheon of drugs. Drink booze, smoke pot, snort coke, shoot heroin—that was the natural order I thought. Eric asks if I would like to try it, but I decline, afraid of his sadness. I worry about Eric, but I admire his recklessness—I just wish he did not have to suffer for it.

I didn't know it then, didn't expect it then, but years later Eric would still be carrying that weight on his shoulders, unable to fend off the anxieties, or the drugs, that kept him treading water, distant from the shore. During our last talk before graduation, I try to choose my words carefully, wanting to be honest with him but not wanting to hurt him. I say that he seems to care about graduating or he wouldn't bring it up. If it means that much to him, he should finish school for his own sake, not for the usual reasons of getting a job or living up to expectations, but to make his own peace. He says things are different now that his friends are graduating. Before, people could go in different directions, but they were kept together more or less by the common thread of school. What classes you taking? How's this teacher? What did you do over the summer? See you later. But now "see you later" could be "it was nice knowing you." School's finished now, the web broken. I think everybody feels the way Eric did, but it is more poignant for him. Eric secludes himself. Like most people in isolation, he is suffering and lonely. He needed to get away, to have some solitude, but now he needs his friends back. I wonder about the turning point for Eric, when he could have either expanded and embraced, or retreated from tomorrow.

While Eric was still a small boy, his father told him he would be a pioneer of some sort. It was easy to see. Even now, his gift of intuition, of knowing truths without consciously thinking about them, makes him seem like a latter-day prophet. I once asked him what special talent he would like to possess if he had a wish. His answer surprised me then, but makes perfect sense now. He wanted to know what to do or what to say to help people in pain. I wondered how much this wish came from his father, a prosperous doctor who died when Eric was still a child. He acts nonchalant about the death, but I know that he also felt pressure to become his father's successor. My own desire is that his kind wish for others be blessed upon himself first.

In the late afternoon, the sun is low and I feel it warming me from the

inside out. In the backyard of my friend's house we all kick back. This day is for real, something we'll all remember for the rest of our lives and we know it. It doesn't happen often, these brief moments when it seems people can do nothing but smile and laugh. These times before stuff happens, before life happens. Eric is here along with my friends Ray, Matthew, Gabriel, and Nick. We slip into a happy babble about nothing in particular, but as the night goes on we remove our masks and tell our stories. Our disfigured families. Breached innocence. Lost loves and fresh dreams. There are plenty of things that we do not understand, and may never understand. Some demons are brought to light and stay in the open, dissipating into nothingness, no longer possessing their victims. Others surface and submerge, but still the exposure weakens them. It is okay tonight.

Ray grabs my shoulder and says, "Ah, shoulder presses." We're both vain and proud of our bodies. Lifting weights together does for us what Sunday Mass does for others. I'm jealous and proud of Ray, jealous of his looks but proud that he is my friend. He is better looking than I am, a genuine Adonis sculpted by Michelangelo. I console myself by noting his occasional social awkwardness, despite the true charm that shows when he trusts someone. Ray looks lonely at times. He disguises this by diving into his work completely, oblivious to his surroundings, oblivious to people or himself, oblivious to life. At least that is the way he seemed when Kim died, the only time our circle of friends shared tragedy, an unhappy reunion. Neither Ray nor I knew Kim that well, but when she burned to death—on Thanksgiving Eve of all times—we owed her our presence at her funeral. Ray skipped out, had some final or something like that. Our group of friends came out of the church after the service and saw him biking to class. I wasn't so proud or envious of him then. Would he skip out on me someday? Still, he is my friend and this indifference, genuine or not, is part of the package. I know he is not made of stone, just driven in other ways. Five years from now he will find a woman who teaches him how to trust, who compliments him and unveils his latent happiness, chipping away the stony surface to let the warm flesh breathe.

Later Ray, Eric, and I head to the front porch of the house and sit on the bench. Our inhibitions have dissolved enough for us to sit there holding

hands openly in full view of anybody who walks by. We know we probably look gay, but we don't care. We will, of course, later when taboos seep back into our blood. For now we're free and pure. I feel whole sharing this moment with my friends, to be close to them and to hold them. The world does not allow us to be like this always. We are so constrained, accepting the taboos and false values. Let it go and accept it, treasure what you experience now, I tell myself. So I do. We do.

Tonight we are no longer just a bunch of kids getting together and drinking. We are a community, a tribe gathering in the darkness to perform a celestial ceremony, like the natives from the old world. Perhaps because tonight is primal and sacred, our conversation turns to mythology. Naturally, having always believed that I was (or should have been) an Athenian in classical Greece, I start to babble on about Greek mythology and the wonders of the classical world. My friends don't share my passion, but they put up with my rambling, having heard it before, amused at my eccentricity. Sing muse the wrath of Achilles! Sing muse the farewell of good friends! We gather to share our blessings, heal our wounds, pour libations in thanks. Our journey is an old one for the world but new for each of us. After several hours people leave our kingdom and return to the netherworld. I go home as well but lay awake in bed and sing poems in my head.

The next morning I try to call an old girlfriend to ask her if she will marry me. It is a crazy, spontaneous moment, totally exhilarating. I try furiously to contact her, calling information in the foreign country she resides in. I never do reach her. What would have happened? How would our lives be different? The small details of fate you never know. I wonder if she ever thinks of me, ever thinks about what could have been. We talked about the unnatural death of our relationship as a big question mark that would hang over us, stamped on our psyches.

The next day my parents arrive. We take our seats. I sit with my classmates in alphabetical order, my parents in the guest section. We endure the heat. My section is called to stand up since our names will soon be read. I hear mine, walk up the stage, and shake the university president's hand as he gives me my diploma. No big deal, simple enough, I think. A couple of years later when I return home from my expatriate pilgrimage, my father shows

me a picture he took of me receiving the degree; I'm shaking the president's hand but don't really seem to notice him. I'm relaxed, smiling, looking down at the paper and reaching for it. My dad says that I look like I just won the grand prize. I'm actually kind of embarrassed that I look so happy in the picture. I never thought graduating was a big deal—just something you do if you go to school. But neither he nor my mother finished college, so maybe it's special for them that their son did. Maybe I wasn't thrilled about graduating in particular; it seemed just like finishing another grade and having a bigger ceremony. But there I am, looking goofy and happy for whatever reason. My dad looks closely at the picture, obviously proud to have taken it. I look at it more closely, too. In the picture my eyes are radiant, two suns illuminating the photograph. Perhaps the ol' man saw something that I am only beginning to see.

Copacabana Beach

MARCELO BALLVÉ

I went to Rio de Janeiro in search of something real.

I had been working at a Long Island newspaper for the summer. In that bedroom community of banality, even the beaches seemed sterile.

I wrote one newspaper article about jellyfish; there were swarms of them washing ashore that summer. I paced the beaches. I was disappointed the jellyfish I found didn't hang iridescent slime or trail blood-red tentacles. I found only stiff disks of gelatin, translucent polka dots strewn across the sand. I needed a place where things dripped at the edges.

I had grown up as a Latin-American Coca-Cola kid. My father—a hardworking executive—helped proselytize the world's taste buds into collective worship of the sugary effervescence. I myself drank tons of free Coca-Cola, enjoying the kaleidoscope of well-accommodated life in Latin America's capitals—Buenos Aires, Mexico City, Caracas. After studying for eight years in the United States, I convinced myself that *these* places were teeming with reality. The Third World seemed a petri dish where social life forms, revolutions, and colors were coalescing.

University types ramble about new hybrid identities proliferating in the world. Globalism's mutant progeny. We do not belong to any tradition; we do not feel invested in a particular society. We are arch-individualists, because we can't swallow the myth of belonging. I believed myself to be one of

the new cosmopolitans—part of a new breed. The sons and daughters of peripatetic immigrants, diplomats, multinational executives, military officers, wanderers, or career missionaries. We're nothing new, but there are so many of us now; increasingly, our stories shape the world.

A few months after leaving the newspaper, I boarded a plane for Rio. I told myself I would live simply. I'd expand my narrow comfort levels.

I learned quickly that if the United States was a fantasy of clean lines, air-conditioned interiors, and sharp corners, Brazil had its own pattern of illusions.

It turned out that Rio was a pornographic city.

The beauty of appearances there ran like a membrane along surfaces—ready to alter into something unrecognizable, perhaps even offensive. The mountains dripped slums, the blue sea seethed with trash. The oiled bodies of people splayed out like seals on the city's beaches were often hybrids of silicone and flesh. Along the swirling sidewalks of Atlantic Avenue, the nights were as bright as day. Even deep into the night, everything still glowed. The spray from the sea was caught and transfigured by the sodium-arc lights into a radioactive mist that hung over the crowds.

Here—along the border of sea and city—all of Brazil was accessible. Copacabana Beach at night was itself a quiet white plain, spotlit by streetlamps. A no-man's-land of ghost footsteps leading out to the black sea. There were pale, naked bodies—giddy tourists who sometimes ran naked into the waves. Prone dark shapes: drunks and drifters. A row of figures might stand out, conspicuous in bright orange. These were the uniformed municipal trash collectors, raking the sand for the day's debris.

In regular intervals, coconut-vending huts dotted the sidewalk following the curve of coastline—surrounding mountains just a shade blacker than sky and sea. The coconuts hung in bunches from the thatched roofs, where the vendors could easily pluck and plunge them into the icy coolers to chill before sale. Coco Gelado, cold coconuts lopped off by a razor-sharp machete. Their water was bracing and mild at the same time. If you wanted anything else, you could ask the coconut vendors: cocaine or marijuana, women or girls, boys or transvestites. They could direct you to beads, charms, and curses, to venom and witch doctors.

On certain nights, candles flickered here and there on the savannas of sand, the slightly green glow of offerings made within vessels of palm leaves, the scent of burned flowers, the glow of white roses bobbing on the waves. These were offerings to the sea goddess Yemanja, a deity brought by African slaves, the blue-fleshed goddess whose body is said to run like a salty salve between the crashing bodies of the continents, the gears of cities.

The mountains of Rio pushed Copacabana, its great mess of apartment buildings, almost into the sea.

On one side a tunnel connected Copacabana to its richer, more famous, and more lovely younger sister neighborhood—Ipanema. Another tunnel linked it to the more staid and smoke-filled canyons of downtown Rio. A guidebook I owned said Copacabana was a last middle- and working-class redoubt among the touristed districts of the city's South Side. The book said Copacabana was one of the most densely populated strips of land in the entire world.

That certainly felt true in my home, a one-room apartment shared with three other men. The living space was found through the newspaper, past the regular apartment listings, in a shorter section labeled "Vacancies." My rent was $83 a month. I shared a room with Ernildo, a coppery-skinned migrant laborer from Brazil's poor northeast. Ernildo traveled from city to city in search of work. He wanted to talk about little besides the slippery nature of money, getting this money, the wickedness of women, and the Bible. Sometimes he'd ramble about the cost of whole chickens: differences in price across the city, where they were cheap and plump.

There was also a German-Brazilian from the south, Vladimir, a balding, blond, blue- and watery-eyed notary of some kind who fell asleep in his wide, striped ties and white oxford shirts stained brown at the armpits. He owned the apartment but slept in the living room on a couch with flattened cushions. This was his domain, which he never left while in the house. He spent most of his time watching a television that produced images but no sound. His roommate, Ronaldo, slept on the floor of the living room. He was a student studying English and computers. My roommate claimed that Ronaldo and Vladimir were secretly lovers, and this seemed to me probably true.

My bed in the only bedroom lay next to a wide eleventh-floor window. My view was of the grimy apartment block that was opposite ours. All the windows were hung with pastel-colored laundry. In one window across the concrete canyon, a single spot of bright color stood out—a red hummingbird feeder. If I stretched my neck out, I could also see a spot of green: the great curve of a nearby mountain, with a sheer rock face and a close-cropped crown of forest on its summit. I lasted exactly one month in this apartment.

It was an incredibly dirty place. Small, shiny black insects crawled in and out of everything in the kitchen—the sugar bin, the packages of rice, any leftovers left to sit on the stovetop. If you weren't careful, they would crawl into anything you were eating on the living-room table. The walls and carpets were stained; the door to the apartment did not lock—anyone could have broken in at any time. The entire place smelled bad, of something dry, but that was somehow rotting at the same time. I imagined the small insects I saw scurrying around all day, all of them dying and crumbling away in common graves within all the unseen corners and nooks of the muggy apartment.

Ernildo and I would talk to each other as we fell asleep at night on our tiny, stiff-mattressed beds; I was still struggling to make myself understood in Portuguese. He was certainly a real Brazilian, at least as I had envisioned one. He was short—almost dwarflike because he was so thick—and muscular. He was dark, with kinky hair shaved close; he had golden, almost yellow eyes. Fake teeth filled the front of his mouth, and a huge scar curved over his torso from his shoulders down to his swollen belly. When he stood next to me, I could feel the coiled energy inside of him. His scar was not recent. He said that many years ago he had been doing work on a colonial house in the northern city of Salvador, painting walls while sitting on scaffolding that collapsed. He fell three stories into a pile of glass and wood, knocked out his teeth, and cut himself open. He believed that God saved his life. As he fell asleep at night, he would place his fake teeth in a cup of water and suck at his gums, making loud, wet, clucking noises.

The first night I slept there, I didn't know who or what he was. I didn't even know that I was supposed to share my room. I thought I had found a real bargain—a private room for so little! But then Ernildo arrived in the

47

room drunk and passed out on the floor; he moaned and kicked at the closet door all night, despite Vladimir's protests. For days, I thought Ernildo was a madman. A week later, we went to a club to dance forró, the country music of northeastern Brazil, which is danced by holding your partner tight and swinging your hips back and forth. He lent me a shirt because he said my clothes looked effeminate. We drank some beer I had bought. We put on some music and we even danced together, Ernildo giving impromptu lessons. When we arrived at the club, I had to pay his cover charge. We ordered a bucket full of ice and beer bottles. He found me a girl to dance with but then became angry when I stopped paying attention to him. He kept on tapping me on the shoulder and asking for money. I stopped giving him any. I think he finally left the place. I didn't leave until just after sunrise. When I awoke later at the apartment, it was because Ernildo was shaking me.

The first thing I noticed was that he was wearing my favorite T-shirt, a green shirt with a Hawaiian pattern of yellow hibiscus flowers on it. The second thing I noticed was that he was completely drunk and had a wild look in his eyes. His arms were full of random objects: a package of socks, a plastic toy truck in another package, a soccer jersey. On his head was a new baseball cap with the tag still hanging from it. Sand covered his face. Evidently, he had slept on the beach. He managed to garble out that he had spent most of the night playing at a bingo parlor, the only places where Brazilians can legally gamble. They compete for prizes and gifts instead of money. He gave me the cap, squashed it on my head, but demanded more money. He claimed the bouncer at the bar wanted to kill me because I had not paid our tab. I refused to hand any money over. He was drooling, aggressive. He claimed I had spent the entire night dancing with a transvestite he had introduced me to, which was entirely possible. This made me angrier, and I began screaming in broken Portuguese that he was a parasite and a shameless bastard. I demanded that he hand over my T-shirt. *Ladrão!* I called him a thief. I was afraid that he would attack me; his eyes smoldered. Finally, I skirted him and shut myself into the bathroom. A few minutes later, I heard him stumble out of the apartment and bang the door.

I felt relieved, then immediately after—incredibly stupid. I went in the room and looked in my wallet. The twenty *real*-bill I had in there was gone.

I was enraged. It was a little less than $10. At that point, living by teaching an English class here and there—my savings almost wiped out—each quantity of money had begun to mean something definite to me. Each amount meant something precious. Lunches, dinners, sustenance. Later that night, while Ernildo gleefully told my other roommates I had danced clutching at a transvestite all night long, I wrote in my journal.

March 26, 2000: "I was friendly with Ernildo last night, and even now he's talking about how I danced all night with a transvestite and so what . . . all the fucker ever talks about is money and different sums—20, 30, 15, 40, 70—always calling up fat whores on the phone to come and give his pathetic drunk ass money."

I was angry; I had to leave that damn apartment. I had no privacy, no protection from Ernildo. He could take whatever I had in my room. He could interrupt whatever I was doing. At a moment's notice, he could attack me. Quite simply, I was scared of him.

A few weeks later, I was washing some of my shirts in the bathroom. The room always smelled strongly of urine. I was bent over the bucket, scrubbing the cotton fabrics against each other, stripped down to my boxer shorts so that I wouldn't get hot. As I worked, I felt something tickle my back. I instinctively reached around to scratch at it and came away with a huge, winged roach squirming and mangled in my hand. I screamed in disgust and flung it at a wall. I decided I couldn't live there any longer. It seemed that there was something better out there; something cleaner, perhaps something not quite so real.

After I left, I lived in a series of other apartments—all in Ipanema. All had their advantages, they were cleaner, and I had more privacy. The last apartment I lived in cost seven times more than the room I shared with Ernildo. I lived there alone. It had a sweeping view of Rio's lagoon, and Corcovado Mountain rising behind it, the famous Christ statue on top with outstretched arms. But I also realized I had never liked anyone I lived with as much as Ernildo. I started forgetting his aggressiveness and remembering that when I came home from Portuguese classes, and from e-mailing a faraway girlfriend I was losing, it was Ernildo who came up to me and clapped me on the shoulder and received me with a cheerful greeting.

Even after I left, Ernildo had an impact on me. The entire time I lived in the apartment, I was known as the Gringo, *"O Gringo."* I am Argentine originally. I look South American; physically, I could be mistaken for Brazilian. Still, in Brazil the term is the all-purpose word for any foreigner. Ernildo would continuously repeat a phrase to me all the time, and I was utterly convinced it was an insult: *"Esse gringo é um barato!"* he'd say. So I was a *barato,* I thought—great. I thought I knew only two possible meanings for that word. In Portuguese, as it does in Spanish, *barato* means "cheap." I also knew all too well that the word *barata* means "roach."

Both meanings could have been true. Ernildo thought it was contemptible that roaches made me angry. I thought maybe it was some kind of slur, equating the foreigner to the roaches and playing on the fact that I was relatively intolerant of them. There was also tension between us about money. Intuitively, he could tell that I had more money somewhere, despite my lack of possessions and my off-the-rack wardrobe.

My thinking was way off. Only weeks after I left the apartment, I learned at my Portuguese class at a local university that *barato* was also a slang term. The phrase that Ernildo hurled at me countless times every day meant something like "That gringo's a trip!" or "That gringo's a blast!"

The whole time, he had been saying that I was alright, that he was glad I ended up as his roommate. I wondered what he made of my sullen receptions when he sang out his accustomed greeting.

I tried to find him. I went to back to the apartment. It was by then the middle of summer. Vladimir was sitting on his couch in a pair of ratty shorts. His narrow, pale chest heaved in the heat. He offered me a glass of water but sank deeper into the couch as he gestured toward the kitchen. "We kicked Ernildo out. He was a total alcoholic. He stole a lot of money from us." Where'd he go? Nobody knew.

I walked along the beach and went into some of the bars where we had drank together. I talked to some workmen at a construction site where I knew he had worked for a time, caulking spaces between the square black-and-white stones that made up Copacabana's famous trippy, swirling sidewalks. *"Ele foi embora,"* they all said, "He went away." They were men as

broad shouldered as Ernildo, with hands as large, men as stunted, but dull-eyed men.

Ernildo had flashing yellow eyes. I remembered that one day—in the midst of a drunken rage—Ernildo had gestured to a collection of Afro-Brazilian religious statues that Vladimir kept by the door. He had railed against Vladimir for being a religious poseur. "You can't just have those statues," said Ernildo. "You have to make offerings to them, give them rum and candles. You have them by the door to protect us, and you don't even feed them." Vladimir languidly told Ernildo to mind his own business. Ernildo pointed to one of his eyes, tapping under it with his scabby finger. This was a common gesture with him. When he wanted to emphasize a point or prod the listener into deeper consideration, he tapped under his eyes. "Look man, you can't just collect those things," he said to Vladimir. His statement stayed with me.

There is a tremendous temptation—especially among those lucky enough to contemplate wide horizons—to collect authenticity in the vulgar way one collects postage stamps. We've tired somewhat of competing in the vapid realm of things; many of us are now beginning to compare our private vaults of experience, vying to outdo one another in either breadth or depth. For the right place absorbed in the right season. We want the authenticity we perceive in certain places—or within rooted people—to somehow seep into us. Run warm in our blood, stain our skin different colors. We want things to exactly match the glossy catalogs of experience we've invented. Our desire becomes a premeditated coercion; we travel and strive to discover nothing but what we've advertised to ourselves.

Take the example of a nighttime walk on Copacabana Beach. If serendipity is allowed, one could end up anywhere. You might be nudged awake during a cloudy dawn by a man holding a rake and wearing a pair of orange overalls. You might push yourself up from the sand, reaching for something that isn't there. You might chase the orange-clad man to the edge of the waves—lunging for his pockets—thinking he's the guy who stole your wallet. He eludes you anyway. The wallet is gone; the identifying pictures of you, a rainbow-wad of bills. The night covered your face and arms

with a layer of sand. It left a sour taste in your mouth and only fuzzy memories. You have no place to go sleep your hangover away.

What remains now is a clear memory of that morning. An awakening on Copacabana Beach. It had little to do with the Brazil you imagined, and it wasn't any less silly than waking up on Long Island.

Above all, people shouldn't be collected. They will stay with you anyway. I remember Ernildo clearly. He was a bastard, a real *barato*.

Globalization

PAT BOYER

Beautiful Country

EMMELINE CHANG

I held on to the pole while the bus bounced along the heat-choked Taipei street. *My clothes give me away,* I thought. At any moment, I could be discovered. If you didn't look too closely, I blended in. After all, no one could see the *Lonely Planet* guidebook jammed into my backpack, and my hair and features and build were right. Still, my clothes were too casually American: rubber-and-Velcro Teva sandals strapped to my feet, a JanSport backpack, a white undershirt, and a rough wraparound skirt. I stared out the window. The concrete buildings and a jumble of Chinese signs were familiar, but the streets I remembered were gone—the dusty mix of motorcycles, compact cars, and bikes had been replaced by sleek BMWs and shiny scooters.

I wanted so much to belong. I wanted to wipe away those painful summers—those trips where my sister and I sat mute while relatives talked about us as if we weren't there. Despite our parents' explanations, our relatives couldn't comprehend: we didn't speak Taiwanese, but we understood it. One afternoon I retreated from an uncle's living room to cry.

"I can't stand it," I sobbed to my mother. "I can't say anything! I can't talk to anyone, and they all treat me like I'm stupid!"

During those childhood trips, Taiwan was a poor, dusty country filled with roaring traffic and greasy-haired, glasses-wearing people who did noth-

ing but work and study. At traffic lights, motorcycles surged forward, old Japanese hatchbacks and bikes following in their wake. Dust rose. Housewives and old men in flip-flops wove among the traffic on bikes. It was chaos and poverty. It was Taiwanese. In the United States, our Taiwanese family friends, the Chens, drove an old seventies sedan. The faded beige interior smelled like Mr. Chen's unwashed hair, and the roof's sagging upholstery was held up by strips of electrical tape. From the backseat I could see flecks of dandruff lodged among Mr. Chen's oily strings of hair. Until fourth grade, I had washed my hair once a week, as my mother had taught me; by the end of the week, I could brush flakes of dandruff past my bangs and smell the oils of my scalp. It was the smell of being an outsider, of not taking part in the shiny-haired, bouncy lives I saw on TV.

Though I didn't like to think it, I knew that I was a nerd in the United States, and this was related to being Taiwanese. I was serious and studious and got good grades, but didn't have the clothes or social skills to make up for those defects. When a classmate whispered, "Chink," as I walked by, I flushed with shame at the half-understood insult. I knew very few Asian-Americans—only three or four classmates and the families I saw at Taiwanese church gatherings—but, in my mind, similarities bound us together. The competition over grades, the classmate who wore tacky plaid shirts and Toughskin jeans: I hated it. There were no Asian-American rock stars or political leaders or athletes to shape my idea of who we were, no Asian-Americans in the TV shows I saw or in the magazines and history books I read. We were alone—a handful of nerds and outsiders drifting in this American sea, vaguely connected to an Asia so faraway it was almost a mythical land.

By the end of college, I saw things differently. Our hairstyles and clothes and cars had been shaped by political and economic forces. My shame had been a form of internalized racism, a self-hatred I was learning to overcome. While Taiwan had changed (transitioned from exporting cheap appliances to semiconductors; gone through an economic boom that brought the joys of Gucci and cell phones; and moved from martial law to raucous democracy), I had started to think about identity and diaspora.

So, a year after I graduated from college, I went to Taiwan. I wanted to connect to the place my family had come from and speak to my relatives as

an independent person. I wanted to expand my one-dimensional image of the place—to move beyond the distorted view informed by childhood memories, model minority stereotypes, racist ideas of the Third World, and what I saw in other suburban Taiwanese-Americans.

Once there, though, I was caught in a whir of new needs. What mattered was learning new words as quickly as possible: "stationery store" and "vegetarian," and then, as life situations continued to press on me, "cough" and "fever," "waterproof hiking boots" and "antimalarial medication," "answering machine" and "government" and "second aunt on my father's side." I hurried through my Taipei life collecting vocabulary, twisting and turning to navigate new social identities. Daily interactions were nerve-racking. Without skin and hair to mark me as different, I lacked the freedom to flounder adventurously through this new society. As a Taiwanese-American, I knew just enough to guess all I might be doing wrong—but not enough to understand this new world.

I felt freer with other overseas Americans. Comprehension, communication, common manners—all of it was easier. Nuanced word choices, the subtleties of humor and irony and cultural references were at my command once again. It was a relief to sympathize with others who were bothered by the choking pollution, the miniature trucks that circled the streets endlessly broadcasting campaign slogans, the vendors and piles of junk crammed onto the sidewalk, or the way people pushed onto buses instead of forming lines. Yet I often felt disloyal. I imagined us sitting over china plates and cups of tea, fanning ourselves and shaking our heads: "These natives just can't get it right."

I hadn't expected to express all the sides of myself in Taiwan, but as I became more fluent and met more people, comfortable self-expression was increasingly possible. With my American friend Cheryl, I took moonlit motorcycle rides along the twisting mountain roads outside Taipei. I drank milk tea with my language-exchange partner, Ting, and talked about everything from parents to travel to social activism and sex. I loved discovering the Taiwanese version of Thai and Indonesian and Korean cuisines and delighted in Chinese foods that had felt disturbingly foreign to me as a child.

By the time a friend e-mailed me the phone number for a Taiwanese lesbian group, I had gained enough vocabulary and confidence. So, one February afternoon, I stepped into a chilly cafeterialike room with high ceilings, fluorescent lights, and folding chairs: this was the annual gathering of Taiwan's oldest lesbian group. I looked around uncertainly, then tried to read the program. *Greetings and welcome. Introduction games.* Women drifted in and filled the chairs; there were close to fifty of us in all.

At the front of the room, a woman tapped the microphone and introduced herself. I strained to catch her words. Two women stood up. They were Ah-Fang and Xiao Mei, the emcee said. They had met at an earlier gathering, and they had been together for two years now. I watched, perplexed, as Ah-Fang explained at length how she and Xiao Mei had met. People clapped, and the emcee introduced another couple. I was confused. The atmosphere was strangely formal; the structured program reminded me of the Taiwanese cultural programs my family used to attend for Chinese holidays. But why *did* it feel so strange? Then I realized: I had expected groups of women sitting in circles, sharing their coming-out experiences. A potluck, groups of friends talking, announcements about upcoming rallies. In other words, a Chinese-language version of groups in the United States.

"Let's have some activities to find out about each other," the emcee said. "*T*'s to one side, *po*'s to the other." The women around me began to separate. I had never heard these words—*T* and *po*—but I could tell from the appearance of the women on each side (boyish haircuts, vests, and dumpy bodies versus long hair, makeup, and tight little skirts) what kind of division was taking place. I didn't know which way to go but finally hurried to the *po* side since my fashion and grooming choices more closely resembled theirs.

The emcee had moved on. "So remember, I want you to meet as many people as you can," she was saying. "The person who has the most responses wins." Women shifted forward. "All right," the emcee said. "Find five people who have the same *xie xing* as you." The women began milling around. *Xie xing?*

A round-faced woman interrupted my confusion. "I'm A *xie xing*. And you?"

"Uh, well, I'm a Taiwanese-American, and my Chinese . . . sorry. I don't know what a *xie xing* is."

"Oh." She began speaking very quickly. "Do you know *xie?*" I gave her a confused look. She indicated her veins. "You can be A or B or O."

"Ohhhh!" I said. "Uh, I'm type O."

"Oh." She looked disappointed.

"My name is—" I began, but she had already rushed off to find someone with type A blood.

"All right," the emcee called. "Now find a person from every *xin zuo.*"

The milling became more urgent. I wondered if I could absent myself. I'd thought my Chinese was good enough for this retreat: I knew words like "lesbian," "bisexual," "condom," and "AIDS." I hadn't imagined needing to discuss my blood type. Eventually, I would learn that Taiwanese people love to discuss the personality traits that correspond with different blood types, much the way that Americans talk about their astrological signs.

I didn't meet anyone until the organized activities came to a close. I stood alone, watching the women, who stood in groups along a low stone wall overlooking the lights of Taipei. Then I felt someone beside me.

"Are you lesbian?" The woman was short, with small eyes, puffy boyish hair, and bangs cut straight across her forehead. During my teens, when being an Asian-American with good grades put me at high social risk, I would have stayed far away from her.

"Well, actually . . ." I decided to be brave and honest. "I'm bi." When coming out, lesbians were one of the groups I feared most.

"You mean you can be with men? But then why are you here?"

I began a stumbling explanation about confining social assumptions and wanting to be part of a community of women. My Chinese was definitely not up to the task.

"You're not here to find a girlfriend?"

I was surprised. I had always gone to queer groups for the progressive worldview, or to make friends, or to take part in political actions. Perhaps this attitude was possible because in the United States, if you spent time in certain circles, you didn't need a group to find a girlfriend. Eventually,

though, I found Taiwanese lesbians who lived with more freedom, met the leaders of the Asian Lesbian Network, and learned about their Asia-wide lesbian conference in August.

By that summer, I rode the buses with my hair clipped up into a wooden barrette. In my long, slim skirts and tight-fitting Taipei-bought tops, I looked Taiwanese. And it was such a luxury to see Taiwanese women everywhere—in magazines, on TV, on the street. They were beautiful. I was beautiful.

By August I knew enough Chinese to attend talks about transgender or HIV-positive life. I could tighten my mouth for a passable accent and shift between feeling Taiwanese and American by changing what I wore, how I walked, how much I listened. Listen carefully, and I was Taiwanese: competent, comprehending, able to communicate. Stride aggressively, backpack strapped on my shoulders, and I was American.

At the Asian Lesbian Network conference I saw how different my life in Taiwan had become. I read the destinations on the bus windows and got onto the right bus. I watched the city thin out as dusk fell, the tile buildings and 7-Elevens appearing further and further apart until we were winding through the country. When I walked into the low, Japanese-style bungalows, the organizers waved me over and handed me a microphone. I stood before a room filled with lesbians from all over Asia, and while the emcee led us through introductions, announcements, and a version of charades that had me doubled over laughing, I translated. The next day I bought myself a Chinese "Action = Life" button, talked with women from Korea, India, and the Philippines, and ate dinner with a group of Taiwanese acquaintances. At night, they turned the music up and the lights down: I danced, developed a crush on a Taiwanese woman, and clambered down the slope behind the bungalows to wade in a stream with friends. Later that night, a group of us walked to a hidden hot spring. Dark tree branches moved above us as I slid in among the women. I leaned back against the rough stone and breathed the rich, humid air. Half-submerged in the water, looking up at the stars while English and Chinese conversations flowed around me, I knew this was a life neither my parents nor mainstream America had imagined for me. Only by coming to Asia had I found it for myself.

By my second winter, I was dating one of the conference organizers, Xiao Zhuang. With Xiao Zhuang, life fell into certain rhythms. We went to Chinese opera and foreign movies. We had potlucks with lesbian friends, went to her friends' gallery openings, and took a trip to central Taiwan so she could interview a man about the gods carved into temple doors. We discussed Taiwanese social issues with her roommate over breakfast and analyzed our experiences as Taiwanese and Taiwanese-American women.

Without conscious awareness, I had grown into a life filled with things important to me: friendship, conversation, community, politics, and the arts. I had made a life in the land my parents came from, and I had made Taiwan my own. The Taiwan of their youth was a point of origin: they had emigrated to the United States and put our family on one trajectory, while Taiwan continued on its own trajectory. Now I, in crossing the seas, had crossed onto Taiwan's path. I could not return to my parents' former lives, but by crossing over to see what the other trajectory had yielded, I could triangulate back toward some vision of the place we all came from.

What I saw in Taiwan was a whole society. How liberating it was! Taiwanese people weren't just aspiring valedictorians and hardworking doctors—they were taxi drivers arguing for Taiwanese independence, undershirted men chewing betel nuts, and carefully coiffed karaoke hostesses. They were business families who took gambling trips to Korea, a single mother who wrote radical cultural criticism, a student sleeping with her older married friend. Here was a whole world filled with every type of Asian person.

Lesbian life in Taiwan, for those comfortable with their orientation, was an invisible revelry. You could hold hands on the street and blend right in with the schoolgirls and female friends. Xiao Zhuang and I kissed on the street, went to underground bars, and took group trips to all-female spas. Of course, invisibility meant misery and loneliness for many people, and a lack of legal protection for everyone. Politically, queer people were on their own.

One afternoon, I hurried into Taipei's feminist bookstore for a safer-sex presentation. When I pushed the door open, the room was already darkened. At the front, images flickered on a screen, illuminating the tops of

heads, the lavender walls, a poster of Virginia Woolf. I stood on my toes to see. Women wearing leather armbands. Men holding signs. Marble buildings fronted with columns. A broad avenue. A crowd, bright with T-shirts and rainbow flags. This was footage from the 1993 March on Washington!

For a moment, I was disoriented. Why was footage of a U.S. march playing at a safer-sex presentation in Taiwan? But the video played on, drawing me in. Two women pushing a stroller. Banners moving down the avenue. Nevada, New Mexico . . . Dignity . . . the Metropolitan Community Church . . . LesBiGay Teachers, Queer Telephone Workers . . . There was the White House. The couples gathered at the mass commitment ceremony. And finally, this: a group of people standing around the National Mall, the Washington Monument above them, swaying as they sang. *O beautiful for spacious skies, For amber waves of grain . . . For purple mountain majesties above the fruited plain . . .* Images rose in my mind: the grassy hills of central Maryland. Heated city pavements, the snow-covered Rockies, Kansas like a tabletop of blowing grass. The nonprofits in every city and town, the activists, the demonstrations, the people who wrote letters to the editor, and the people who gave money to support it all. There, in that lavender-walled room crowded with Taiwanese people, surrounded by Chinese books and posters of feminist authors, I stood, tears filling my eyes. In that moment, I knew what made America beautiful.

1999–2000

LAUREN KESNER

From June 1999 to June 2000 I took these photographs. I had just graduated from college, and as the real world's structures fell around me, I found that there was little I believed in, as trite as that may sound. Nevertheless, I moved with the quickness of the time and collected pieces along the way. The pieces felt real, self-conscious, and honest. They grounded me. The pairs of photographs in *1999–2000* are questions about how physical space

intimacy I

SMARTY PANTS THE CLOWN, BROOKLYN, NY, 2000

defines us and how we define it. I wanted to understand why people attach themselves to places.

Before I left the United States, I did not understand that what I craved was something bigger than myself. I was caught up in the day, the debates over globalization, the excitement of the stock market, the new possibilities of the Internet, and the amazing stories of my peers' travels around the world. This time was filled with excitement, but I felt that something was missing. Progress led the people, and the people lost a connection. This was the atmosphere in which *1999–2000* came together. Looking back at these photographs, I see them as reflections of this absence.

In Armenia, where I live now, people understand their lives and existences in relation to Noah and his ark. Mt. Ararat, where Noah's Ark is said to have landed, stands high over the country as a reminder of history and of our size in it all. I am not Armenian, but I understand that this is the context I was looking for: history. In an atmosphere of progress and wealth, one has the luxury of forgetting the past. But, still, history defines us. It places us.

1999–2000 is a testament to my longing to find a mountain to look up at in awe and to see my size in it all.

intimacy II

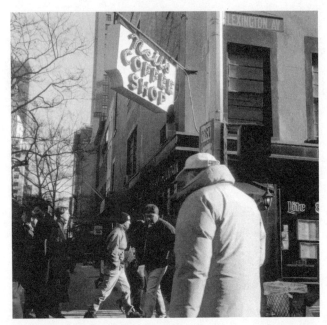

UPPER EAST SIDE, NEW YORK, NY, 1999

BEDROOM IN QUEENS, NY, 1999

freedom

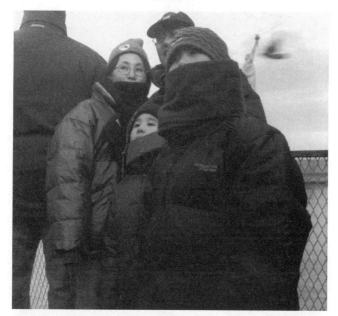

STATUE OF LIBERTY, NEW YORK, NY, 2000

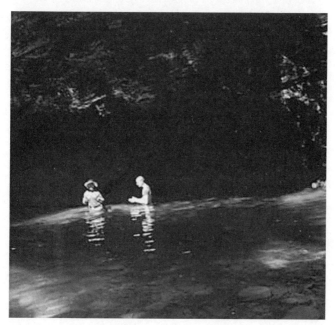

WOODSTOCK, NY, 1999

scale

PURDY, WOODSTOCK, NY, 1999

BROOKLYN VIEW OF MANHATTAN, NY, 2000

Red, White, and Blue: One Spunky Young English Girl's Transatlantic Memoirs

JESSICA YORKE

trying out this american garter for size

Oakland, early January

When I first moved to Oakland, my life was cool. Well, it seemed cooler than everyone else's. I lived on refried beans and cheese soft wraps while everyone else I knew stocked their freezers with gourmet pizzas. I had a great motorcycle and a best friend named Nancy who drove a beat-up truck. In the morning, I would take my busted BMX and lap Lake Merritt three times, stopping off at the grocery store to stock up on decaf and ketchup, all the while yelling at all the men who wore slacks so low you could see their asses cracking. It got dangerous if you headed further into town, by the freeway. But I liked the kicks I got from standing face-to-face with men who thought any woman looked like a lesbian if she didn't do her makeup like Lucille Ball. My lover of the time was a real-life Texan with a drawl so slow it was like pulling gum off a sneaker sole. His mouth was wet and slippery, and he wore T-shirts with day-glow badges. We made up ideas about heading into the desert on camping trips and driving to Mexico, but they all fell as flat as a trannie's chest without the push-ups. Usually, he would slump into our velvet couch, listening to Indie vinyls, smoking American Spirit Lights, as the rain pelted down outside. It was often wet in Oakland. We

might as well have lived near the lake instead of being situated up the hill, staring at its derriere.

first impressions

America is a dirty place sometimes. You can get off on the danger for a little while, but when you come face-to-face with poverty, it's not easy to swallow. All those glossy sunny afternoon celluloid moments suddenly turn into a Nirvana video. English people always have the "deary me" aspect to every sentence. It's all that tea I reckon. Those Protestants, I tell you. My dad's practically High Anglican, so I should know. But church is what got me confused about having breasts and molesting my teddy bears, all my pink flabby flesh exposed like a Los Angelino in a San Francisco library; the church services and vinegar atmosphere of all those communion sessions; the heavy repentance. American kids jus' don't seem to be raised the same.

Luckily, I have a giant bulb in my brain with a "start running now" caption whenever events get too dull to be able to handle. It amazes me that some people everywhere are just content to talk slower and slower and get fatter and fatter until they can only lie on their fake-leather couches all day watching game shows. Some trigger that ought to make them sit up and yell "goddamn!" just isn't happening. I often find counting my blessings works well: clear skin, young age, freedom. But freedom is not all it is pumped up to be: your mind can go haywire with alternatives if you are not careful. You wind up living in a dreamworld full of get-rich-quick fantasies; your eyes get glazed; you get that pathetic, vacant personality that can't crack witty one-liners. My main goal is to wage a one-person war against conventional ideas. Personally speaking, the worst feeling in the world is to have a "suburban chick" label stuck above my head like a sterile Gap billboard and for there to be nothing I can do to fill that gaping hole of Midland Bank statements but have All-Bran for breakfast. That is why I got out of London. My life was turning into an unmarried Shirley Valentine's. I mean, what is a goddamn job worth if all you are taught you're good for is whacking typewriter keys

like you're at a donkey derby? So, here I am, living near the city of San Francisco. Gee whiz.

euro angst still lingers like an aniseed apertif

I have difficulties with my European status. I always feel like I have to apologize for my ancestors who marched into territories and took them over as fast as rabbits in springtime. I feel my ancient warrior instincts come into play, but I'd rather be peaceful and cute, so instead I sit around chewing my nails in the Laundromat gently grinning. I'm beginning to realize my Euro vacancy now. What I really want is a personality as loud as RuPaul's lipstick. So I'm going to screw all the apologies, start screaming loud, and eating all my meals with something spicy and upfront. According to my great grandmother's birth certificate, I have gypsy blood in me so I'm not completely white, although when I walk through the 'hood I must look like the ghost of Christmas past.

Sometimes I think I may just be running away. I have all these different directions leering at me like Ronald McDonald, and which one should I choose? For the first time in my life I feel like I am able to make clear-cut choices, but I am hesitant. The wall between my parents and me is called America: that's a big one. I'm not interested in hanging on to my Englishness. Yeah, the people blah blah, the violence blah blah, but if you'd ever lay down in a smoky boat listening to the Santa Monica radio, huffing on the best damn grass you've ever tasted with a group of the most magical, warm-hearted heads you can imagine, then you'd know what I mean. It was all so damn sweet.

while the government shits on me

So now, at twenty-two, I'm meant to be at the sophisticated stage when I have settled down and got this job thing hooked up. I ought to be sassy and

streetwise, but when I get into a situation where I need to deliver the verbal goods, I feel like there are tennis balls in my gullet. I am kind of attractive if I haven't been drinking or when I'm at work and I get this hard-assed gravel-wouldn't-melt-in-my-butt look about my jawline. I thought I had skipped through the red tape at airport immigration with my story about slumming with old pals. Period pains used to get you out of PE; why couldn't I plead pathetic female innocence in this case of testosterone government schmaltz? Oh no, the Queen isn't kosher currency in the international field of play. Perhaps England kicks ass because of the Beatles, Elizabeth Hurley, and Tetley Tea. But relying on the Empire these days is not going to get you further than the counter if you're under twenty-one with two liters of Scottish malt at Rite-Aid.

I was all set up with an assistant job in publishing, then the working visa issue was brought up, and I flaked. I watched my beautiful job float away from me like a paper boat on Regent's Park Lake, and I shed crystal tears of regret that my mother didn't give birth to her sixteen-pound bag of human jelly on the same ground that spawned Abraham Lincoln and Richard Simmons. But it is my fault, not hers. I should have listened to my father's sober address on the state of U.S. employment as I sat shrinking away like a suckled lollipop in his IKEA-kitted study. My yellow-brick road's turning dirty brown, my stairway to heaven's got a bit creaky, and my platinum blonde's washing mousy. What the hell can I do now?

wanted: brit chick

The other flat mate has gone back to Santa Cruz now so the place we share is as quiet as a bomb-scared K-Mart. If I do not get a job soon, my credit card will combust from friction strain, and my brain will drop cells like a split bag of rice. I have answered more ads than Cheers has reruns and phoned more companies than can fit into the Oakland Yellow Pages. I'm getting frustrated that my mates back home are getting drunk on Fridays and I'm not there. Why did school have to end? When I finally made it to San Francisco, I wanted to go the whole hog, all the way to the negative

vibes of 6th and Market and the mind games of high-rise offices. I never did do things by halves.

Now, I'm thinking of ringing up those dial-a-spell numbers and pleading with some astral witch from Tucson, Arizona, to throw some ether over the INS so I can frog march into the document office and have my wicked way with them. I just hate waiting at home for the phone calls. Man, I ought to be at the power-lunch stage of my career, buying stilettos in North Beach, doing back crawl in the Marina, ripping up bills for my pooch's litter. Please God, let there be a legal way to work here. I want to be Hugh Hefner throwing mansion parties where you fill up swimming pools with red wine and everyone jumps in naked. Idealism, volunteer work, flag flying! I would do it all just to feel alive.

when the living was easy

In your first ten years of life, your awareness is not sophisticated enough to tell when you are queuing for something. If you're bored, then you scream, throw a tantrum in Safeway, or fall asleep and drool all over the place. In your teens, you get confused with all the hormones going wild, and you fantasize wildly to alleviate the tides of precious, youthful nausea and suicide attempts. But, the early twenties? Straight out of college if you've hung on, you envision a corridor lined with adrenaline-boosting winning tickets that have your ego written all over them. You think the world is waiting for your precocious patented breath. You see yourself on this victorious path to the Disneyland of lifestyles, the Oscars of fulfillment. Wake up, sugar bean. There are a trillion of your kind, a millisecond sooner on the phone to get that job, feistier on the page, and more super-intelligent in print, with more charm and guts than you thought.

Oh, you can try, but you will be waiting awhile. And if you ride a lucky break and hit the G-spot, then for the sake of God, keep it mum. You can go back to knocking yourself out with classifieds and Internet info and dancing till you drop, but know that it takes practice to bake fairy cakes. Instead, why not put a dime under your pillow and dream sweetly that to-

morrow the golden opportunity will be FedEx-ed. Or screw it all and denounce that Mr. Ogre Capitalism is a friend of yours. It all beats getting a Ph.D. in Glasgow. There's always the women's argument that half of the population can fall back on: I wouldn't be doing this a hundred years ago; I'd be locked up and gagged and decapitated by some Victorian masochist. Today, I can watch the butterflies and read so many books I want to throw up and let my mind reach the solar limits of chemical expansion. Thank heavens for small mercies.

the universal ballet

I wonder if it all balances out somewhere and whether one person kicking back is making way for another going into labor. In some area of psychic mutual self-preservation, we are all working together in a cosmic ballet, stepping forth and holding back for the greater good, giving and receiving according to a golden law.

I have always been into those salt-of-the-earth-type scenarios, which is why I probably like America. My friend Emma's dad ran a car pick-up company, and I loved the mechanic scene. Back then I used to spend beautiful summers on a farm where my brother and I watched baby chicks hatching and calves in labor. Something about roasted peat innocence, midsummer madness, and horny hay fantasies makes me shiny all over. The meaning of life's right there. You can live through three-dozen reincarnations and you won't get any closer to the truth.

But this can be a crock of liberal banter to the good citizens of the United States who know that for every bit of optimism there are just as many greedy truths to be told. So, instead, I'm caught head-on between the seduction of the peace-and-life attitude versus the stimulation from new pressed suits and high-stress offices. Being a student does that to you. Beer and drugs and missed A.M. lectures send you upside down with chemical imbalance hysteria for a while and then you have to get intense about reading three hundred pages in a half-hour while studying for your finals. Maybe it's time that I put my tail between my legs and apologize to all those people who thought I ac-

tually was an independent female. Because I do need things like affection and support. I feel like a floating amoeba in a tide of other floating amoebas, all getting tossed around in the storm. Maybe I'm still grasping for something that has to come from a lot deeper inside me—like God, love, and religion. But doesn't that just make me more dependent?

sex and politics: please release me

When I'm totally relaxed and just hanging out and someone asks a question in a certain tone, I just break out into crushed watermelon color and I can't stop the rush of blood. I have to face it; I'm a bit of a nerd. I think way too much about gnarly details that everyone else passes over. It's just not fucking human to forget about sex accidentally on purpose. I believe in the power of the crowd, you see. Fear isn't cool, nor is blushing.

Being a nerd is really a cover-up for having a wailing, full-throttle personality disorder. The most highly intellectual bag of crap I think I've ever been ordered to sit through has to be my classes in post-Marxist critical theory. All I can remember is some peculiar story about how every woman is bisexual and how you can draw up this little matrix with pigeon-hole gaps big enough to fist in order to explain why there is no center to anything. I loved Foucault's *History of Sexuality* because it showed me how taboos are upside down. And no one else batted a painted eyelid. Maybe those wiry academics had something with that everyone's bisexual theory; I wouldn't be so liberated had it not been for my early experiences playing doctors and nurses with a plump girl named Jane after primary school in her parents' attic. I was in Willy Wonka's factory, permanently on sweet innocent heat just waiting to figure out what drove me inside my vulvic hemisphere.

Coming to the United States of America put all my nice middle-class fears into order, not to mention the coke-crazy lesbian exploits of my girlfriends back home. When you live above a club where dudes breathe S&M, you get used to the necessary perversities of the human condition. You realize that people like being hurt. These creatures are the ones who can laugh the crystal healers out of town on their patchouli backsides. They think their

brand of evil is superior to the removed thinking of the closeted, Jesus-on-the-water type of aristocratic hippies who make up in class-ridden sarcasm what they don't get from practicing dirty sex. But I'm stereotyping of course. Enough politics, already. Give me beans and cheese wraps and I'm happy. I'll stand on the sidelines and bellow alright, but I'm not wanting to be anyone's uppity role model. That's just bad taste.

enter: new bloke

So it looks like I might be getting hitched at twenty-two. I just fixed myself a pan load of buttermilk cake and wanted to see that in writing. We will probably do it quick so I can get to work sooner. But I have to admit that this time around I'm probably more in love than I've ever been. I've flown back home to tell my parents the situation, then back to holidays in the Sierra Nevada, legging it over a Yamaha down the Bay Bridge. Now, my independence has nothing to do with this. I will still officially be a "Miss" whatever, still going about my life with all the zest of a cruiser, still sick-minded and eternally dissatisfied because this revolving planet isn't ever going to give me what I really want: everything right now without down payments, the sharpest thrills for no fee, and a big pill to swallow, swallow, swallow. Plus the ability to see, mind, animate; get wine from water; feel like a soaring bird drawn off the page; and live dream sequences. Oh well, (sigh)—I just might have found someone who suits me.

uncle sam wants you!

I've landed in good time in London and marched down the arrival catwalk. I'm not going to catch that miserable disease that is as contagious as herpes in these parts: attack of the killer my-life-is-sourdough routine. I am here only for a week to pick up my gear and jet, to tell them about my new bloke—the final one and only. All the neurotics and sloth and guilt in Britain won't drag me in again. February is a cruel month when you are liv-

ing in a place overrun by stern Germanic values. I am so ready to be an American right now that I would enter a wet T-shirt contest on Jerry Springer.

Today I broke it to my parents about the marriage thing. They were totally cool. They haven't seemed this cool since I took mushrooms and thought they were Paul and Linda McCartney delivering a spiritual message from the sixties. I think my grandmother might flip out like she did when my parents got together, but I'll bring her around. This is a woman who is deaf, beautiful, and as stubborn as Margaret Thatcher. I'll just say to her, "Grandma, we're having a party as big as a coming-out convention." If she wants to pay the airfare, she can come out here to the USA. But she hasn't been on a flight since 1959 when my mum, my grandfather, and she went on tour in Bulgaria. They brought back these foreign dolls wearing flat caps with tassels and carrying air rifles. Since they fired her from selling second-hand clothes at the Red Cross shop, she has watched text-TV and argued with Granddad. He usually escapes by riding into London and selling off his surplus army gear at a posh auctioneer's. That could be my life in fifty years. But somehow I doubt it.

No One Knows My Name

TAIGI SMITH

It's 4:15 P.M. on a Friday afternoon and I'm frantically trying to hustle a seat on the next red-eye out of Tucson. You see, I've been braving Arizona's blazing heat for the past two weeks and the saguaro cactuses have finally lost their charm. I've had it with this swanky resort, full of overpriced piña coladas and hot-stone massages, and thankfully, my job as a television producer is done. I'm dying for some curry chicken with extra plantains, I need to get my nails done, and I really miss the dreadlocked, fast-talking, well-groomed boys of Brooklyn. Besides all the particulars, there's an even more pressing issue at hand: I've missed two weeks at the Heads-Up hair salon, and my straight hair is growing nappier by the minute. Gilna's hands have not greased, blow-dried, deep-conditioned, and most important, run the scalding teeth of a hot comb through this wild mane in more than fourteen days, and at this moment, I'm feeling like an addict who hasn't had her methadone.

You see, Gilna and I have an unspoken agreement that goes a little bit like this: If I'm in Brooklyn on a Saturday morning, I can stop by her smoky salon at any time, wait the typical one to three hours, talk a little crap with the ladies, watch a few talk shows, discuss politics, men, marriage, work, vacation plans, menstrual cycles, rising rents, and the state of the black community, and, of course, get my hair done, for just $31, tip included. Gilna

has created an enclave for her customers, and it is here, for a few hours each week, that we are free to curse, laugh, suck our teeth, change our opinions, and most important, be ourselves. At the Heads-Up salon, curling irons and no-lye perms equalize us, and we bond, beneath the hum of hair dryers and the sizzle of hot grease. To the untrained eye, we are simply women grooming ourselves on a Saturday afternoon, but beneath that facade, we are sisters seeking clarity and guidance from the extended family we've come to know and love. Our weekly chats lend our lives a sense of calm in the midst of confusion, and at times, when we're at our best, we find peace.

After haggling with an incompetent travel agent for forty-five minutes, I finally hold an e-ticket from the deserts of Tucson to the chaos of New York City, and at this point, I breathe a bit easier, because in less than twenty-four hours, I'll be back on the rugged streets of Brooklyn, safely nestled in Gilna's chair.

I live in Prospect Heights, Brooklyn, on a seedy stretch of Washington Avenue surrounded by West Indian restaurants, an illegal social club for African immigrants, and a funky gambling establishment that covertly masks itself as a tailoring shop. Prospect Heights is not one of those bloody urban war zones you read about on the pages of *Newsweek,* but is instead a community on the edge, made up mostly of cracked pavement, abandoned buildings, lackluster businesses, and working-class residents. The old-timers sit on their stoops and talk, bonding like kinfolk over the mundane: Section 8, bad-ass grandkids, and contempt for white people moving into the neighborhood. In the mornings, they sweep outside their brownstones and gaze at the few flowers that have survived the piss showers of stray canines. The scratching sound of their brooms comforts me and I humbly say hello, silently acknowledging the wisdom acquired after living six decades or more. I've developed a ritual with the old man who lives near the corner and tinkers with his car. I pass him on Sundays as I walk the four extra blocks to pick up *The New York Times* (it's funny that they don't sell papers like the *Times* or the *Wall Street Journal* in my neighborhood, but to whom do I complain?). "Good morning, young lady," he says. "Good morning," I reply. I wish I knew his name, or where he came from, or how long he's been

here, and what his story is. I wish I could have him tell me stories about what it was like living down South, but instead I spin my own tale for him because I'm just too busy and too scared to stop and shoot the breeze. My neighbors remain nameless to me, identifiable only by face and voice. We nod sometimes, and other days we say hello, but most times we remain silent and disconnected, living separate but close within our ten-block radius. Herein lies the irony of my situation.

I made the conscious decision to move to a grittier part of Brooklyn almost two years ago because I needed to live around people who had brown skin and kinky hair, and loved eating fried fish with grits on Sundays. After spending endless hours as a network news producer, I yearned for a bit of peace and needed, more than anything, a place where I could truly be myself. I spent most of my days around white people who knew very little about who I was and what I stood for politically and personally, and although I was very successful at work, I spent many of my days feeling as if I were invisible. I felt out of place at company luncheons and parties, and during those times, I realized I was an outsider whose presence would always be questioned.

After just a few years in the workforce, I became distinctly aware of the subtle racism that surrounded me, and within that time, it became brutally clear that I would never be seen as a woman, but always as a black woman, and because of this, I would always be judged on the basis of my color rather than on the merits of my work. My feminist training at Mills College had not prepared me for the anger I would feel when white people deemed me intellectually inferior because their nannies and housekeepers and doormen were black—like me. And after overhearing several disturbing conversations about the "hired help," I found myself asking one very simple question: how will these people ever respect me if they don't respect the people who raise their children, care for their aging parents, and clean their toilets?

And so I moved to the 'hood. I moved to Prospect Heights so I could wear a scarf tied around my head and say words like "ain't," and phrases like "Nigga pleeze!" on my days off. At the time, I needed to feel connected to black people and felt as though working in the news industry was causing me subtle mental damage. I felt unsure of myself and was searching for spir-

itual rejuvenation, and most important, I needed someone, anyone, to tell me the truth sometimes. I was starving emotionally because in the midst of professional success, I'd found social disconnection and extreme loneliness. I knew everyone and no one at the same time and existed in a bubble that included taking business trips, going to work, talking on my cell phone, having Sunday brunch, and maintaining a limited amount of human contact.

There are days when I wish that my neighbors and I could communicate the way human beings did before two-way pagers and e-mail took over. More than anything, I'd like to be a part of the community in which I live. Living in New York has turned me into a verbal mute whose words lock themselves somewhere in my soul, so instead of speaking, I write essays about the people who live around me, and I pray they'll never see the stories. If I had the courage, I would tell the young girls on Prospect Place to respect themselves and walk with their shoulders back and heads held high. I'd talk to them about safe sex, listen to their gossip, and watch as they braided one another's hair on cracked stoops, and somehow, I'd try to get involved. I'd beg them not to emulate the women they see letting it all hang out in music videos and remind them that Foxy Brown and Lil' Kim came after Cleopatra and Nefertiti, the real princesses from that 'hood called Africa. I would tell them to learn life lessons from their grandmothers and elders instead of from shows like Ricki Lake and Jerry Springer. But instead of communicating, I keep my mouth shut, because like so many of my peers, I find it easier to stay anonymous. I remain silent because two years in my community has shown me that although my neighbors and I may look the same, we are different. I grew up in a community like the one in which I now live, but because of sheer luck, I was fortunate enough to receive a full college scholarship and escape the mental ghetto that traps so many of my people. This is not a ghetto called Prospect Heights, but a mental ghetto that traps some people, black and white, into feeling as though they deserve nothing more than Section 8, cheap handouts, and substandard education. This mental ghetto I speak of is one of self-imposed disenfranchisement, unemployment, low self-esteem. It's a prison of the mind that tricks able-bodied people into accepting poverty as if it's a constitutional right. In a

sense, it's this mental ghetto, this prison of the mind, that has caused many of my people and my neighbors to give up.

My neighbors and I are separated by class, not race. Sadly, we have very little in common beyond our common hatred for racism, discrimination, and blaring car alarms at three o'clock in the morning. I do not talk to my neighbors because I fear that they will not understand me as a young, black, educated woman trying to survive in the snake pit of corporate America, and if I acknowledge our differences, then I will have to accept that, once again, I do not fit in. I have long since realized that I will never really find security around white people, but the thought of being rejected by my own people, my neighbors, terrifies me. And so I remain silent.

It is the year of 2002 and I pay well over a $1,000 a month to live in a Brooklyn neighborhood where the amenities include a round-the-clock liquor store, a marijuana delivery service, illegal all-night gambling, and numerous buildings reserved for Section-8 families and people on welfare. I live in one of several buildings earmarked for upwardly mobile professionals and white people. Throughout the neighborhood, signs of "revitalization" are cropping up. There are the white kids walking smugly down the street, sometimes riding rickety bikes or skateboards. *The New York Times* recently published an article about my street, and there are trees being planted on once decrepit blocks. Internet businesses are opening up alongside yoga studios, and I, for one, have a fully renovated apartment with brand-new appliances and superfast, T-1 Internet access. I am on the cusp of the revitalization, and while I have an amazing apartment in the midst of the 'hood, I am more than conscious of the fact that the low-income people around me may not be here for long. At times, I am sure they look at me and all the other professionals moving into the neighborhood and wonder, "What are they doing here?" Do my low-income neighbors realize that the new buildings being sprouting up like weeds are not for people like them, but for people like me who can afford to pay inflated rents for renovated apartments in the 'hood? Because I lived through this before while growing up in San Francisco's Mission District, I am keenly aware of exactly what's happening to Prospect Heights, and I realize, maybe more than anyone around me, that neighborhoods don't have to be financially rich to be culturally vibrant,

and that white people moving into poor neighborhoods do little good for the people who already live there. I want so badly to tell my neighbors to wake up. I need them to realize that within a year, they will look around and not recognize the place they once called home. This business of gentrification benefits no one, except people with money who can afford to pay exorbitant rents for shoebox apartments in the ghetto. When white people move into black neighborhoods, the police presence increases, cafés pop up everywhere, and neighborhood bodegas start ordering different newspapers, but you rarely see low-income housing built alongside million-dollar lofts, or social service centers built next to yoga studios. When I think about this, I am caught somewhere in the middle, because although I have the money to live in a neighborhood that's being gentrified, I still hear the words my real-estate agent whispered to me when she was trying to rent the apartment. "Just think of this as your own little castle in the 'hood." The truth is, she wasn't lying.

It is when I come home at night and see the crackheads loitering in front of my building that I realize I may have switched sides in this fight over land. It is when I dodge cracked glass and litter when walking my dog that I realize that this neighborhood really could use a facelift, and the yoga center that just opened up on the corner is a welcome change from the abandoned building it used to be. Parts of my neighborhood are symbolic of all of those things the media and sociologists say is wrong about "the inner city." Today, I live on a block where the police don't arrest drug dealers who peddle crack in broad daylight, a place where young black men drive around in huge SUVs but barely speak grammatically correct English, and a street where I see the same brothas, day after day, standing on the street corners, doing absolutely nothing. They don't hustle or harass me, but instead politely say "hello," as if they've accepted me but don't really understand who I am or where I've come from. To them, I am an anomaly. I am the girl who lives alone but gets picked up in Lincoln Town Cars early in the morning and then disappears for days at a time. I am the girl who's almost never with a man, the girl with the little dog, the girl who rarely says hello, the girl who almost always looks like she's in a rush. Sometimes their faces question me, but I never answer because I know too much about statistics, and sociology,

and race, and class, and all that other academic rhetoric that really means nothing when you're just trying to survive on the streets. At times I feel strained by my situation, because I am intimately aware of what's happening to my new neighborhood, but I feel powerless against gentrification. I've been here long enough to know that while it's not the most savory neighborhood in Brooklyn, it is a community where people feel connected, a place where the old folks know one another, a street where neighbors still chat and say hello.

When I come home at night, I kick off my work shoes, take off my corporate clothes, and transform myself into the person I really am. I put on my sweatpants, throw on a hoodie, gloss my lips with Vaseline, tie my hair up in a scarf, and then head outside to walk my tiny dog on littered sidewalks, past boys standing on street corners, past tomboys in goosedown coats doing one another's hair on stoops of aging brownstones. When I see these girls, I remember my own childhood and realize that they deserve more than this. They deserve a neighborhood that is clean, safe, and provides some hope; a place where they can learn that some dreams do come true and that Prince Charming really doesn't drive an Expedition and sell weed to his friends. As I walk the streets and think, I realize that yes, my neighbors and I are alike in many ways. We like the same foods, we listen to the same music, and most important, we are a group of African-American people living together in a neighborhood that is on the verge of change. But in the end, we are also very different. If the rents go up, I will have options and they may not; we remain separated by a slip of paper called a college degree. As an African-American woman, I find white people's allure with the ghetto perplexing. It amazes me that they are willing to pay exorbitant rents to live in the ghetto, while many blacks, who realize that a better life exists elsewhere, are plotting their escape. At times like these, I ask myself, "If we can't have the ghetto, what can we have?"

It is a sunny Saturday afternoon, and as the wind kisses my face, I am feeling blessed because I've finally spent time with Gilna and the girls over at the salon. I leave the shop feeling rejuvenated, my kinky curls now bone straight, my hair having been tamed into beautiful submission. My mane smells like burnt grease, but I feel uncontrollably sexy as my locks dust my

shoulders. As I round the corner closer to home, I see the nameless brothas standing on the corner of Prospect Place and Underhill Avenue. They're looking rugged and fly, decked out in heavy denim suits with freshly cut fades and impeccably trimmed goatees. I see the outline of cornrows under the wave cap of one brotha standing in front of a pay phone hijacked from Ma Bell. Beepers beep and cell phones ring. The guys talk to their girls and their customers simultaneously. Their hands are calloused from doing what I call the black man's hustle, which is OK because moving nickel bags keeps everybody fed. "Real" jobs for young black men are scarce when your only degree reads G.E.D. or less, and besides that, most of these black men have nothing else to lose but their freedom and their lives. In this part of Brooklyn, the brothas chill on street corners and lean on their jeeps, listening to JZ and Mobb Deep nonstop. They watch as I fling my hair, ever so seductively, and today one of the guys decides to say hello. "Damn Ma, you look like a straight-up supermodel." I answer him with my eyes because his overt flirtation has left me speechless. "I am home, black man, I am home. And in Brooklyn, in this torn-up, boarded-up, working-class, multi-accented, noisy, crowded, quickly gentrifying slab of Brooklyn, we are free." Moments later, I stick my key into the doorknob and steal a glance at the African men playing cards just a few doors down. Their late-model luxury vehicles line the block, and they laugh loudly, dressed in traditional African garb. Their black skin glistens in the summer light and they seem happy—has America been good to them this time? As the B-45 bus whizzes by for the fiftieth time today, I realize that there is no place else that I'd rather be. For just one moment, there is peace.

Allah Akhbar

JUSTIN MOYER

The food is good, but no one
eats. The light is good, but no one
draws. There is no music, but if there was,
no one would listen.

There are wealthy young men and then
there are wealthy young men. There are the men
who sell the world. There are the men who
buy it from them. After all, a city is only a city. A neighborhood

is just a neighborhood. But how
are we feeling? That is the question. How
are we breathing and bleeding? We bleed
red. We bleed more red. We bleed

blue. We blush the way that kings blush. We preen
the way princesses preen. We devour
the drones the way the queens devour
the drones. The drones, the gods, the bees,

the buzz. The gods that hold our interest are the
gods that bring results. We asked the whirlwind
what it was, and the whirlwind said, "There is no
God but God" and moved over the water. The water spout

swirling, saying "yes" to "no." The young
men's pockets turned, turned out. The drones devouring
the vicious queen in inescapable hexagons of honeycomb.

The Joy of Mud

CATHERINE BLACK

taro: an Asian tuber, the cultivation of which reached its largest scale in ancient
 Hawai'i.

lo'i: taro patches; traditional wetland beds in which taro was irrigated by a com-
 plex network of tributaries diverted from mountain streams.

poi: delicacy made by peeling, pressure cooking, and grinding the root (corm) of
 the taro plant.

As always, it is warm outside. Another Wednesday morning in the end-
less summer I remember so well. With its unnerving ability to erase the pas-
sage of time, Hawai'i once again dissolves the years that separated us.
Waking in the familiar soft air blowing through my louvers, I put on some
old shorts and a swimsuit, wondering what Vince—my poi-pounding
friend from the Wai'ane—has in store for me "up Mauka." The term nor-
mally refers to the mountains, but today seems to harbor a secret surprise.
All I know is that we're headed for Waiahole Valley.

He soon scoops me up in his pickup truck and we drive north along the
coast, presided over by the Windward Mountains in their wet, green glory.
Entering the rolling pastures of Kahalu'u, traffic narrows into a single-file
line; orchid farms and cows replace the Burger Kings and strip malls of
concrete-encased Kaneohe. Vince updates me about his life on the West
Side while we crack open pistachios, popping them into our mouths and

tossing a trail of shells from the windows. I squint at the morning, dazzling between the boats on the bay.

Entering Waiahole Valley and parking beneath a banyan, Vince steps into the forest on a narrow footpath. Wild ginger and elephant ear break the light above us into geometric green and gold shapes. We cross one shallow stream, then another, both cold and quick around my bare feet. Vince walks ahead, his dark ponytail brushing the top of his T-shirt.

Turning a corner and descending a short, muddy slope, a wooden shack-like structure comes into view below us: smoke rising from a pit nearby, figures moving about, a large brown horse with a pale star on its forehead. The sun drips through an immense mango tree, pooling light through the smoke and creating bands of bright blue that twist like serpents into the sky. Beyond it, a breadfruit tree, some rows of papaya, and about two acres of taro patches, each divided by raised pathways of packed earth and thick grass, fresh Waiahole stream water swirling through the beds on its downhill path to the sea. The forest is a lush wall on all sides, and the mountains are crowned with clouds overhead.

I stop for a moment, stunned by the realization that this place has always existed only twenty minutes from where I grew up. "OK, Cat," Vince turns to me with a grin, "are you ready to work for your lunch?"

Ten minutes later, I find myself sinking knee-deep in the lo'i, trying gingerly to stay as clean as possible. This is no easy task, since mud is in great abundance here. It's the beginning and end of taro's growth cycle and therefore, they tell me, the beginning and end of our own. Stepping into the lo'i is like stepping into a vat of chocolate syrup, only cooler, and pungent with the fresh, damp smell of nutrient-rich soil. My assigned task is to pull out the weeds that eagerly choke taro corms before they can mature.

At some point I forget about staying clean and grow increasingly absorbed in this wet world. Several hours pass, and I am still bent over among silky, heart-shaped leaves that nod pleasantly at me in the breeze, marveling at the mud as it slips smooth between my toes, the long, hidden weeds straining against my foot soles. My movements acquire a slow, deliberate rhythm as I travel up and down the rows, pulling out green stems at the

root, rinsing the rich mud off, and tossing them onto the wet embankment. Taro—the mythical ancestor of the Hawaiian people, the metaphor for family and the ancient symbol of life—is also a glossy-leafed tuber that thrives in mountain mud. *How nice to finally meet you,* I think, as I pull up a fat corm and inspect its pink, root-whiskered body.

Vince is demonstrating to a group of teenagers nearby how to cut the tuber from the stalk with a machete and save the latter for replanting. There are probably twenty people scattered throughout the lo'i, and they all seem to know one another on that multigenerational level that turns everyone you meet into an infinite amalgam of cousins, aunties, and uncles. *What would it be like to be surrounded by so much family?* I think to myself.

A flash of equilibrium and understanding penetrates me and seems to set quietly in my muscles and bones. *So this is Hawai'i,* I think with surprise. After sixteen years of floating on the peripheries of an island home I never cared for, I've snapped straight back into its cool green heart. The combination of sweat and surreal scenery, the labor of cultivating food with others, the clarity and sweetness of the stream as it weaves among us—it all combines so that just standing here, with the mud dripping down my calves, makes me ache with a kind of goofy happiness. "I love this place," I say out loud, and Vince, looking my way, says, "doesn't everyone?"

Until that moment of seamlessness in a Waiahole taro patch, I believed that beautiful places were meant for admiration, like pieces of art, more than concrete grounds for participation. Bicultural and bred on mobility, I wound through a series of exotic exhibits that led me to absorb the world with an art dealer's distance and a teenager's ego. I watched carefully—often marveling—but rarely engaged, and certainly didn't commit.

Born in Kenya to a Japanese mother and an American father, I spent most of my adolescence in Hawai'i waiting impatiently to escape. Unconsciously, I exuded a cultural and intellectual elitism that put me out of sync with the down-to-earth humility of the Islands. Instead of surfing, I hunted down the few coffee shops Honolulu could offer and buried myself in novels set in faraway times and places. I learned French instead of Hawai'i's pidgin English and developed a taste for European pastries instead of the slightly sour, glutinous starch of poi. Heading East for college and traveling

abroad instead of home for the holidays only seemed to confirm that I meant to wear scarves in some foreign country where people drank wine instead of Bud Light. When I bid them farewell on the eve of my departure seven years ago, my friends and family assumed—as did I—that it was for good.

Ending up with my feet planted blissfully in Waiahole mud was an unexpected but ultimately necessary way for me to learn a key lesson: I had always prided myself on being rootless, yet here I was experiencing rootedness in the most literal sense of the word, and loving it in spite of myself. Dirty, sweating, and sunburned, I felt *solid* and more connected to the living, breathing world around me than I could remember. Details exploded around me—the smell of fish smoking on the fire, the striking pattern of breadfruit leaves against the sky, the bearded taro farmers and their young followers passing along a chain of cultural knowledge that created community by continually investing it in one place. Hawai'i was more unique and foreign to me than I had ever imagined, and I felt a new embarrassment for my earlier dismissals of its so-called provincialism.

As we rinsed the freshly picked corms and steamed them for lunch, I was struck by the thought that I had helped pick this sweet, purple food and that the little girl swinging in the hammock across from me was now eating it with a huge grin on her face. It tasted so good I could only grin right back. Looking around, it was clear that most of the people around me had done this all their lives, growing up with their feet in the mud and the valley in their souls, and it dawned on me that, far from being limited, this life of continued investment in a single place was both rare and inspiring. What unified everyone gathered at the lo'i was their overwhelming love for Waiahole. They physically and figuratively planted their time and history in this taro patch every Wednesday, cultivating a sense of belonging that could only come from a deep connection to common ground. The mud itself was precious to them, and this produced a pride in their work that I suddenly longed for as well. You could taste it in the taro, which I'd always heard was the best on O'ahu.

I spent two years waiting tables at a Mexican restaurant and freelancing for a smattering of publications and nonprofit organizations in a quest to

acquaint myself with the spirit of Hawai'i that I first glimpsed that day. I wrote grants for struggling nonprofits, attended countless community meetings, and learned to quiet my college-educated ego behind a willingness to listen. In the same way, I learned to recognize the quieter community of native plants and animals that also form the base note of a place and hum with its history. Climbing the misty ridgelines of O'ahu's mountain ranges, I recited their Hawaiian names, traditional uses, and mythical personalities. *Koa:* the warrior, the canoe, one of the most beautiful woods in the world, was also a tree with sickle-shaped leaves that curled its body gracefully around the ridgeline of the Ko'olaus. I met people who fought for fundamental things like land and family with a passion that put my own idealism and ideological fervor to shame. I went home and I fell in love with a place I couldn't claim for myself. This did what nothing else could until then: it humbled me.

I became increasingly attached to these islands, so rooted in their singularity and isolation, but I also knew I would have to leave. Perhaps because I already had one foot planted in the vast promise of continents, perhaps because I was infected with the restlessness of privilege or ambition, perhaps because I could simply never wear one of those T-shirts that proudly read "Born and Raised"—whatever the reason, my imagination released a thread that always unwound out, across the Pacific to the wider world beyond. At times, there was nothing I wanted more than the security of knowing that this was where I belonged, but I couldn't dismiss a feeling that I would later come to understand as I traveled back and forth between the Islands and the West Coast: I had always existed more on bridges than on land. Culturally, geographically, and even professionally, my identity was formed in that space between fixed points. Whether I will one day choose one or the other remains to be seen, but for the time being, I am satisfied trying to narrow the distance between them. Though I left Hawai'i in pursuit of more knowledge and experience working with the grassroots sector that I first discovered in Waiahole, I would like to believe that I am preparing myself for a time when I might return and not feel compelled to leave again. I would like to believe that I am becoming more useful to a place I could eventually call my own.

As the afternoon cools down to a deep green murmur and most people have gone home, Vince ambles up and seats himself on the bench next to me.

"So, you like working the lo'i or what?"

"Are you kidding? I can't remember the last time it felt so good to be this dirty and sore," I say, holding out my mud-encrusted fingernails for emphasis. "This is amazing," I add more quietly. "I can't believe I was clueless about it for so long."

"Does that mean you're gonna come out with us every week?" He eyes me seriously above the broad, whiskered smile. Though I know this is a moment of truth, I can't lie either.

"Vince, I aspire to be ready for this every week. But for now I'll have to admit that I'm only at the beginning of a path I never expected to travel."

He raises his eyebrow. "Oh yeah? What path is that?"

My gaze moves across the patches of taro to the space where Waiahole Valley opens up to the ocean.

"Maybe it's the one that will eventually lead me home."

Not Quite

LAURA PLAGEMAN

part 2

(Amani Willett)

orking

To: jkarlin@hotmail.com
From: illanaumasky@berkeley.edu
Subject: lychees

Life and work have such a weird relationship to each other. You want to do something you love, but it's hard to find something you are going to love every day Mon–Fri from 9–5. I don't know if it's possible.

<i.u.

To: regenbook@hotmail.com
From: jonesfranzel@harbourcast.org
Subject: none

When the cord was cut, and I was cast to the post-graduation job market, I grabbed at everything that came my way. The travel agency on Wall Street. The Internet start-up in Atlanta. The Maine outdoor school. Nothing fit. I was paralyzed. Somewhere in all that liberal schooling I had picked up the abstract notion that I should be "doing good." A strange, self-important idea, but it was my magnetic north. Now that I am actually

J ob-hopping during our twenties today is about ardently attempting to find work that will be everything to us: intellectually engaging, socially fulfilling, and financially secure. "Dear Lord, what do I want to DO?" comes the refrain over and over again, or "how am I going to do a, b, c, d, e, f, *and* g?" Our careers are important to us because we think that they will define us, and they do. We find ourselves answering on a daily basis, "I am a waitress," or "I am an advertising assistant." Contributors in this part delve into *Working* as they try to fix their cubicles with just the right light. Sitting inside the desperation that ambition can create, we slowly learn that creating meaningful work takes compromise and life experience.

A strong emphasis on and an obsession with work were inherent in the submissions; we received more stories concerning employment than any other topic. None of us consciously fixate on the Protestant work ethic, yet it is there under our skin: Luther's idea that pleasure and idle thinking are sin and that God is best served through a commitment to one's trade, or Calvin's preaching that accumulation of worldly goods is a sign of salvation. Like it or not, this ethic has been stripped of its religious markings and has infiltrated our daily lives with the notion that work should be a major focus. From Protestants to venture capitalists, Americans are hard workers, profiteers, and individualists.

The United States is built on streets supposedly lined with gold. It is an incredible story: if you work hard enough, you will make money and be successful. And if you cannot find gold where you are: Go west, young man, go west! Clichés about "pulling up your bootstraps" and the "self-made man" tell little about the individuals who don't have boots and who are not able to buy their way into overused phrases. Political and social ethos that blame unemployment on personal inadequacy while ignoring structural problems shape our welfare laws and make us think that we are our work and are per-

sonally responsible for its success. And there seems to be no viable alternative to the story of capitalism's success; twentysomethings today were teenagers as the last bricks of the Berlin Wall were falling. In 1982, Reagan described "the march of freedom and democracy which will leave Marxism-Leninism on the ash heap of history," and twentysomethings now have capitalism's mantra of "private ownership and increasing accumulation" stamped into their work ethic; long blown away are the ashes. Without a grand structural alternative, twentysomethings look in the mirror and see Reza Assemi's collage *No Longer Green* staring back: stock-market quotes written all over our chests.

Politics and religion today are ineffective compared to business's ability to innovate change. It was scientists working for a private biotech company, not a government-sponsored program, who deciphered the human genome. Business also emerges as the site for solving many social problems. Many of us in the educated class who go on to business careers aim to merge social values with money. Journalist David Brooks coined the term "Bobos" to describe the rise of this bohemian bourgeois—mixing and matching bohemian values with a capitalist market. This makes some of us "Bobettes."[1] We use fair and trade in the same sentence (isn't that a previous anomaly?), and some of us have Working Assets credit cards that allow a certain percentage of everything we spend to go toward progressive causes of our choice. Michael Ellsberg, who wrote the story *Juana*, started an environmental venture-capital firm. Jennifer Karlin, in her essay *Reverse Commuting*, dreams of creating a business that is a think tank, film-maker, newspaper, music store, that blasts a progressive cause all at once from every angle. We are not satisfied with the capitalistic urge and are trying to find ways to mediate between a public discussion that seems to have ended long ago.

A computer hacker is a contemporary metaphor for bringing new social values into the workplace. A hacker can even be considered a modern-day evangelist reformer—playing the part of Calvin and Luther—using technology rather than religion to reconstrue what work should be for us all. While destroying the framework on which modern-day work rests, hackers

[1]Credit for coining this term goes to Jen's friend and coworker Lily.

view their work as a life philosophy. One hacker explains: "You can do almost anything and be a hacker. You can be a hacker carpenter. It's not necessarily high tech. I think it has to do with craftsmanship and caring about what you're doing."[2] *TakeBackTheSiesta.com* by Andy Isaacson envisions a whole new way to tap technology and, underhandedly enough, use it to slow life down. Isaacson uses an IRS form to apply for nonprofit status and to argue for the necessity of injecting the siesta into the modern working world. The opportunity to reform work is a privileged one, but it is a hope that we all have to maintain because according to the International Labor Organization, the average worker clocks nearly 2,000 hours at work every year, and the hours keep increasing.

Those who have received a liberal arts education have learned how to critique the capitalist system despite the fact that we need to land a job within it. After studying the culture of everything, liberal arts majors often wonder what they are qualified to do. Yet that might not be all bad. As one contributor wrote, "I want to believe that I went to school to get an education, not just to get a job."[3] Rachel Hutton's essay Tutoring makes fun of a cycle among the educated elite in the United States today: graduate from a topnotch school and then help others study for SAT tests in order to eventually graduate from a top-notch school. Sometimes it feels like a liberal arts degree only begets another liberal arts degree. These sorts of educations do not necessarily make us marketable for entry-level jobs, but they teach us the important skills of how to think, connect, and problem-solve.

The dialogue about the necessity of education is a long, historical one that can be traced back to the ancient Greeks. It ranges from what should be taught—critical thinking, humanities, science, technical skills—and who should be taught—the wealthy, government officials, theologians, everyone. Liberal arts educations nowadays teach how everything relates to everything else—literature double-helixed with history, biology reflecting religion.

Leaving the academic setting makes life less structured; no more do we know exactly what we are working toward. We do know, however, that we

[2]Pekka Himanen, *The Hacker Ethic and the Spirit of the Information Age* (New York: Random House Inc., 2001), chapter 1.
[3]Michael Irwin, "Why I Write."

102

wish we could get paid to think, tinker, and create. Deregulation, expanded trade, and lower tariffs on a global level have slipped into our private work lives to create an atmosphere in the office where people tend less to ask what they can do for their company but what their company can do for them. Companies have even restructured themselves to this new atmosphere by forming small work groups and by offering flexible hours and positions. Jobs can sometimes seem anemic—lacking the benefits and responsibilities that managers and workers were tied to before. In the past, companies had a more difficult time excusing short-term hires and not offering long-term benefits, while workers had difficulty switching from job to job. The *New York Times Magazine* pictured a "Liberated, Exploited, Pampered, Frazzled, Uneasy New American Worker," a free agent with a briefcase in hand, running to and from his or her job, owing little to workplace authority. In a corresponding article, author Mike Lewis described the "general drift away from old-fashioned corporate order and a tendency toward individualism in work life."[4] Reflecting on this work environment, many of our friends often express the desperate sentiment, "I just want to work for myself."

The twenties has always been a time to be pompous and idealistic, but the Information Age has exacerbated traditional infections of hubris, giving today's twentysomethings the sense that they can do anything immediately. Called everything from brazen to arrogant, twentysomethings "often act as if they're doing you a favor by working for you,"[5] according to marketing experts. We are adept at multitasking—balancing all of our responsibilities on a pinky, finding information with our pointer, and arguing for our beliefs with our other hand. So why can't we find all of that in one job that will utilize our skills set? One friend, for example, worked at a public relations firm as a secretary in charge of coffee and travel arrangements. Fed up after six months, he went to his boss's boss and said, "Look, I have a lot of skills and feel underutilized. I have a lot to offer." Furious, the boss explained that he had started working as a mail carrier in the company and only after fifty-two

[4]Mike Lewis, "The Artist in the Gray Flannel Pajamas," *New York Times Magazine,* 5 March 2000, 46.
[5]Nelson Mui, "Here Comes the Kids: Gen Y Invades the Workplace," *New York Times,* 4 Feb 2001, Sharon Beder, *Selling the Work Ethic: From Puritan Pulpit to Corporate PR* (Carlton North, Australia: Scribe Publications, 2000).

years of dedicated service had he become a supervisor, while most of his former coworkers still carried mail. Although his boss had a good point about patience and inexperience, jobs and workers today in general are much less rooted and are moving more laterally across the job market than ever before.

Many resumes these days are filled with time spent in self-induced free labor, as employers increasingly demand a variety of experiences. Many publishing houses, magazines, banking offices, and hospitals offer "work for free" positions. How many of us can afford to work without pay only in hopes of landing a "real" job? One contributor wrote, "I had the ironic experience of writing an article about living-wage campaigns while I myself was being paid the distinctly non-living wage of $0."[6] As impossible an economic situation as it is, the internship—the modern-day apprenticeship—opens opportunities for us to gain experience in a field and provides a needed workforce for organizations that do not have the resources to pay.

Even when we finally land a full-time job, the reality is that most of us spend our workdays dealing with paperwork, bureaucratic incompetence, and hierarchy during our first, second, and third jobs. *Office Space, Clockwatchers,* and *Temp Slave* are movies that depict some of our worst fears about work. Open up the New York City Yellow Pages and therein lies fifteen pages devoted to temporary opportunities. Bayne Gibby's *Time and Life* shows us that while temp jobs may lack a clearly defined future and benefits like health insurance, they give us flexibility and allow our schizophrenic interests to keep changing. Although we received numerous stories complaining about temping life, we chose to use Gibby's piece to offer a glimpse into the difference in lifestyle between a twentysomething and an older single mother, both temps. Despite their daydreams of Time and Life being more than just a building on the Avenue of Americas, only one of them has the freedom to walk away from the situation. For those of us who have kids, it is a lot harder to escape our disgruntled job situations.

Frustrations surface out of the disconnect between unrealistic expectations of work and actual job after job after job experience. We feel responsible to do something meaningful with our educations and opportunities, but

[6]Emily Weinstein, "Twentysomething."

we compare ourselves to an ideal image and are not sure if we will ever be good enough. Not all of us can be rock stars despite living under the privileged kindergarten fairy tale that we can be everything and anything as long as we work hard enough. The structural pressures we put on ourselves for early success by comparing ourselves to imaginary perfect peers are real and heavy. So many of our contributors and friends talked about a kind of paralysis because we cannot seem to discern between choices about what to do. Eventually, rejection letters can be learning experiences about how to reorient our goals.

Although a luxury to think about, all of the essays in this part wonder about how to translate a passion into a commerce-driven economy. We open this part with Bayne Gibby's humor to remember not to take work too seriously. Two essays then discuss how class and race affect similar professions: private tutoring and public-school teaching. Courtney Booker's artist-at-work photos remind us that we need to keep working at creating even while we may be doing other jobs to earn money. Paul Ohan brings us into a day in his life to show how work does not have to be his most important activity, that there is life after 5 p.m. Andy Isaacson's *TakeBackTheSiesta.com* is a necessity in this part because, besides really wanting the siesta to come back in vogue, Isaacson shows how older notions of lifestyle can be recycled and useful in modern terms. With each new job and story, we see twentysomethings humbling themselves and compromising just enough but not too much.

The notion that one's work ought to be one's passion is a post-'60s phenomenon. How lucky we are to imagine spending our long hours getting paid for what we believe in (all the while trying to decide what exactly we believe in). Caring and bringing our best to our work is what most of us would like to be doing. Perhaps the cliché question "So, what do you do?"—with the "do" meaning professions that pay—should be rephrased to "What do you enjoy doing?" And then we can wait for the long, descriptive responses.

Time and Life

BAYNE GIBBY

Temping usually stinks. At best it's fine. Fine, the way going to the dentist is fine. A really bad temp experience makes you want to curl up in your childhood bed and cry while listening to "Total Eclipse of the Heart," the same way you did after Jimmy Ruddy had his friend tell you that he was dumping you in front of your whole gym class.

It's easy to feel like a complete idiot when you're a temp. You're usually replacing someone who is sick or on vacation, and for some reason everyone assumes that you must know everything that the other girl knows. People seem to forget that you just got there, and when you don't know where Ed keeps the extra key to the conference room, they decide you must be stupid. Meanwhile, you have no idea who Ed is or that there even is a conference room. Just when you figure out where you are and what people's names are, you're saying good-bye to them.

I usually temp in the Time and Life Building on 6th Avenue. The best thing about that place is the cafeteria and bookstore on the second floor. I can't tell you how many times the joy of the Sizzlin' Caesar Salad for $4.95 saved me from digging out the Bonnie Tyler tape and making that journey out to my mom's house in New Jersey.

Lunchtime. An hour all to myself to savor my salad and browse through the bookstore, reading cover flaps of books that I wish I had enough money

to buy, and fingering handmade greeting cards with pressed flowers on them—the kind that are perfect to send a lover, if you are the type of person who can spend $5.00 on a piece of paper folded in half.

I always experience a small post-lunch depression, knowing that the afternoon drags on excruciatingly, with only the thought of the free coffee and Snapple to keep me from going berserk in my little borrowed cubicle.

It had been a rough morning. It was Monday and I had just returned from visiting someone who I love very much and who happens to live across the country. The reality that my vacation was really over wasn't completely apparent until I walked into the Time and Life Building and stood in line to get my little paper pass. You have to show the little paper pass to go anywhere in the building. You practically have to show it to take a leak. By the end of the day, it's limp and curled up at the edges from traveling in and out of your pocket so many times through sweaty hands. The full-time employees have laminated IDs with their pictures on them and an electronic strip that opens doors automatically.

My eyes were blurry and my head was full of things that were said to me two days ago in a bed 3,000 miles away. I kept dragging my eyes back to the single piece of paper that was placed on the desk that said, "Welcome temp! I'm on vacation all week. These are the things you will be doing!" which was so much less interesting than the life I just had two days ago.

The phone rings. I have a quick look down at the cheat sheet. Whose office is this?

"David Faber's office," I say, trying to sound chipper.

A hurried, intolerant voice on the other end says, "Yeah, is he in?"

Somehow I know this is his girlfriend. I know the way girls just know. She feels she has special privileges and has no time to be nice to me.

"He's not in yet, can I take a message?"

"Just give me his voicemail."

Shit. Shit. No, I know how to do this. Transfer. 24420. Transfer. Ring. A woman's voice: "Hi, you've reached—" Release. Shit. Double shit. Wrong voicemail. I await the inevitable.

The phone rings again.

"David Fa—"

"Yeah, you just gave me the wrong voicemail."

Some people are so mean.

"I'm so sorry. Let me try that again."

Transfer. 34420. Transfer. Ring. An Indian man's voice: "Hi, this is Vevet Shah—" RELEASE.

Oh my God. I'm dead. Dead. I clench my teeth. Wait. Nothing. No rings. I get up and go to the bathroom.

I bet she got frustrated and gave up. She's busy. Can't spend the entire day making social calls. I stare at the phone. I want to call someone. I want to call the person who is thrilled and surprised when I call him at the office. I would be nice to his assistant if he had one (if he wasn't an assistant himself). We'd be friends and chat about things that girls chat about. I'd invite her to lunch.

RING!

Panic. Fear. Where is the cheat sheet? Whose office is this? Who am I?

"Hello, Daniel Faber's office."

Pause.

Pause.

"I think you mean *David.*"

It's her. Suddenly I'm back in middle school and she's the girl who tells me I have a huge booger hanging out of my nose because she thought I'd like to know.

"Yes, I do. I mean David. I'm sorry. I just got here."

"Just get him!"

"He's not in yet."

Huge groan.

"Never mind."

Click.

Twenty minutes later I meet the famous David/Daniel/who-gives-a-shit-what-his-name-is guy. The first thing he says is, "I know Jennifer told you, but my name is David. And it's Faber, rhymes with 'robber,' not like favor." Got it.

I'm dying. All the coffee I'm drinking is giving me a pain in my chest. I never get pains in my chest. Could my heart actually be aching? Is my heart

pounding on the inside of my chest yelling, "Get back on the plane, you idiot! What are you doing here? This is a joke!"

There are clocks everywhere. On the phone. On the computer. On my wrist. On Daniel/David's ass. I'm temporarily amused by this thought, until I laugh out loud and realize how lonely laughter sounds when there's no one to hear it. This reminds me of the tree falling in the forest riddle. I must be really losing it if I'm thinking about nobody listening to a tree falling. Help. What time is it?

A face appears at my door. A little girl reveals herself from around the corner. She's about nine years old and looks like she's dressed for the beach. Before I can say hello, she asks, "Do you have anything for me to do in your office?" *My* office! I think I actually say this out loud.

"No, I don't. I practically don't have anything for me to do in my office, but I do have to make a copy of this," and I pick up a piece of paper.

"Can I help you?"

It's hardly a two-person job.

"Sure."

She follows me into the copy room as if I've promised to buy her ice cream. She looks up at me.

"Can I make a copy of my hand?"

I'm fifteen again, the cool baby-sitter who chucks the meatloaf in the backyard and lets the kids eat cake for dinner. When I lower the big flap-thing over her hand, she grows serious, like a patient getting an x-ray, fearful of a multiple fracture. The copy comes out just as someone walks into the room. I pretend it's an important document.

"So, what are you doing here today?" I ask the girl.

"My mom works here. She's a temp."

I wonder if her mother tricked her into coming here by telling her they were going to the beach. I wonder why she couldn't get a baby-sitter.

I ask her where she lives and she says that she's going to Florida for the summer to live with her dad. I ask her if she's ever seen a palm tree, and she says yes, and asks what Florida is like. She is shocked when I tell her it will be very hot. I tell her there are a lot of grandparents who live in Florida who drive really slow, but they've earned that right because they are old. I lose her

there and she's off down the hall, telling me she has to go help other people. A little life skipping down the corridor. That's the first real conversation I've had today, I think.

A few hours later, I meet her mother. I know it's her because she and her daughter look exactly alike. She is trying to make a photocopy and the edge of the paper keeps getting cut off. A small pile is accumulating in the recycle bin. I can relate. I'm trying to send a fax to Helsinki for David and it won't go through.

"I hate these machines," I offer.

She holds up her latest attempt silently, showing me the little sliver of text that is gone. I place it on the copier and the text appears intact. I show her my trick, a veteran of copier frustration. She is quietly grateful. She mutters to no one in particular, "This machine isn't going to beat me, I'm gonna beat this machine."

I look at the clocks and calculate what time it would be if I were still on vacation and imagine what I'd be doing. I hear the little girl talking to the guy who brings the mail. He is flustered. She wants to help him deliver it and he obviously has no idea how to handle this. She follows his cart down the hall, the student desperately studying her mentor. She whizzes by my door, a flash of green, and I feel myself wake up.

I look at the clock on the phone. Three thousand miles away someone I love is still asleep. I pick up the receiver and begin to dial.

Tutoring

RACHEL HUTTON

Being young, hardworking, and exploitable, I spent six months as the Upper East Side's version of a sweatshop. I wasn't folding laundry, selling batteries, or pushing light-colored babies in strollers. I was just a recent college grad who had answered an ad for "Ivy League Grads, $25/hr" and found myself tutoring SAT math to the progeny of the city's upper crust. "Hi, honey!" Emily's dad announced as he came into the study.

"Hi, Dad," she replied. He turned to me.

"Did you hear about Emily's scores on the PSAT?"

"Yes," I answered, "she did well for her first shot."

"Yes she did, but we've got plenty of room for improvement." He dipped his chin toward his daughter. "Right, Emily?"

"Yeah, Dad."

"Well," he turned his eyes back on me, "I've got a proposition for you. You're the math tutor and Andrea's the verbal tutor, right? So, if both you and Andrea stick with it until June, the tutor who raises Emily's scores more gets a free trip to the Caribbean!"

Although I'm not always sure how to spell Caribbean even as I type it here now, I do know that the man was totally serious. I stared at him for a second. I shrugged and grinned with the socially appropriate combination

of enthusiasm and nonchalance. "Sounds good to me." I looked at Emily. She grinned but looked a little embarrassed. "Dad, I've got to study," she said.

"Okay, honey," he responded over his shoulder on his way out of the room. "Keep it up." Emily looked at me and rolled her eyes. I smiled.

"Want to take a look at number twelve?" I asked.

Growing up in Edina, Minnesota, I've always considered myself a member of the upper-crust elite. Upper-middle class for sure. I got new jeans for the first day of school, my dad drove an Audi, and my friends had cabins on the lake. As our hockey and tennis teams took one state championship after another, rivals' fans heckled "Cake eaters, cake eaters." But after attending college at Stanford and working in New York, I realized that upper-middle class for Minneapolis wasn't upper-middle class for the rest of the country.

Along my way, I encountered something I'd never really been exposed to and still don't quite have the capacity to comprehend: PWMs, People With Money. Real money. Old money. Lotsa money. And I don't mean Daddy-bought-me-a-Jeep-Wrangler-for-my-sixteenth-birthday. That's Edina money. I mean Daddy-bought-my-tutor-a-trip-to-the-Caribbean. I mean my mom's maiden name is Gamble, as in Procter. I mean my dad got me a position as Dick Cheney's aide. I mean my house on the Upper East Side is a house, not an apartment. The guy who answered the door isn't a member of my family. That kind of looks like a Picasso on the wall, well, because that *is* a Picasso on the wall.

Even as an upper-yuppie-up-and-coming college grad off to an ambitious design career, I became the underclass for this upper-class caste. I found myself in closer parallel to a factory laborer except that I wasn't churning out T-shirts; I was churning out statistically reliable test takers.

It wasn't the fact that I made $25 an hour while my employer charged $180 that made me want to quit. Well, yeah. It was. But it was also the fact that I had students who had ordered thirty hours—that's $5,400 worth of tutoring.

Now, I'm a pretty good tutor. I teach with a balance. I push students to figure things out for themselves, to work hard. And I praise their achievements. All the while encouraging them to keep it all in perspective. No

matter where they go to college, they're going to learn a lot from living on their own and making new friends. One can work hard and get good scores without having to sacrifice family, friends, and self-actualization.

But I'm not a teacher. I have no formal training as such, and for 5K, you'd think I'd know enough about how antilock brakes work to explain it to a ninth grader. I just felt like people were getting ripped off.

As college admissions become increasingly selective, parents feel pressured to shell out thousands to guarantee their children a spot in one of the country's most prestigious schools. I don't know why. After they graduate, they'll just join the rest of us SAT math tutors.

Lamont

AMANDA DEWALD

Lamont came in last week with his hair tied up into little black knobs—thirty or forty of them, all uniform. Each one was pulled up from a perfect equilateral square of hair on his scalp. He walked into the room half slyly—proud but bracing for the machine-gun commentary.

"Check you out, man. When you get that done?"

"Ha—Lamont—you get your head stuck in the drain?"

"That's hot. My cousin has his like that too—he had his done up on West Jackson Boulevard . . ."

A girl sitting in the corner glanced up at him, and said nothing.

Michael had stepped forward and shyly patted Lamont's shoulder with one quick thud. "That looks good, man," he had said quietly.

"Thanks," Lamont replied, hanging up his jacket and his book bag in the closet. For a moment everyone had stopped and thought only of Lamont's hair. Then the class seemed to resume itself again, slow and important gaggles of sound rising up everywhere as the students put their things away, gossiped, and got ready for a day in the hard, blue plastic chairs.

I made it through that week, but today, when it was already 8:15 and I hadn't said anything at all, the students began to look at me suspiciously. Tony came up to me at my desk, where I stood tiredly rearranging papers into folders. With his head half cocked and a look of grave concern, he said,

"Hey, good mornin' Ms. D." I looked up at him. "Good morning, Tony." My voice crept from the back of my throat, like an old door turning on its hinges squeaking and grinding. I hadn't realized how strained it was until I had had my first conversation that day with the security guard at the door of the school. I tried to speak when I saw him, his kind and consistent face like a lighthouse at the end of the long, concrete stairwell. Sometimes I felt that I could not face them—or the tired, yellow-tiled walls—again. But then I'd see Mr. Marlon's face at the door, calm, and I'd just say, "Good morning," have a talk, and sure enough—go upstairs to face the day. But that day I tried and no voice came out when I tried to speak. The months of talking, and talking, and yelling, and talking, and talking . . . they finally got their prize. My voice was completely gone. The kids had won.

"Well—look at you!" Mr. Marlon said, surprised in his subtle way. "Why you come in today? How you gonna teach when you can't even talk?"

"Uh-oh," I said. "I didn't know it was so bad."

"Well, it's bad. What happened to you?"

"I don't know, yesterday I felt OK, but then last night after dinner, I could feel it coming on."

"I keep on telling you to take care of yourself. You're always working so hard—I'm telling you. I've seen a lot of teachers beat from the day. You have to go home, relax . . . that's why I like riding my bike, too. Just twenty minutes from the South Side—it's quicker than the bus . . ." Mr. Marlon started to say. A sudden sense of urgency started to build in my chest as I tried to envision what the day would be like without a voice, trying to teach my huge classes of children. I made a quick comment to Mr. Marlon, then moved on to the main office, where I stopped by my mailbox and set my attendance card for the day. Ms. Morra sat behind the desk in the attendance office. She glanced at me over her glasses. Preoccupied, she greeted me, "How's your grandmother?" I always replied, tensely, that there was little progress. The conversation did not distract me from her scribbling hand— writing out those grueling forty-five-minute assignments to cover a sick teacher's classroom since the district could not afford nor bother with finding substitutes. With 1,700 students and more than 100 staff members, you

barely even saw all the people on your floor. Traveling to the other end of the building was no walk in the park, where the eighth graders' malcontent loomed over you when you tried to gain control of their classroom. "Why should I listen to you?" you could almost hear them say. "I'm too old to be baby-sat." I couldn't blame them. I would lift the heavy facade of authority just above my shoulders, like the struggling weight lifter, and bear it. I hated those assignments. They were enough to ruin my day. I watched Ms. Morra's hand nervously as she ripped off the little white assignment sheet. She passed by my slot, and stuffed it into one a few spots away. I breathed. Not saying much, I hurried upstairs.

"I'll teach them sign language," I thought.

The time before the first bell quickly ran out before I had accomplished anything I planned to do. The piercing sound of the bell caused me to take a deep breath—even late in May. "OK. Here we go."

I went to stand at my classroom door to monitor the kids as they shuffled into the building—hundreds of them. "Take the hat off, please . . . Hats off, please . . . Lose the hat, sir, that's the last time . . . I'll put it in Mr. Sonny's safe, and once it's in the safe, it never comes out again. . . ." My voice would trail down the long corridor, lost in the mayhem of teenage voices and bodies.

"Good morning, Ms. D."

"Mornin', Ms. D."

A cursory glance from the short boy.

"Morning."

The whole thing passed as usual, and when Tony prompted me that morning and discovered I couldn't talk, he thought it was charming, but I was secretly tense. It took about thirty seconds before the whole class had heard the news. After they sifted in and the second bell rang, Lamont announced, tapping his pencil on the desk, "Y'all be quiet! Ms. D lost her voice!" I looked at Lamont to thank him. His hair was out of the knobs this week, back in a big afro, a blue comb sticking out of the back. I knew Ms. Morra would come in at some point today and look at him petulantly. "Take that comb out of your hair," she would say. "This isn't a beauty par-

lor." I knew the rules and that I should stick by my fellow teachers for the sake of professionalism and coherence. But I didn't say anything. I liked the comb.

The class quieted down almost immediately and looked at me expectantly. I tried to talk and only one squeak of sound came out during the whole sentence, "I lost my voice." I guess they got the point, anyway.

"Whoa—what happened to you?" A couple voices blurted out, but they were quickly quieted by the other students' urgent "SSSSSHHHHH-HHH!!" The class fell silent again.

With the first obstacle defeated, I moved swiftly on. I said not another word and just wrote on the board, "Repeat exactly as I do." I held up my hand and formed the letter A with my right hand, and slowly the children all held up the hand, too. My hand then formed the B and already Michaela had caught on. "B," she said out loud. I went through the whole alphabet, and by the time we got to Z, I had paused twice to regain the control of their enthusiastic, heightening voices, all yelling out the alphabet.

The morning passed. The kids were receptive and quiet and took responsibility for themselves. They listened closely as I moved through the lessons. They worked quietly for long periods of time. Lamont was the judge, his pencil-gavel quieting the crowd whenever the class's din overwhelmed the pitch of my voice. The pencil would always elicit an enticing "shut up!" from someone else across the room, annoyed at Lamont's self-proclaimed authority. "You shut up," Lamont would rejoin. "You shut up . . ." from the instigator. Then a third party would yell "SHUT UP!" and they'd all look at me again.

After a relatively successful day, eighth period came, and on his way to the garbage can, Tony passed Denzel's desk. Denzel took a sheet of paper resting on his desk and, wanting a little action, waved it in Tony's path. Suddenly the whole class burst like a bomb. Tony swung hard across Denzel's desk and hit him in the jaw. The desk was shoved violently aside, screeching across the floor, and the two boys fell to the ground, both swinging. The class formed a circle around the thrashing arms, fighting aimlessly and hard. I swung around, amazed and unprepared for the outburst. I snaked quickly through the rows of desks and tried to keep my body language calm as I

pulled the top boy off, struggling to get his thrashing arms secured behind his back. Once I had him in the hold, I could talk to him quietly from behind. "Calm down, Tony, calm down," I said to him. He wrestled against me. The other students tried to soothe Denzel. I realized that Tony was sobbing. I pulled him quickly outside the room.

"Tony? What happened? What made you react like that?" My brow was crossed and I spoke to him intensely, trying to convey the severity of his actions. Tony frenetically wiped the tears off his cheeks with the back of his hand and shifted back and forth across the hallway, refusing to look me in the eye. "Tony . . ." I put my hand on his arm to make him stand still. After ten minutes, I finally deciphered that he had lost his summer school notification letter. Earlier that day, the assistant principal had come in and threatened that anyone who didn't return the letter that day, signed by a parent or guardian, would automatically repeat the grade. Terrified, he had pent up his stress all day, searching his bag again and again for the letter, and had finally released his aggressions on to an unsuspecting Denzel. But I had no choice; he had hit another child. I delivered Tony to the office to receive his consequence.

Returning from my conversation with Tony, I was anxious that the rest of the students were unattended. Just before I reached the door, I heard someone yell, "Ms. D's coming!" I opened the door and found Kevin strewn across the floor, laughing hysterically as Laura leaned over his curled body, yelling something. Various other figures darted around the room behind them, all scrambling back to their seats to avoid being a culprit. In an irrational rage, I revoked Laura and Kevin's spots on the field trip and pointed to five other students who were talking in a circle.

"You . . . you . . . you . . . you . . . and you. Detention," I said. A rebellious moan rose tentatively out of the crowd. Then I noticed as three of the victims retreated from the circle, that at its center Esperanza stood crying. I told her to wait, and, at the sound of the bell, I shuffled the class down the four flights and out the door, returning to the silence of the five offenders, who sat, slumped, jaws out, arms folded, resentful. Lamont was among them. After two long minutes of silence, he got the idea to bop along with the beats from the cars down below. Reaching into the deep archives of his

mental musical library—rap, blues, country, gospel, R&B, hymnals, and some classic rock melodies—he would pull the song. The car would pull up to the stop sign four stories down, provide the melody, and drive off. Then Lamont would bop forever, continuing the song with perfect timing and lyrics, until the next car drove by and reset him like a well-tuned jukebox. I watched sullenly as my strident and victorious detention session dissolved into a web of giggles—renewed and stronger each time another car drove by, and the shake of Lamont's shoulders grew bolder.

"Put your chairs up quietly. Everyone is free to leave, except Lamont," I said, and my determined teacher face was fixed and staring down his laughing eyes and gaping mouth. "Wha . . ." he started, but I cut him off.

"You know why," I said, and walked back to my desk. "I understand you like the music, but you can't mock me and get away with it. I had you here as a consequence because I wanted you to think about your actions, and when you're bopping around you can't do that. You're wasting my time! I could be at home by now, calling my grandmother . . ." I caught myself in one of those shameful actions that I thought I would be exempt from before I actually stepped into a classroom—leveraging my personal life against the students. I began to feel the blood rush to my face as I turned to face him. Our eyes met, and I stood for a moment, regaining control of my anger, before I spoke to him in a quiet voice. "Go home, Lamont."

Lamont hesitated. I watched to see his back disappearing through the door.

I collapsed at my desk and clutched my throat with my left hand. I could almost palpate the red striations on the inside of my esophagus, and I thought I felt them running down into my stomach. I wondered vaguely about where Esperanza was. I remembered the beginning of the morning— ages and ages ago—when my sore throat had conquered all my discipline mistakes. "It's only a week after vacation!" I thought, "and already I am energy-less, disheartened. What happens when I come in? I yell at them like a mass of bodies at times, but when I looked at them as individuals, I think, 'No, it's not you I'm mad at, really . . . or you . . .' Tempers run hot. Everything feels hot and just beneath boiling point, all the time." The feeling would often come over me during the first year of teaching, as I struggled

to become adult enough to deal with the real responsibility of being a role model, always watched. I set expectations for myself to be wise and fair-minded, but the calmest days could turn wild, and then guilt-ridden. I watched my own struggles and mistakes face up to the students, and I would punish them with the frustration that I felt over having an out-of-control day, feeling incompetent, feeling lonely, or overconfident or petty or "visiting white girl." I failed to talk to them as adults. I wanted to story-tell, inspire, make them laugh, but the heavy realities kept pulling me, like leaden shoes, back down again into unplanned and unhopeful motivations. *"Do I have enough depth for this job?"* I asked myself. I got up from my desk wearily and, without thinking, wandered over to pick up a piece of paper at the back of the room. Unfolding its creases, I saw that it was Tony's summer school notification letter.

About forty-five minutes after he had left, Lamont appeared at the door. He looked pensive and upset. I saw that another teacher stood behind him, prompting. "Go ahead," she said. "Give Ms. DeWald the letter."

He stuck out his hand and I took the unevenly folded paper and opened it.

Nothing is relly wrong I was just sitting there thinking. Because I got in trouble. I was thinking about how I can control myself from talking during class. I don't want to get in trouble but sometimes I lose control. I'm thinking about what I would be like if I go on like this. Miss DeWald is a nice teacher and I don't want to upset her but I know I did. I relly want to tell her I am sorry for causeing so much confution for her but if I do it again she might not think I meant what I said. But I will try to do better and this time I mean it.

The warm spring air descended on the looming housing projects that overlooked the school from five blocks away. In an effort to maintain the humane and victorious aspects of our year, and not the conflicts or my intermittent sense of complete exhaustion, I organized a picnic at a nearby botanical garden with my students. Although it was only fifteen blocks from their neighborhood, many of them had never been there. As we sat down to

lunch at the picnic tables that afternoon, Lamont kicked off his sneakers with abandon and began to inspect his feet. Sitting across the table, Michaela, Maria, and Lalana, three of my most brilliant and hardworking students, looked at him with disgusted faces.

"Yo, I got the nicest man's feet," Lamont said, rubbing his hand up and down the sole of his foot, which was crossed over the opposite knee. "Ain't no man got feet as nice as mine. They're so SMOOTH."

I looked at Lamont. I had been his teacher for nine months now. He was fourteen and more able to handle my sarcasm. Trying to contain my laughter, I picked up my lunch silently and moved over to the next table. Lamont continued unabashedly to admire his foot, leaning over it, scrutinizing it.

"Ms. D—why aren't you eating with us?" He lifted his head up finally and looked at me.

"When you put your shoe on and I don't have to smell your feet while I eat my sandwich, then I'll come back."

The girls broke up in laughter, and Lamont smiled, got up from the table, and moved over to an adjacent patch of grass, kicking into a handstand, reveling in the feel of the earth slipping out from under his smooth "man's" feet. Watching him indulge in being a child, I realized that, in fact, he was almost a man. Despite his desires or his age, his environment had pushed him too soon into a position of responsibility, where he cared for younger siblings, cleaned the apartment, and, above all, shaped and charged his own motivation toward his future largely on his own and in the face of monstrous obstacles. Had I justified this overlap in my classroom this year? Had I been a teacher, or another misplaced adolescent, too early for the shoes I had to fill? Had I really educated the students, or played into the sick inequities that they experienced every day? Was I too wrapped up in my own self-reflection to even see the situation clearly? How many complicated emotions had I taken out on them, frustrated by my failure to provide them with something different?

I thought back on the past ten months, the 5:30 A.M. awakenings, the pots of coffee, the three-hour naps after school, the enormous success I felt when my whole class worked together in industrious groups or won the reading contest, the waking up in the middle of the night to plan lessons . . .

make posters . . . correct papers . . . get in an hour of my own reading. As the mayor cut another $190 million from the city's public education budget, and excellent teachers with temporary licenses were cut in the midst of a 12,000 personnel teacher-shortage, I remained at times like an artist in my studio—working silently, vigorously, and with great angst to capture the elusive yet tantalizing and proximate vision of my students' success. "Where am I going to move Juan's seat now?" I would scavenge around my head's interior to try and uncover another solution. "I've put him in every single group and he can't work with anyone. I've moved him to the front, the back, the side, the middle . . . and I still can't get one piece of work out of him." As the after-school programs were slimmed down, and there were more angry letters from the union declaring our imminent protest, the boys' and girls' bathrooms remained without toilet paper. We decorated our room in December with gold, silver, and blue garland, and bilingual holiday cheer. More teachers came and went, and some even stayed—the solid and persistent and erudite among them working, like the foundation of a house, largely unthought of and unpraised.

Whether I liked it or not, there I was in the middle of it—the students depending on me in their own hungry, curious, resentful, or loving ways. There we were experiencing the tidal forces and the driving outcomes of the city's economic and social movements. Even if I wanted to run, the fire fueled by sadness, outrage, obligation would outrun me. So, instead, I worked. In fact, the way I handled my own responsibilities as an adult had been slowly swiveled and shifted when I became, suddenly, a shaping force in the lives of so many other people. My daily creed had been summed up by Lamont in his letter to me, as heartfelt and as reiterative . . . "But I will try to do better and this time I mean it."

Painting

COURTNEY BOOKER

In a Day Again

PAUL OHAN

I've woken up on time before, but last night I kicked the shit out of myself. I'm more hungover than I was yesterday, and my body feels like it's twitching on the inside. I've got a permanent sour taste in my mouth caused by dehydration and too many cigarettes on the walk to work. My commute is only ten minutes, but I insist on packing it in with as many drags as possible right up to the revolving door of the building. In the elevator, I'm the guy you don't want to stand next to. I'm told it's not the most pleasant of experiences. I can't help it really. I smoke. Right now there are more important things to worry about.

Like Caron beating me to work again. She isn't really into speaking to me now. Did she walk in with a list of things for me to attend to? Did she want coffee? What if she just wanted to say hello before the day started? I wouldn't know. I am her assistant; I should be there every morning to greet her with stars in my eyes, and a nice tie. Instead, my breathing is hard and difficult, and for the next hour, I know everyone who talks to me will smell the alcohol on my breath. I begin with the usual phrases: "Yes, Caron. Sorry I'm late. Here you go, Caron. Your next meeting is now, Caron." Followed by "Caron's office, may I ask who's calling? Hold please." and "Can I take a message. No, I told you, she's in a meeting." I never learned this in college.

We play this game of who's going to get there first every day. Although I

know she wishes she lost more than she does. I wonder when she's going to call HR and get a new assistant. Some broken-spirited person with more obvious values is what every executive really needs. Not a half-difficult young man who's constantly brandishing his personal life around her office, accidentally of course. The kicker is that I really don't mess up at work. I keep track of everything that goes on—dates, messages, appointments, and lunch orders—very well. I'm polite and always complete personal errands. When a crisis happens I handle it; I take the blame if it's not my fault just to be finished with it or try as hard as I can to assist in its solution. It's work and I'm glad to get my paycheck. I'm good at what I do, which is why I take small liberties like chain-smoking and not shaving today.

I've been working at this fashion house for the better part of a year and have a good rep. All the execs seem to like me because I can handle their diva attitudes and I use my common sense. It's a prerequisite that you retire that part of your personality after you've risen up the ranks of any corporate ladder. Vice presidents become irrational and impatient. I guess I would too if I got to where they are. Maybe they were always little bratty children, working until they got to a level where it was safe to slack off. The spoiled shits we knew growing up don't just disappear. Apparently they do very well with their careers and ask you to get them coffee. I don't care. I just wait to leave this place and get back downtown where the drinks, smokes, and some drugs can always be found right next to my friends.

I look busy on the phone as Caron goes to a meeting so she feels comfortable knowing things will operate with her not around. Sitting at this prison cell of a desk, I watch a L'Oreal product parade walk by me trying to see if my boss is there or not. Maybe some of them don't want to run into her and are glad she's gone. The sentiments are mixed, but the action is always the same. Their necks must have developed a kink by now from cocking it up, over, and left or right trying to sneak a peek in. Not my problem. I wanna laugh but I just find them annoying, clocking hours that pay my rent and wasting time that could be concentrated on advancing my career in publishing. Calls keep coming in, but I forward the lines to voicemail 'cause I want to go downstairs and have a cigarette. It's the only way I'll be able to think and get my head organized for the day. Truth is, I don't want to sit here

and deal with answering calls and scheduling meetings yet. All that will happen today, and my eyes are still glossy from last night. My head is still pounding from last night, and my esteem is suffering from last night. Being late didn't help the situation. It isn't smart of me to jeopardize my relationship with this corporate cash cow like I do so often. But I think I know what I'm doing.

Which is why I was out last night. It was fun like most of the nights before it. I was drinking at the bar with a bunch of people my age talking about nothing special, listening to music and kicking it. I can't really afford to be spending money, and neither can they. But at least I feel like I'm doing something for myself. And it's good to know that I'm not the only one thinking this. I run into the same people all the time. Most of them have lost their jobs and are scraping by. There's Liz who was at a Dot Com, and Chris who was a programmer. Lucinda worked in advertising; Erik worked at a recording studio. Ben quit his job. We all seem to find a way to stay afloat and make it back out. It's a pretty good group-therapy circuit; we just don't address that fact.

I was with Girlfriend up front by the entrance playing pinball, singing an R&B song about love and betrayal. I was having a stellar game. Girlfriend was lighting a new smoke off of mine.

"Excuse me, Cheeto." She calls me Cheeto. "You need to be putting this kid shit to the side right now. There are some cute men to be had, and if I don't get laid tonight, I'm going to drip all over this hellhole. C'mon, let's go hang with these kids." Girlfriend always has a way of convincing me. We abandon the pinball to sit down with Lucinda and Chris who got a table. Chris wants to get back into programming and is trying to figure out how he can work from home. Lucinda just sits silently and smokes her Parliaments one after the other. Someone put money into the jukebox, while another character pushed the coin tray into the pool table, releasing the balls like a chorus in the background. I light a new cigarette and swallow a healthy portion of my drink. Girlfriend is counting her money since it's her turn to buy a round of vodka tonics for us. "Well vodka is fine Girl, thanks." But she knows that. "Like I was going to get you that top-shelf shit."

Tonight I just feel like listening to people as I stare up to where the walls

meet the ceiling. There's a new art installation hanging above the bar. It's not that good of a piece. What's a large metal spike supposed to symbolize? I turn my attention to Girlfriend at the bar doing her part to keep the morale of the men up. She's talking to them as if they have a chance of getting in her pants. What a beautiful woman, part Black and Italian with a cute ass and perky tits. For attention, Girlfriend will break out in front of everyone and slap the booty of some stranger like a kinky sex act. Or she'll bend over and stick her ass in the air repeating the phrase "what, what, what" to the beat in her head. She also kicks her leg out in the middle of conversation and screams *jack knife!* I haven't figured out the reasoning behind this yet, but men seem to like it. Of course I hear her bitching about the rock music being played in the background. "In the name of God, I'm going to rip my hair out one by one if someone doesn't fuckin' turn this shit off." Two seconds later, it's "I'm going to pluck my own eardrums out of their sockets." The men chuckle and don't know what to do with themselves.

She brings the drinks back to the table, picks up her purse, and heads to the bathroom. "Thanks, Girl," I say, and sip the top off of my new cocktail. Everyone around me is doing something. There's one guy in the corner who's been chain-smoking all night, reading a book. I could never do that well. I've tried it with a newspaper and a magazine and always seem to stare up and around at everyone else. I prefer my thoughts most of the time; I think better with people around. Chris is trying to flirt with a woman while a guy with long hair and a distressed leather jacket passes out a flyer for a show tomorrow night. "It's the same kids who're playing next door at the Pony if you want to check them now," he says. "They're fresh." It's been a while since I heard some rocker-guy use the word *fresh* and mean it. I look at the flyer and read that the group is called SCUM. Society Could Use Me.

I love them already.

"Word, I'll check it out, thanks," I say, and turn my head away from him. By the bathroom line Girlfriend has created, I notice a short, dirty-looking kid I used to work with. We nod at each other and he makes his way over to the table.

"What's going on, bro?" I say with a smile. I forgot his name for a second but remember that it's Richard. We both worked for a company that ran a

few websites. My old job required me to go out almost every night to parties to talk with fabulous people and stars. I would ask them what they were wearing, and laugh by their sides as my photographer took their pictures. In the morning, I'd write it up and publish it online for bored secretaries, like myself, to read. Richard worked at a site that dealt with sex and horoscopes. He created an online reference guide of fuck positions for twentysomething males. Our hits were just about the same most days.

"Hey dude, long time, no? What are you up to now?" he says, grinning.

"I'm freelancing." The polite answer.

"You still doing the writing thing?"

"Trying, but you know how it goes. I've done some small pieces for random people. And you?"

We know that neither of us is doing anything exciting. There aren't many opportunities, and only so many job websites around that everyone ends up looking at the same postings. Never mind fighting for it. If I ever met anyone who got a job I wanted online, I'd probably have an impolite freak-out after they walked away.

"Yeah, well, I'm thinking about going back to school. It's safer there, and I'm not doing anything here that I'm proud of so . . . you know." He gives me one of those annoying, awkward laughs.

"Word, Richard, good for you." Dropping his name makes the interaction easier. "What do you want to go back for?"

He looks me in the eyes and says, "Business administration, or neuroscience, or business administration."

Right.

"Awesome, good luck with deciding." The middle option seems pretty interesting. I don't understand what he means by not being proud of what he is doing, though. Who is? I remember he used to have a band, but I don't probe. I can't judge him too hard; Maybe I'm a knucklehead. I'm only twenty-five, but so is he.

Girlfriend comes back from the bathroom wearing a wicked grin and holding a lit Newport she just bummed from a homeboy with hot biceps. She's feeling way good right now despite the rock 'n' roll. Walking like she's in a dream. Taking a step every two seconds for dramatics. It's her way of let-

ting whoever is paying attention know that she has something going on in that little head of hers.

Girl doesn't look at Richard 'cause she can tell that I'm not totally engaged. She wraps her hand under my arm and suggests that we go next door to check out the band. Ben and Liz have joined the table, and they are talking about suicide bombers and online dating services. Girl announces the migration and pulls me aside.

"What was that guy talking to you about, Cheeto?"

"Nothing, we use to work together, he's going for his MBA."

"Don't sound so depressed, it's not your life."

"True, if it's good for him, I can't hate."

"Oh word. If he wants, he can have my job. Paralegals get free dinners for working late."

"Be nice, he shook me for a second. I'm not sure if I'm being stupid for not doing something similar."

"Tell me about it. But you need to focus on what you got going on now. Nobody's paying your rent, or mine. Anyway, I'll catch you." We share a quick kiss, and walk out onto the street.

Next door at the Pony, I break out my Prada wallet and order a round for the two of us. It's a deep-brown leather with a pretty, green diamond pattern lacquered over it. The thing cost me $200, and I've never carried that much money in it, but I love it for all the shallow reasons you can think of. Girlfriend grabs her drink, saying "thanks slick" as she goes back into the crowd to mingle with a short thug who probably has a big dick. She has a nose for things like that. I tip the bartender, say "thank you," and hear the sound of my father's voice come out of me. He died seven years ago from lung cancer, and I'm still smoking.

I wonder what he would think of me, with this wallet, and tonight. He never cared what I did, as long as I was happy and honest with myself. I think he made a lot of mistakes and wasn't into seeing his children repeat his errors, or what he saw as errors. My bro joined the army, and my sister works in advertising. I guess we have to wait to see if what we're doing is right for us. Right now I know that staying home watching "The West Wing" doesn't feel good, and the music here is pretty on par.

To my left I see the only preppy kid in the bar looking a bit out of place. He has blond hair and a nice square face. I can't tell the color of his eyes in the dark, but they're pretty. I bet in the morning he'll have a few freckles.

He's making his way to the bar and I move over so he can squeeze in next to me. He orders a drink, and I stare at him with a small smile for a second. I don't want to come on too strong; but he just gave me this great grin. I chat him up about the music, and he starts telling me how he and his girlfriend got into a fight earlier. I ask if he wants a shot and try to take it from there. After a few minutes we go to a table to continue our conversation. I have to be careful to not scare him 'cause I'm drunk and speedy now. But he's had a few too. He slowly leans into me wearing that grin again. We kiss. I thought this was going to be one big tease. I love the feeling of his tongue and can taste the alcohol on his breath. The top of his hand is fuzzy with hair. He asks, "How far away do you live?" I look for Girlfriend and see that she's just as busy. So I tell him, "I'll pay for the cab," even though I can't afford it.

My preppy goes to the bathroom, saying he'll be right back. I nod my head casually and light a smoke. Upon exhaling I take a swallow of my drink and then another drag. I can feel the sharp taste of vodka all over my freshly kissed tongue and even feel the subtle metallic taste of the cigarettes in my mouth. Kissing always cleanses the pallet and sobers you up. For whatever Freudian reasons, I start to wonder if everything I'm doing is like my father's mistakes, before he was my father and just a man. The music kicks in and everyone throws a holler into the air breaking me out of my little moment. Girlfriend is making out with her thug in the middle of the floor. I check the time off my cell phone and head toward her.

"Work's only a few hours away Paulito!" she says as I kiss her good-bye. She winks at me while I stand there grinning. Girl always comes off like she's only about the party. She knows when to be serious. The antics are just antics. It's that fine line she plays that makes her incredible. I know she'll be late tomorrow too.

My prep is back at the table putting his coat on. His face is wondering what happened to me. I walk over and reach for his elbow with my free hand to assure him that everything's still good. Chris, Liz, and Ben grab Erik and

Lucinda. They're trying not to laugh too hard as I ignore them on the way out. Preppy asks to bum a smoke from me. I give him a drag off mine and we catch a cab to my place.

"Bye Paul!" is the chorus that sticks in my head as we exit.

I listen to the sounds of cabs and delivery trucks zoom up Madison Avenue and flick my cigarette onto the street curb, still replaying last night's episode, smiling to myself. I watch the smoke of my butt rise from the street for a second before I turn my back to it and go through the revolving door. I'm sure everyone smells me on the elevator again. I still don't care. I made it to work this morning, and now I'm about to handle whatever tasks are required of me.

I check the voicemail and make a list of people I need to call back on behalf of Caron. Girlfriend left a message wondering if I made it to work or not. People are still walking by, trying to get a look into Caron's office. When I stare at the doorframe long enough, the whole scene feels like an aquarium. A bunch of beautiful fashion people swimming up in the pool of vodka that I ingested last night. They're inspiration for my next story.

Caron smiles at me as she returns to the office. I reciprocate and read off the list of people who called while we were both out of the office. With everything in order, I offer to pick her lunch up. It will give me a chance to go outside again. I'll take care of her world and make sure she has nothing to worry about. I'll make sure she can attend to her duties without being bothered. I'll sit here and greet Caron as she comes back from her meetings all day. I don't mind. I'll be out again tonight. "I got us on the list for that SCUM band" was the other part of Girlfriend's message. I felt bad making my cute preppy leave my apartment with me this morning, but he needed to get home and shower. I hope he and his girlfriend resolve their differences. Last night I left my time sheet on Caron's desk. When I came in today, it was back on my chair with her signature. I'll remember to thank her for it when I come back with her lunch.

No Longer Green

REZA ASSEMI

Reverse Commuting

JENNIFER KARLIN

Once, at the bottom of the Grand Canyon, some overly hairy cook who lived alongside the Colorado River told me that I would be a perfect candidate for a job working on the basement level of the layered ravines.

With her arm firmly grasping my shoulders, Sarah the cook explained to me the work qualifications I needed to get a job at the Phantom Ranch. "All you need to be is good worker." She pronounced "good worker" without an article, making it more like one word that sounded Germanic, *gudwerker.*

With her simplification of the job requirements, I was in disbelief. Certainly, there had to be other requirements.

"Well, you need to be three things, really. You need to be on time, you need to be reliable, and you need to be *gudwerker.*"

Sarah continued to explain to me the complexities of the job, sometimes confusing whether "reliable" and "on time" were actually the same thing. Maybe I only needed two qualities for the job.

During her narration of a day in the life, Sarah sometimes forgot about being *gudwerker* completely. "And so you would be perfect for this job. You just need to be on time and reliable."

". . . and *gudwerker,*" I would gently remind her of the third characteristic, a distinct and important one, in my opinion.

"Ah, yes, of course, we all know you have to be *gudwerker,*" she cooed into my ear.

Since then, I have used *iamgudwerker* for all of my Internet password needs. It is a reminder about Sarah's mistaken conflation of job qualifications and my own aversion to a hierarchal authority telling me how to be a productive member of society. If being on time means being reliable, then I am certainly not reliable. I have developed the idea that productivity is not based on a linear staircase but on spiral staircases on which I can traverse, climb, and slide. If being reliable is about doing what I say, staying committed, thinking outside the box, and respecting my coworkers . . . here *I am, gudwerker,* at your service.

Forget about being on time; I wake up as late as possible to get to work. I like to sleep and I *hate* waking up. I have convinced myself, and some others, that it is the opposite of laziness; it is due to the fact that I thoroughly enjoy whatever it is I am doing (or that my blood-sugar level falls dramatically as I sleep). Whatever it is, I want to keep doing it. So, when I am awake, I don't want to go to bed; when I am asleep, I certainly do not want to pull myself from the vivid images simmering under my eyelids.

The images are simmering chocolate brown. Everyone in the gymnasium is wearing jumpers, dyed dusty shades of beige. Each uniform is anointed with patches stitched on to the most prominent outside portions. The symbols depict a Brownie helping an old lady cross the street on a rainy day, figuring out how to sew a new eye on a doll, and, most commonly, successfully selling boxes of cookies. The patches are supposed to set individuals apart, announcing new and intriguing combinations of sportsmanship, craftiness, and humanity. All of the parents smile proudly, reading achievement into these paraded markings.

To me, the symbols do just the opposite. The smell of thick mud overwhelms my senses. All the possible uniquenesses blend into one. As if the dirty Mississippi suddenly washed over the gymnasium to make the bodies move in the same lurid flow.

I stand slightly apart from the other girls, joining in conversation and

games at all the most appropriate times. I am wearing some nonuniform blue sweat suit and a comfortable cotton shirt, with only trinkets of my achievement sewn into the troop leader's and my parents' minds. That is how I remember myself: confident, socially keen, and unwavering in my beliefs. I try to talk to some of them, but they all look the same to me as they try to please the troop leaders in the most obvious of ways. Markings turn into bodies, and mud washes the room. I feel sick from the overwhelming smell of murky monotony. The mud is not clean; it is oil drenched and heavy like the Gulf of Mexico. No one knows when to stand up and say that enough is enough, that they disagree. They are all begging for recognition by being the same. From the outside, I must look like them. I want to scream, but the mud fills my lungs.

My alarm in New York City sounds off for the first time at 8:15 A.M. Actually, my two alarms sound. The one near my head drones electronic slurs, and the other, sitting on a ledge on the opposite side of my lover, introduces NPR's best morning news. Most people I know regard the 8:00 range as a late hour to rise. New Yorkers and other urban species have an excessive obedience gene determined for mass-proclaimed productivity. Even though I too grew up around New York City, I tap the snooze button. I press it a few more times for all the well-programmed people who cannot press it. My first good deed for the day done before I even notice that the day has dawned upon me. Imagine that.

Snoozing is my favorite part of sleep; I can often change the ending of a dream that has turned sour. A teacher once told me that we can control what happens in our dreams. He explained to our class that he kept having a dream about a spider that was trying to bite him. But, just before the spider would bite, he would always wake up. A similar physical mechanism that keeps us from suffocating ourselves with a pillow must control our instincts during unconsciousness. Because achieving such an idiotic desire for a spider bite is unfeasible during wakefulness, my teacher yearned to stay asleep long enough for the spider to bite, to see what would happen. Finally, after years of practice, he learned how to let himself wake up, turn over, and let

the lids of his eyes close just as the spider's teeth sunk into his skin. He would fall into a deep sleep at that moment, and in his new dream, he would rise outside of his body and fly above himself. His out-of-body experience brought new knowledge to his everyday life. He learned to step outside of himself to gain new perspective. This story was so persuasive to me that I have long practiced my ability to change dream endings after tapping the snooze.

I turn over and wrap my arm around my lover. I speed up the ending of the dream sequences so that I am not too late for work today.

Immediately after the Brownie troop lets me join, I get kicked out on charges of not abiding by the Brownie rules. Upon repeated accounts, I refuse to wear the uniform, refuse to embroider beads and strings on to material, and decline reciting the Brownie mantra. The troop leaders stand with disapproving stares as I explain that the uniform is not comfortable for playing ball, that I would rather play ball than sew, and that I feel automated rather than human when I join in recitation. Above me swirls fiery red and virulent purple clouds, and I prance away unscathed.

Sometime around 8:50, my lover is pushing me onto the floor and off of our bed. He is teasing me for getting in trouble yesterday; I was late to yet another meeting.

My lover is the epitome of *gudwerker*. He is *always* on time. He gets mad at me for rolling out of bed when I do, getting ready for work in under fifteen minutes, and running out the door. He, on the other hand, always leaves enough time to shower, dress, chill, and stroll to work. His bosses adore him because he is always on time, always willing to pick up an extra shift at the restaurant, and forever ready to do everything required. They never hear a complaint from him.

When I was little, I was always rewarded for standing pudgy-legged, proclaiming how the world should be. Compromise is not necessary at a young age. Throughout school, I received good grades even though I refused to

memorize my times tables because I knew I could always use a calculator, refused to learn how to write longhand because I knew there were computers with which I could learn how to type, and refused to read an analog clock because we had digital ones all around our house. College taught me the language to express my emotions in intellectual jargon that sounded smart instead of stubborn. I learned to rephrase questions to win arguments that I wanted to win. If someone asked me to name the differences between a male and a female brain, I could swiftly reply, "How do you define man and how do you define woman?" or "Who is funding the studies, and how do you intend to use this information?"

Most mornings, this type of defensive response only brings to me a turn of my lover's back and a grumble that I am full of shit.

Maybe he is right, maybe not. I usually continue while throwing on some clothes for the day. My dad's words are ringing in my ears: "People tend to follow into the most crowded lines; always scout out for the shortest one."

Right. (I nod definitively.)

My dad grew up in the Jewish projects of Jersey City in the 1940s, started working in a hardware store at age ten, learned how to hustle, never played by the rules, and could charm anyone at just the right moment if he wanted to get his way. If he did not get his way, his temper rose. Armed with charm and the threat of temper, he got his way more often than not. After losing his father at twelve years old, he went on to take care of his family, pay his way through college, and eventually landed in California as a gambler and business entrepreneur. He owned the largest chain of car washes in Los Angeles. He then started a computer company that made PC-based training software for pilots, taking advantage of the increased air traffic off the Gulf of Mexico due to the early eighties oil boom and foreseeing the growth of PC usage. My dad always seemed to know the right numbers to bet on to beat the odds.

With my parents running their own businesses throughout my life, I never realized that other people really worked nine-to-five jobs and followed orders within a hierarchy. If my mom did not feel like going to work one day so that she could take me to an activity, she would make up the hours on

Saturday. Instead of showing up at dictated hours, I learned that work is about communication and after hours, as my parents spent many nights screaming about business over dinner. I did not acknowledge that the food we ate depended on the money that they earned in that argued-over company. We were bankrupt at various times, but somehow they kept this quiet. The only lesson I learned was that a good, hard work ethic is about outsmarting everyone else around you and worrying about the money later. If I ever needed it, I was smart enough to get it. First, in the shorter line, come my ideals.

My ideal right now is to get an extra five minutes of sleep. My arms rewrap the boy lying on the other side of the bed and I drift off.

From the corner of my eyelids, Atlantis is rising up. Clear, clean water. Fresh air. A place to piece together rather than simmer in a mud-packed hole. My eyes flutter dreamy waves in and out of the city of San Francisco, ready for Atlantis fog to flood me with its underwater logic, long gone the oiled slicked Gulf and the murky Brownie monotony.

I am guided by the red beacon of the TransAmerica Building. I meander through the streets of San Francisco without any destination, doing my best to interview for restaurant jobs that I am not qualified for. I am led to a small, late-night restaurant where I am sure to find some answers. I want to hand sustenance and inebriation across the zinc bar. I extract direction from stool-top success stories so that I can learn from other's mistakes and start to construct my own life. Meaning solidifies over a plate of smoked salmon with crème fraîche and toast. My bar nights are balanced by days of community service work and a course in midwifery on Sunday afternoons. Everything integrates, and nothing feels compromised.

It must be the reflection of the water that makes the Golden Gate Bridge so golden. It must be the sweeping movement out to the sea. The continual fresh air that brings new ideas together. Movies. Flashes. Intimacy. A new idea is born from my friend's lips. She drools beauty, and I lap it up into a practical achievement. I let go of midwifery to focus on the mindful

birthing through other's interpretations of the contemporary world. To collect and piece together an anthology out of what others are creating. To call for submissions to see what else is out there. To hear how others are making decisions and making meaning in a world that is too complex to steer through one linear path. Excitement rises within me. Submerged safely in San Francisco's gray underbelly, I partner in a project that is entirely unknown and work toward learning.

Standing at the edge of the bridge, I look below at the cascading water. I look above and see my parents staring down at me. Their heads loom like two giant balloons at the Macy's Day Parade. I wink at the sky to see if they will respond. They nod on, murmuring about how they started a computer company training pilots, not knowing anything about computer programming or flying. Just try something and then you can see where it goes. I jump off the Golden Gate Bridge tied to my coworker and weighted by stories, research, *The Writer's Market,* hundreds of proposals, thousands of versions, many rejection letters, and long, long days and nights.

Like hitting cold water at full gravitational accelerated speed, I encounter awake. For a moment, I am not sure where I am. My boyfriend is nudging my side. My heart jumps for a moment trying to regain balance. My eyes wide open, I turn my head to the red lights of the alarm clock, scared I have overslept. 9:00. Perfect timing to jump out of bed and speed off to work. I will still be able to make it on time.

My heart does not stop pounding as I throw together some ensemble for the day. Putting on a pair of slacks, I talk to my boyfriend about everything that needs to get done that day. Laundry. Dishes. Garbage. I try on a wool tank top and search for my cell phone. I check my e-mail and drink a glass of water. I tell my snoozing bed partner about my plans for the rest of the day. Friends. Movement. Space. I take off my shirt and try on a different bra with it, explaining about how my supervisor is one of those people who I look at with my mouth gaping open; a most passionate person. She is probably one of the only people who could inspire me to make a deal with my

lover to push me out of the bed every morning. She is always at work before me and always stays later, determined to find a way to get another person health care. I need to get to work because I have much to learn and do.

Looking for a few pages to edit for my subway ride, I am lost in my own thoughts. How do I keep up this balance between projects and work, between friends and business, between daytime life and nighttime dreams? Dreams and memories are what create our perceptions of who we think we are, no matter if they happened or not. What we remember as fact is not necessarily what happened—I have even asked my mom about the Brownie incident, and she does not recall such a happening. She says that the Brownie troop I belonged to did not have enough money to buy uniforms; how could I remember getting kicked off for not wearing a uniform that never existed? But these memories are my reference points and my confidence to keep up the charade about who I think I am. I cut and paste my daytime work life into my nighttime project life. I let naps infiltrate my days and work infiltrate my dreams. I am *gudwerker* because I do not section these things off, because I do not give 100 percent to only one thing. Because I can tie all the areas of my life together, and piece together different sections and ideals from my life into a new model of what work will be for me. Maybe naps at work are the ultimate integration? My *gudwerker* instinct keeps everything tidy. Although I may be an authoritarian's worst nightmare, I am convinced that the extra ten minutes of snoozing translate into more productivity in the midday hours.

At 9:30, I am walking through the door of my office. For the last few days, I have been trying to show up on time, negotiated by me as between 9:30 and 10:30 A.M. In New York City, it is best to try to go to work at off-hours so that you do not have to cram into a tiny subway car full of people slugging muddy coffee, only reminding me about the fact that Starbucks is on every corner. But I am lucky lately. I have a reverse commute as I travel into a borough of New York City and live in Manhattan. I feel proud that I do not have to give in to the people streaming in lines moving in the opposite direction.

I have told my friend whose father is a very successful businessman, and whose own business finesse is instinctual, about my idea for a new type of company. The company would have jobs that anyone could change every few years so that no one would get bored. Musical chairs. The collective knowledge could be saved on videos and in databases, and workers could tap into the knowledge to intensively learn about their new counseling positions. Media mixed with film, a health center, public relations, nutrition, a restaurant. Integrated living all under one roof. Learning curves would be steep at the start of any new position. Longevity within the company would last because job-hopping within would make everyone always excited to do something new. I would oversee it all; we would birth projects organically as everyone would begin to see their skills overlap different fields.

My friend, with his brilliant business mind, thinks my idea is stupid and will never work. People become more productive when they become good enough at one task that they can perform it without thinking, that they are reliable and always there to perform that specific task, automation of mind and body. Monotony. I think I might have to disagree with my friend's brilliant business mind. As difficult as it has been to try to be my own type of *gudwerker* in a work world that prioritizes conformity in the workforce, I have learned how to breathe within the mud. How my new company might work, I will figure out only after I take a little snooze nap.

The spider's teeth pierce through my skin as I begin to float up.

TakeBackTheSiesta.com

ANDY ISAACSON

San Francisco, CA

Internal Revenue Service
ATTN: Exempt Organization Screener
Fresno, CA 93888-0002
Re: TakeBackTheSiesta.com

Dear Sir or Madame:

Enclosed please find the following in this case for your information:
1. Form 1024, Application for Recognition of Exemption and attachments.

In seeking exemption as a "social-welfare organization," TakeBackTheSiesta.com is compliant with the following requirements, as outlined by the IRS:

> To be considered operated exclusively for the promotion of social welfare, an organization must operate primarily to further (in some way) the common good and general welfare of the people of the community (such as by bringing about civic betterment and social improvements).

As the enclosed form demonstrates, TakeBackTheSiesta.com promotes general welfare by supporting a social institution of well-being, the siesta.

I must admit, however, that I have never actually incorporated the siesta into my life. After all, I grew up in America. These days I work nine hours a day in a skyscraper in a major metropolitan area. The windows don't open.

I eat take-out lunch, oftentimes in my office, listening to the sounds of circulated air and the drone of desk telephones. At least seven of those nine hours a day I am seated at a desk, eyes gazing at a computer screen, right index finger clicking.

The office I work in has massage chairs. But frequenting them would be perceived as slacking, so they are rarely used. Napping during the workday—or "sleeping on the job," as it is known in our culture—is also frowned upon.

TakeBackTheSiesta.com was born out of a belief that the siesta just makes sense. It honors our bodies and our minds. Rather than devalue productivity, the siesta makes better, happier, and more fulfilled workers. It allows us to better appreciate our food. By setting aside a time in the middle of the day for personal "well-being," it blurs the modern-day boundaries imposed on us that separate work and play. Siestas are taken around the Mediterranean, and it is my impression that they have done something right over there in living the good life.

Please feel free to contact me at the address indicated above if you need further information. Thank you for your attention to this matter.

Very truly yours,

Andy Isaacson

Andy Isaacson

Form **1024**	**Application for Recognition of Exemption**	OMB No. 1545-0056
(Rev. April 1996) Department of Treasury Internal Revenue Service	**Under Section 501(c)3 of the** **Internal Revenue Code**	Note: *If exempt status is approved, this application will be open for public inspection.*

Read the instructions for each part carefully.

A User Fee must be attached to this application.

If the required information and appropriate documents are not submitted along

with Form 8718 (with payment of the appropriate user fee),

the application may be returned to you.

Complete the Procedure Checklist on page 7 of the instructions.

Part I **Identification of Applicant**

1a Full name of organization
(as shown in organizing document)

TAKEBACKTHESIESTA.COM

2 Employer identification number (EIN)

(57A) 93J602-571

1b c/o Name (if applicable)

ANDY ISAACSON

3 Name and telephone number of person
to be contacted if additional information
is needed.

(415) 752-6574

1c Address (number and street)

2001 MAIN AVENUE,
JUST WEST OF THE FREEWAY

4 Month the annual accounting
period ends

SEPTEMBER (END OF
SUMMER, USUALLY)

1d City or town, state, and ZIP code

METROPOLIS, MODERN WORLD 20001

5 Date incorporated or formed

THE NEW MILLENNIUM

1e Website address

TAKEBACKTHESIESTA.COM

6 Check here if applying under section:

a [] 501(e) b [] 501(f) c [X] 501(k)

7 Did the organization previously apply for recognition of
 exemption under this Code section or any other section of
 the code? [] Yes [X] No

 If "Yes," attach an explanation.

8 Is the organization required to file Form 990
 (or Form 990-EZ)? [] N/A [] Yes [X] No

 If "No," attach an explanation
 (see page 3 of the Specific Instruction).

9 Has the organization filed Federal income tax or
 exempt organization information returns? [X] Yes [] No

 If "Yes," state the form numbers, years filed, and the
 Internal Revenue office where filed.

 FORMA 1053K, 1852, SEVILLA, SPAIN
 FORMA 1879J, 1933, OAXACA, MEXICO
 MODULO 456L, 1891, PALERMO, ITALY

10 Check the box for the type of organization. ATTACH A CONFORMED COPY OF THE CORRE-
 SPONDING ORGANIZING DOCUMENTS TO THE APPLICATION BEFORE MAILING. (See
 Specific Instructions for Part I, Line 11, on page 3.) Get Pub 557, Tax-Exempt Status for Your Organi-
 zation, for examples of organizational documents.)

a [**X**] Corporation— Attach a copy of the Articles of Incorporation (including amendments and restate-
 ments) showing approval by the appropriate state official; also include a copy of the
 bylaws.

b [] Trust— Attach a copy of the Trust Indenture or Agreement, including all appropriate signa-
 tures and dates.

c [] Association— Attach a copy of the Articles of Association, Constitution, or other creating document,
 with a declaration (see instructions) or other evidence the organization was formed
 by adoption of the document by more than one person; also include a copy of the
 bylaws.

If the organization is a corporation or an unincorporated association that has not yet adopted bylaws, check
here []

I declare under the penalties of perjury that I am authorized to sign this application on behalf of the above organization and that I have examined this application, including the accompanying schedules and attachments, and that to the best of my knowledge it is true, correct, and complete.

**Please
Sign
Here** *Andy Isaacson*

 (Signature) (Title or authority of signer) (Date)

Part II Activities and Operational Information

1 Provide a detailed narrative description of the purpose of the organization. **Do not merely refer to or repeat the language in the organizational document.** The description should include, as a minimum, the following: **(a)** a mission statement; **(b)** why the organization was founded, i.e., philosophy, history, etc.; **(c)** some argument for why the federal government should lend any support or tax exemption status to the organization.

MISSION STATEMENT

TakeBackTheSiesta.com aims to bring back into modern society that institution of better living and vestige of a slower-paced life—the siesta—thereby saving it from extinction and us from disenchantment.

PHILOSOPHY

TakeBackTheSiesta.com is a nonpartisan organization, but it is decidedly "pro-life"—that is, we urge people to pursue a fulfilling and enjoyable lifestyle although it is one that celebrates social and spiritual values, not just economic ones. We advance this doctrine of *la dolce vita* by helping to slow down the pace of life, by recalibrating the balance between professional and socio-personal priorities. We seek to change consumption as our central preoccupation, our source of purpose and happiness, and redefine our society's view of prosperity. But TakeBackTheSiesta.com is not anti-business (just about reforming it), nor is it an escape to pre-modernity. Rather, it is an attempt to help redirect the path of modern development, thereby saving our bodies from the circadian rhythm of nine to five, five to nine, and saving our souls from disappearing down the information superhighway.

BACKGROUND

As the story goes, Charles V, the Holy Roman Emperor, is said to have perfected the siesta. According to Charles, a truly refreshing siesta required you to curl up on your throne (never in bed)

with a heavy iron key in hand. The minute it clattered to the ground, as dozing turned to sleep after about twenty minutes, it was time to jump up and get on with running the world.

The siesta makes biological sense. During lunch, energy use increases 25 to 50 percent, as the body sends extra blood to the gut to supply oxygen and other necessities for digestion. As a result, more blood flows to the upper digestive tract than to other areas of the body, causing sluggishness. At the same time, the small intestine releases a hormone that activates the part of the brain that controls sleep, inducing drowsiness. Certain foods—especially carbohydrates—also add to this sleepiness at lunchtime; they increase production of serotonin in the brain. Serotonin works both to stop sugar craving and to make you relaxed. A siesta society could replace a Prozac society.

From Barcelona to Buenos Aires, the siesta is dying. The classic siesta—lunch and a little rest at home—has been all but eroded by an accelerated pace of living, the lengthening distances between home and workplace, and heavier traffic in the world's cities. This is partly a consequence of globalization, as foreign business interests have imposed a global business standard, restructuring the cherished slow-paced local business culture existent for centuries in many countries. TakeBackThe Siesta.com hopes to preserve the siesta in societies where it was originally adopted and introduce it into those where it is not.

2 In what way is the organization suited to operate in the modern world? Include to what extent it is adopting modern technology into its practices.

Why the *"dot-com,"* you might ask?

A. The *dot-com* underscores an irony in all of this: while technology is partly to blame for the demise of the siesta, it could also be used to resurrect it. Technological optimists believe that modern technology can replace, in new ways, resources and institutions that are being depleted or altered or eroded by human activity and the forces of modernity. The environment is one example: some hold out hope that technological innovation and enhanced production capabilities can offset dwindling supplies of energy, water, and other declining or scarce resources. TakeBackTheSiesta.com embraces this theory, but with caution. TakeBackTheSiesta.com adopts technology as an efficient way to gather loyalists and disseminate information. Yet while we believe that technology can support the effort to take back the siesta, we don't let that quick-fix approach prevent us from looking for deeper solutions to our systemic problems. In this sense, we hope to use technology as the Zapatistas do in Mexico: as a tool in the resistance against modernity's more destructive by-products.

B. TakeBackTheSiesta.com is symbolic of another phenomenon of contemporary society—the desire to access the exotic and taste the traditional. This longing is brought on by nostalgia for premodern life, to return but without any sacrifice to our comfortable, modern way of life. We want farmers' markets but also Wal-Mart convenience; we want solitude but also cellular access. And we often use technology these days to satisfy this premodern appetite. Witness "adventure travel": technology (in this case, aviation, transportation, and the Internet) allows anyone with disposable income and a yearning for the exotic to get it. For a not-so-low price, "intrepid" adventurers can build a fire in a Mongolian yurt or dance to the *Son* in Cuba. But adopting the siesta into society is more than just taking an adventure travel trip—it needs to be wholly adopted, not just tasted as a premodern experience devoid of any sacrifice to how we normally go about our modern lives.

3 What are or will be the organization's sources of financial support? Also describe the organization's fund-raising program, both actual and planned, and explain to what extent it has been put into effect. Include details of fund-raising activities such as selective mailings, formation of fund-raising committees, use of volunteers or professional fund-raisers, etc. Attach representative copies of solicitations for financial support.

Our organization's financial structure and business model are unique. For every life we reinvigorate, hospital bill we prevent, or soul we save, TakeBackTheSiesta.com will request a percentage of that individual's net worth.

- Business-to-business (B2B) initiatives:
 We will seek cross-promotional and co-marketing initiatives with the following partner organizations:
 www.takebackthesabbath.org
 www.shamansforprozac.com
 www.PLO.org (Postmodern Liberation Organization)

TakeBackTheSiesta Consulting, Inc., will act as our full-service consultancy, advising businesses on adopting "sustainable siesta" practices. We will work closely with our clients as they incorporate the siesta into their corporate culture, offering internal communications and employee training to ensure that their transition is seamless and embraced.

- Business-to-consumer (B2C) initiatives:
 We also plan to operate a full-service online store called *eSiesta,* which will sell Siesta Starter Kits (portable mattresses, cutlery, etc.), beverages (red wine, bottled water), massage therapy, audiotapes (the Lunch Plate Dishwashing series, the Foreign Language Babble series, Ocean Movements series, etc.), and other siesta paraphernalia.

TakeBackTheSiesta.com will also offer seven-day "travel seminars" to siesta societies. These tours are not designed à la adventure travel, and they are more than simply a kind of voyeurism. They are meant to provide the disillusioned modern-type with a sense of perspective, offering social and spiritual education intended to transform. Offerings will include varied tours such as Napping in Provence, Trekking through Italy's Inner City, and Cooking with Mexico's Garment Workers.

Special Fund-raising Program for Quarters 3 & 4: The Hypertension Challenge. TakeBackThe Siesta.com will match dollar for dollar the systolic pressure (the pressure of blood in your arteries when your heart contracts) of any individual donor.

part 3

(Amani Willett)

elating

To: aborofsky@yahoo.com
From: saramason@wesleyan.edu
Subject: hello to all

I am writing a group e-mail to say that i have just spent my evening having dinner with friends who have a new gorgeous apartment on the west end of town, bursting with books and her artwork and the chocolate stains of their two-year-old (named antonia). came back home (a little wobbly after a few beers, i admit) and sat down to clean out my e-mail account. printed message after message, and found myself sitting here reading your incredible words, all of you. making me laugh, cry, sit here overwhelmed with how blessed i am to have all of you in my life.

<s.m.

A ware of multiculturalism, motivated by the women's liberation movement, and wary of high divorce rates, twentysomethings today are forming relationships that are intense, diverse, and mobile. While we struggle to maintain our independence and individuality, we are anxious about ending up alone. In *Relating,* contributors show us how our varied relation-

ships allow us to better understand ourselves. Taking advantage of today's communication technologies and open social mores, these twentysomethings create new ways to identify and connect to one another. Read with x-ray vision, the unique experiences of the contributors in these stories will reveal our underlying common compositions.

Always rearranging ourselves with different people, we are wary of losing our individuality—our markings, experiences, and stories. When we get into our twenties, we want to prove our financial and emotional independence, and we want to demonstrate our individuality, but we do not want to give up on our needed relationships. Some of us are embarrassed if we move back in with our parents, while independent living arrangements are unheard of in most other countries. Leona Graham's statue *Pressure* explores the tactile emergence of a human body from a homogenous block of plaster. Even though we all are made of the same material, we seek to define ourselves apart from the rest, stretching, pushing, at times agonizingly, to create a self that boasts differentiation.

Individuality is a conception. Difference is based on our context and how we decide to define difference. We know that we are Asian only when standing next to a Sicilian, for example; but when standing next to other Asians, we become Korean, Japanese, or Taiwanese. When next to only other Koreans, we become North Koreans or South Koreans. We are told that we are completely individual, that no other person has the same fingerprint. But, then, what does it mean that our genetic building blocks are being manipulated to create exact copies? David and Gabriel Montero in their essay *Misplaced Identities* give us insight into what twins can teach us as the technology of cloning snips at their identical heels. While the goal of cloning may not be to copy individual human beings, the production of genetically matched cells calls our individuality into question. If, with slight manipulations of a micropipette, the infrequent genetic circumstance of having the same DNA as another can be mass-produced, maybe technology is trying to show us that there is not as much difference as we think between us. Although this is exciting, the Montero twins remind us not to completely erase difference and to remember the humanity that comes with theoretical technologies.

The twenties, however, is purportedly the time to figure out who we want to be, how we want to differentiate. This is not a passive process. It happens as we are forced to live out our priorities and responsibilities in the world. Ayisha Knight's poem *Until* and Michael Ellsberg's essay *Juana* testify to how our identities are based on our interactions and relationships with others. Juana helps Ellsberg to become a different person by challenging his notions of sex, while Knight can only truly be herself when she finally finds someone who will accept her as the complex person she is. Loam Akasha-Bast in her essay *Bi20s-WSM* knows all too well that she cannot develop an identity without being in relationship to her daughter. She is a mother first and foremost because that is her priority and her most pressing responsibility.

Technologies have opened up new ways for communicating that intensify our relationships. Sometimes, our ability to talk to whomever, whenever, is overwhelming; Amelia and Jennifer remember how free we felt when we accidentally left our cell phones at home and none of our contributors could contact us. We all know the feeling of seeing our e-mail inboxes filled by the time we return from vacation. We get more done, keep in touch with more people, more frequently, and in less time because technology allows us to do so. This makes even our shortest of interactions burst like a Jackson Pollock painting: paint and texture slapped and poured around us all the time.

But we can often feel lonely even within this stimulation. *Abrupt Doors,* a contribution by Karem Said, is about the transitory spurts of attractions and interactions that occur throughout our lives as we pass one another by. The story takes place in the split seconds when human paths overlap, the moments when we notice the way a stranger holds his or her hands, their reading material, or wears the jewelry that defines entanglement. We often watch one another in passing and wonder what that person could be like. Sometimes we even make a call out to see if they feel the same way about us. Newspaper and community boards know this phenomenon well with the missed connections sections flourishing. Our relationships today are thickly brushed, layered, and pulsating; we worry when they become stagnant.

Due to this hastened pace of life, our increased mobility, and the fantasy that we can do more in less time, there is an explosion of people with whom

we think we could be in a relationship. In this culture of recurrent emotional interference, some have trouble deciding on just one person to focus our time on, much less to spend our lives with. Chato Zapata explores the rise of polygamy as connected to the cultural phenomenon of multitasking, in his essay *Strange Fruit*. Spending our days and nights in a balancing act of tasks, it seems incongruent to rely on only one person to fulfill our every need. We chose this story, in part, because we recognize that the next generation of children will be so adept at multitasking that it may not even occur to them to be interested in looking at its cultural impact.

In addition, these twentysomethings are forming different relationships because they have learned from the relationships of those who have come before them. Looking back on a thirty-year history of high divorce rates (50 percent of all first marriages and 60 percent of all second marriages end in divorce), twentysomethings know all too well that a boy-girl pairing is an unpredictable designation for a successful, lasting partnership. Even though mainstream culture prioritizes sexual monogamy and marriage over singledom and polyfidelity, we are trepid about diving into a two-person interlock. Instead, twentysomethings maintain high expectations for their lifelong partners, with 94 percent of never-married twentysomething singles agreeing that "when you marry, you want your spouse to be your soul mate, first and foremost" and 88 percent believing that the special person is out there waiting for little old them, according to the National Marriage Project conducted by the Gallup Organization. Furthermore, 78 percent agree that a "couple should not get married unless they are prepared to stay together for life." These expectations create pressure during one's twenties to find a person who can be fulfilling on every level. Heather Maxwell's flippant tone in *Commitment in the Zeros* expresses many of these heartfelt sentiments. Like eight out of ten of her peers, Maxwell believes that her relationship is a private affair that needs hard work to sustain, not floral arrangements and wedding cake. Although Maxwell's story does not present an actual critique of the institution of marriage, she expresses emotional reactions that are familiar to anyone who feels tired of continually having to explain why he or she feels different from the norm.

Today, twentysomethings can openly develop relationships that were once considered inappropriate or taboo. Children of the Women's Liberation Movement, many twentysomething women want to secure independence and a career before marrying and having children. We are trying to decide if, when, and how to create families—should we adopt? Do we want to pass on our sperm? Sasha Cagen invents the term "quirkyalone" to describe her breed of happily independent twentysomethings who do not feel that they must form a pair. Although men too can be quirkyalones, it is a new model for women—vibrators and all—that Cagen envisions. An often ignored issue in the past, acceptance of same-sex and interracial relationships among young people is on the rise. It is not unusual that Valeria Weber is the best man at her ex-girlfriend's wedding to another woman or that Saul Williams, despite his upbringing by black-power activists, is in a long-term relationship with a white woman. We look toward expanding the visual images and public discussion of same-sex and interracial relationships because that is the only way that we will continue on the long, arduous path of understanding one another and expanding our visions for the survival of humanity.

Relationships today are not just *inter*—between two distinct entities—but they are becoming *trans,* existing across categories. The transracial offspring of multiracial couples, and transgenderism's present-day biological reality, hold untold possibilities for moving out beyond check boxes on forms. We are transgressing reified man-made borders as we conflate the natural with the technological. As a contributor explained, "I am transcontinental. Which means that my gender has withstood beleaguered boxes, outsmarted bathroom conflicts. I have discerned that human potential cannot be planted in one category. Isn't this world one huge misnomer because we force continents into countries? . . . I am trans. Transcontinental."[1] In many areas of our lives, we blur categories. We have to do this—we are the progeny of the previously defined and categorized, as is every person who is born into a world with names and distinctions. Together, we move toward

[1] Amy Neevel, "TransNational Geographic."

skewing the previously defined by eating broccolini, being boy-girls/ girl-boys, and inserting humans with microchips. Living in these frontiers, in the land in between accepted borders, we question what the categories ever meant to us in the first place, and, if you think about it, we become dangerous to the previously defined.

Along with figuring out our personal relationships, today's twentysomethings could also be at the brink of restructuring the familiar family unit. With marriage delayed until an older age and the number of never-married twentysomethings increasing, friends can replace the nuclear family. As Ethan Watters describes in his essay *In My Tribe*, published in the *New York Times Magazine*, "I discovered along with my friends that finding that soul mate wasn't easy. Girlfriends came and went, as did jobs and apartments. The constant in my life—by default, not by plan—became a loose group of friends. After a few years, that group's membership and routines began to solidify. We met weekly for dinner at a neighborhood restaurant. We traveled together, moved one another's furniture, painted one another's apartments, and cheered one another on at sporting events and open-mike nights. One day I discovered that the transition period I thought I was living wasn't a transition period at all. Something real and important had grown there. I belonged to an urban tribe." This urban tribe that Watters speaks of may be recalling past communes or present day kibbutzim, but, instead of being closed off and isolated, these tribes infiltrate our most populated and influential of cities. We are attached to our friends and develop bloodlines through the conscientious overlapping of identities, rather than genetic probability. One friend coined the term "friend crush," to which both Jen and Amelia can relate, as they actively maintain lists of and contracts with their closest and dearest friends. Popular TV shows mirror our "families" having evolved from the "perfect" family in *Leave It to Beaver* to families with "real" problems in *Roseanne,* to family outside bloodlines in *Queer As Folk* and *Friends.* Donna Haraway, a professor in the history of consciousness at UC Santa Cruz, may have foreseen the future in 1997 when she proclaimed that she is "sick to death of bonding through kinship and 'the family' and longs for models of solidarity and human unity and dif-

ference rooted in friendship, work, partially shared purposes, intractable collective pain, inescapable mortality, and persistent hope."[2]

All the submissions in this part tell a story about how our interactions create the glue that bonds together fragmented individuals. Contributors layer in superposition to create something larger than an individual. We open this part with three submissions that show how malleable individuality is and how our markings change, depending on our environment. David and Gabriel Montero's *Misplaced Identities* and Jamie McCallum's *The N Judah* both show how individuality relies on the notion that our friends and neighbors are always aware of our most personal transitions. Without the watching eyes of others, the changes would go unnoticed and would be essentially unnecessary. The part then moves into various accounts of how our identities are understood and altered through our relationships with others. Saul Williams's essay, *The Unlearning Tree,* discusses the difficult barriers that must be crossed in order to create viable relationships and maintain the continual evolution of the human race. We close out the part with Chato Zapata's essay, *Strange Fruit,* a testament of our ability to form relationships that act out our multiplicity of preferences.

Contributions in this part show the ways we relate as dynamic, mutable, and tinged with nervous anticipation. Like hydrogen that can stand on its own, or share electrons with another hydrogen and an oxygen to form the element water, we are continually rearranging into new social groups by sharing parts of ourselves. In the course of our journeys, it is often surprising what we find in the spaces between our()selves.

[2]Donna Haraway, *Modest_Witness@Second_Millennium.FemaleMan_Meets_OncoMouse*™ (New York: Routledge, 1997), p. 265.

Misplaced Identities:
Twins on the Eve of Cloning

DAVID AND GABRIEL MONTERO

born 6.7.76 Ə୮୮.ə mod

My twin brother, David, and I have always had our own world. Born of an egg twain, as womb mates we knew tight quarters before the concept of space even applied. Experimental from the start, we each tested different strategies for exiting the womb. I led headfirst, diving to meet life's airs. My brother went second, leading with the toes. Later, still satisfied with the idea that opposites should be exploited to test for alternatives, we divided up the task of manual dexterity: I took to my right hand, he to his left—but we lack the data to say that a correlation exists between left-handedness and feet-firstedness. Born in the month of June, we hold the rare distinction of being recognized as Geminis by both the National Science Foundation and the American Association of Astrology Hotlines.

The facets of our twin culture were many and varied: we developed our own language, a rhythmic mumbling whose cadence seemed devoid of meaning to the outside world, but which made perfect sense to us; we performed outlandish interaction rituals that included coordinated and mutual head smashing; and we explored the limits of identicalness, at first dressing alike, then resisting being dressed alike, and finally becoming angry at the fact that we often found ourselves dressing alike. We were mostly angry

because these experiences left the nagging sensation that we were still connected on some subliminal level, perhaps related only to questions of fashion. We set about to test this. Our procedure: one of us would think of a word, and the other would try to guess it. It didn't work. This was as stupid for us as it would be for anybody, but, as a twin, I started to believe that my brother and I could read each other's minds.

Our experience as twins has been a rare phenomenon. But this may soon change. We wonder how much might be different due to a certain specter now appearing on the horizon, a shadowy figure who threatens to change perhaps all things, including the curiosity with which society looks upon twins. We refer, of course, to the prospect of the clone. An as yet unborn idea, the clone is an affront to our twin way of life. Our fascination with him is a peculiar one; with his potential for infinite replication, he threatens to make our twin experience common, even banal. And yet, as natural clones, we cannot help but feel a certain kinship with him because our experience, including all the misconceptions, the joys and agonies, may someday be his. Likewise, the same fear and fantasy that he inspires in society at large, we inspire every time we come into contact with friends and family. Ultimately, because he forces us to question what we might lose with his arrival, we cannot help but feel a certain need for him. He's a point of reference that we've always needed but have never had until now. What he threatens to take away, he repays with a bounty of self-knowledge. Our understanding of ourselves would not be complete without him. So long a mirror to society, twins finally have a mirror of their own.

mirrors ƨɿoɿɿim

The prospect of cloning has no doubt ignited the human imagination, provoking an abundance of sinister and sanguine pronouncements alike. One moment our minds embrace the promise of identical replication—the sheer wonder of scientific advancement, improved life through cloned organs, or the achievement of some brand of immortality. The next, we shudder at the

notion of a landscape overrun with mindless carbon copies, a world of mediocrity in which individual identity dissolves.

Cloning represents a direct challenge to the most sacredly held notions of individuality, threatening to bring new understandings of the self that some are not yet ready to accept. This crisis of identity, only now reaching the level of public debate, is one that twins happen to know particularly well. We not only struggle with it ourselves; we are its living manifestation. And, as such, we are foreshadowing what is to come.

As with cloning, twins inspire great heights of imagination and curiosity. "Can you communicate telepathically?" is a common question, second only to "Do twins feel each other's pain?" Notions of mistaken identity also abound, taking the shape of questions like "Do you ever look at your twin and think it's you?" These are certainly good questions, valid questions that really seem to be asking, "In the absence of a genetic code or a physical appearance that you can call your own, what makes you *you?*" In highlighting the quandary of my identity, such questions bring us to the brink of an important understanding: in a world where identity increasingly defies categories of race, gender, class, location, or creed, our physical appearance has assumed a new importance as an emblem of one's own identity. Appearance is one of the last remaining fingerprints of the self.

I am reminded of a friend telling me that, as a teenager, she found pride in the following fact: despite whatever contrivances life might use to make her feel ordinary, indistinguishable in either character or ability from her peers, it could never dilute the singularity of her appearance. Her unique physical signature was something no one could take away from her. She drew an almost mystical amount of strength from this thought, preserving it as the cornerstone of her identity.

My friend's observation is of course a fairly obvious one, so basic as to seem nearly a platitude. Except that clones and twins stand in direct contradiction to its logic—a fact driven home every time a new acquaintance collides with the reality that my brother and I look the same.

shattering ɢniɿɘttɒʜƨ

You might not think it, but twins—like clones—sometimes make people angry. Mild-mannered acquaintances, even those Spartan fellows whose reticence we have come to expect, suddenly resort to cursing and flailing when they see us standing side by side. Some become frazzled, frustrated, and angry to the point of needing to leave the room. One high-school friend felt affronted by the idea that there could be two where she was sure there was one. The task of revising her conception of me, with each identical gesture and intonation of my twin challenging her understanding of who I was, was too much for her to bear. For others, the phenomenon is as absurd and silly as any amusement they have ever known. The sister of a dear friend could not contain her giggles when she met me. Accustomed to only one of us, she spent most of the evening averting her glance from my direction. Now and then, stifled bails of laughter reached my ear from her side of the table, and I knew that she had risked a peek.

In all of these reactions, we are witnessing a certain shattering, as if a protective layer were suddenly ripped away. Upon learning of my twin brother, friends have reacted with a perceptible sense of betrayal. This happens especially with acquaintances of mine for whom I have become a whole: my gestures, voice, accent, verbal mannerisms seem glued to my countenance, my body movements. This sensation can be abruptly broken upon meeting the unknown twin. Uniqueness begins to unravel, right before one's eyes—a fact so assaulting and unexpected to the mind that most people reel: How could two people have arrived at the same conjoining of body and mind, voice and movement? How could these disparate elements dovetail in precisely the same way, in another person, and just when I was thinking that this was the signature arrangement of my friend? The mind struggles with the barely articulated thought that their friend somehow belongs together with another person. The entire idea of the person as closed upon itself, as having a border to separate itself from its surrounding space, is gone.

My friend's pride in her appearance is something that my brother and I will never fully appreciate. The logic underpinning our identities is vastly

different, for what makes us who we are is not our unique appearance. What irony, then, that our very identities are based on the fact that we look almost exactly identical.

Cloning may well compel us to consider that genes and appearance, like race and gender, are not the exclusive gateway to identity, but part of a façade in which all these characteristics are included.

whole ɘlodw

Friends and acquaintances have often told me that they would like to have a twin: if they had one, they could put it to work, while they enjoyed uninterrupted respite from labor. There are many variations on this same theme. People who have made such remarks seem to forget that, as a twin, they would have grown up with their double, would hopefully care for and love them, and would, most likely, struggle not to use them. Interestingly, people are often thinking about clones when they think about being a twin, when they imagine themselves as *suddenly* having a twin. But having a clone and having a twin are very different things. Clones have a particular purpose, or they can be made to have one: the point is, they await a function, even if they do not presently have one. They are produced, not only from a technological apparatus, but from an equally technological intention. They are produced to replace someone who is dead, or to provide new organs for someone who is alive, or to better the race, and so on. Clones make no sense without an original to serve as a standard of some sort: cloning is an act of production for the purpose of repetition, and repetition requires an original. It is the very act of producing a being for such a particular purpose that distinguishes clones from twins.

When human agency and desires shape the purpose of another's life, they degrade the meaning of that life. We'd rather that our lives be shaped by omnipotent deities or fate or a whimsical universe—so long as we know that our lives are determined and touched by our relationship to something higher, something awesome, even something catastrophic, that possesses the greatness to bring us beyond ourselves. We need to know that our lives as

humans contain these constitutive relations to more powerful forces. The introduction of human agency into the fundamental processes of creation denies access to this kind of relation—even if it is simply access to a relentlessly mechanical cosmic ordering of events and objects. More than denying access, it replaces the universe's potential for creation with that of human desire. It renders the life of any clone hopelessly insular and base, for as clones our origins would never bring us in contact with anything that exists outside the realm of human action and its effects. The mysteries of our creation would only lead us back to other people, and their particular wants, easily discovered in the records and ledgers of cloning corporations. Even those who have heralded the death of god have had to replace him with an absurd and powerful cosmos, rather than admit to the omnipotence of human action. Never challenged by anything of a greater kind than the human being, clones would become mere objects to be arranged for and by the wants of others. As human beings, we are nourished by the mystery of our origins. The great question of our purpose provides us with our sense of mission and freedom. As clones produced for particular wants, I fear that we would be withered from the start by the absence of such questions.

It is not from a horror of statistical encroachment that my brother and I may balk at the idea of cloning. The possible production of clones does not threaten the uniqueness of our existence nor does the ceaseless production of genetic copies in and of itself portend a Promethean theft of humanity. It is the calculus of utility that horrifies us: "Will the clone's kidneys be exactly the same as mine? Will she look exactly like my other daughter? Will the modifications produce a smarter progeny for the family?"

What makes twins special is not the rarity of their existence but the strength of their relationship to each other—or at least the potential for such companionship. As twins, we were given a chance for companionship that few people are ever given. There can be few things as intimate as the time spent sharing a womb. Even now, without actually remembering that time, I can feel the loss of having been separated from someone with whom I was so profoundly conjoined. I walk about, worrying that everything threatens him and, in turn, me. The way the hypochondriac avoids sharp

edges and cold air, I fear that my brother is a potential wound I might discover, part of me and yet beyond the sphere of my will or vigilance.

But this is not what is promised through cloning. There is indeed a similarity between being a twin and being a clone—but being a twin myself, I know enough to know what cloning will *not* be like. It is precisely the possibility of companionship with another person that is denied through cloning—co-opting the purity of free existence in this way threatens the very personhood of the clone and so subtracts one term of the relation.

Reacting to the sometimes cruel pressure of childhood similitude, twins in the dawn of their infancy desperately seek the purity of their own existence to wall themselves off from influences that blur their own outline. As they do so, they find themselves separating from one of the most important sources of strength and solace they have ever known. The realization of such loss will often cause them to return to this source, as we have done after years of adolescent drifting.

It is only now, after we have become ourselves through the purchase of purity, that the full worth of such similitude is recognized. It was an important lesson to have learned: our twinhood would not have survived without each of us first becoming something full with presence with which to bring to each other. Our entire horizon traced the shape of a shared identity, a shelter whose invisible contours prevented us from even seeing the outside it had in store for us. Worse still, there is the more profound and quiet obstacle of dread: dread at the thought of abandoning one's twin. It is perhaps hard for the non-twin to imagine with what sense of profound hesitation and fear I finally admitted to my brother that I had made love, knowing full well that he hadn't yet. And yet, it was only with the traumatic admission of such differences, and through witnessing that such admissions did not bring about any great destruction, that we began to alter the seemingly permanent symmetry that threatened to anchor the two of us. Such disruptions taught us that neither was the original around which the other must fashion himself. Neither complete only when together nor whole when apart. It was nothing short of the discovery of our own purity, by which I mean our right to our own life.

In our current talk of cloning, we seem to think little of the weight of such purity nor do we realize the preciousness of such purity. Twins are perhaps more sensitive than others about the value of such freedom, because the price we have paid for it has been so strangely awful. It is for this reason that my brother and I find cloning so repulsively callous. While not impossible to overcome, I can only imagine the pain it would involve for the clone to discover that it has a right to itself. It's not trying to grow apart from a loved one: it's trying to build a foundation out of thin air.

Whether or not we actually find the moral arguments to support cloning, the era of "conclusive individuality" has been declared at an end. Projecting into the future, we may imagine a time in which the physical and genetic likenesses of people are so common as to go unnoticed. What may ultimately seem strange are that our society ever found such things as twins curious at all. With technologies more readily available to elicit the latent capacity of replication, we will find it harder to escape the gnawing presence of these others within us, around us, these potential clones that each of us right now contains within ourselves. For those who will be clones and for those who understand the reality of these possible others, the idea of possessing a unique identity may begin to seem a bit strange. Conclusive identity will give way to the idea of an identity shared and rounded out by a family of variations, both possible and real, each expressing tones that the others may have missed. No longer confined to the realm of the imagination, these variations are already forcing us to consider that we are not alone even within ourselves. Whatever happens, we hope that our humanity will compel us forward. Our brotherhood as twins has always striven to do just that.

The N Judah

JAMIE MCCALLUM

Claire didn't look like the kind of girl who I wouldn't see for three years, but she moved west to San Francisco to be with her girlfriend soon after we met. She was gone, she was gone, she was gone, in knee-high boots.

We managed to keep in touch though, and in the letters she wrote me, I stayed up to date. I got to know her better this way, who she was, how it is to live in a big city, how the West Coasters talk, stuff about lesbian sex, and what it's like to change your gender.

She left Maine just before my twenty-second birthday and drove twelve hours to Ohio on seven cups of coffee where she picked up a friend who needed a ride west as well. They drove in silence for four more days, under stars nailed into the sky, sleeping on the shoulder or else at truck stops, eating out of Tupperware to make it easier to save the leftovers. They reached San Francisco at night, and Claire drove the other girl to her boyfriend's house and continued on to the Mission to meet her girlfriend Zoë, who was waiting in the house that Claire had never seen.

It was a dark place in the Mission with low ceilings and loud upstairs neighbors. The backyard had been paved over years ago, but some defiant weeds had pushed through the cracks. The front window was big and dirty and painted shut, but it looked right out onto the sidewalk. The good and bad lives of the people who walked by could be seen from the kitchen—all

the terrible and wonderful things people did to one another were hers
to know.

Within three blocks, there were four Laundromats and lots of those
check-cashing places. Life became expansive there. She discovered cow-
brains burritos, mashing the mousse of them to the roof of her mouth,
pushing it vaporously through her teeth, rushing with half-life and protein,
across her gums and sliding them down behind her tongue. Knowing her,
she hoped for a flashback of life, for the animal's memory to suddenly en-
ter her via the cervelles in a glimpse of old wildness. Always something
dramatic.

Claire found two jobs close to her house. The first was at a floral shop,
arranging bouquets for corporate meetings and proms mostly, the second at
a bookstore. The owners of the bookstore were traveling in some faraway
country, spending money they'd stored offshore years ago. The employees
pretty much had run of the place. Often, they'd close early and play cards on
the sidewalk outside or throw jacks against the wall, playing for change. San
Francisco made her happy.

Stuff with Zoë was another story. Living with your partner is hard, they
both agreed. The initial fights weren't so bad, considering they were both
stubborn dykes. Then after a few months, Zoë admitted to an affair with an
ex, and Claire had a fit. There was an argument, and Claire's hand swung
clumsily and Zoë fell down. Neither of them said anything. Zoë entered
into a locking-doors phase and would occupy the bathroom for hours, forc-
ing Claire to use the nearby restaurants' toilets. Sometimes when Claire left,
she wouldn't come home for days, making Zoë sick with worry and regret,
and relief whenever she showed up safe.

One night they got back from the Lexington, drunk and ready to have
sex. Zoë had Claire pushed up against a wall, breathing hard in her ear, with
a hand down her pants, while Claire was still struggling with a fresh pack of
gloves. Wear gloves, the dyke mantra. Everyone is sick and everyone has cuts
on her fingers. Five minutes into it, one of them started crying, which set
the other off. It was like that in those days, something was wrong, but they
didn't know what, hanging in the air like the sound of a whistle that only
dogs can hear. In another life, she'd have stayed back East. Her parents were

always telling her to come back when she would call crying. But what sucks most about the past is that no matter how stupid it seems that you can't erase it or change it, you can't.

That winter, snow piled sideways against my house in Pennsylvania, the wind rattling our shutters, the cold freezing our windows shut like heavy eyes. I was laid off from the landscaping place I worked at on account of the frozen ground and spent three months collecting unemployment, which was just fine with me. It was the worst winter that had been recorded in years, and supermarkets were full of panicked people stocking up on canned goods and battery-powered everything. Those days I hovered just above everything I would become, between unemployment and come what may, always in danger of careening backward into the past.

At the same time, nature was fucking with San Francisco, too, and Claire was slowly becoming a boy. There's barely an explanation for the strange evolution of her photo album that doesn't seem obvious. It's like growing up a boy only faster, and after having grown up a girl. Your voice drops from the injections, your natural hormones are purged and replaced, like in a blood transfusion. Thick, coarse hair creeps around your face like a rash faster than you'd think. Sometimes you lose a little hair off the top of your head, sometimes a lot. You sweat a little more and smell different, and you gain weight in other places.

These days Claire lives a not-so-polished performance in a bizarre theater of one. But no one transitions alone; the whole world watches. The first few months she'd wake sweating and cold, with nightmares about the recent carcass of her past threatening to reenter her body like a ghost. The body of a woman hung in front of her, persistent and annoying like bangs. Every minute she feared a lapse in the act would send her spiraling months backward into some horrible nightmare land, not to mention draw stares and frowns from the mean, unbelieving world. Out of fear and obsession, she spent most nights naked in front of the mirror, searching her body for changes.

There's a ridiculous pageantry about changing your gender. Claire's life became a huge public dress rehearsal, but she learned to enjoy the privilege of the company of men. Guys began to strike up oafish conversations with

her about sports and girls. Within six or seven months, she was walking in and out of men's bathrooms unnoticed; the friends she still had referred to her as "he" or "him," although the fight for a new personal pronoun still flares up occasionally. And, after three years, there's still a big fat "F" next to "sex" on her driver's license.

See, I'm a failure, she told me later, and laughed, showing me her ID, which had a man's picture on it. Fuck the DMV.

But Zoë couldn't deal. She was a dyke and wanted to have sex without a dildo. She wanted her girlfriend back. The end of their relationship was a long slow slap in the face. One of the last nights they spent together, Zoë put Claire's head into the corner of a door just for kicks, the way a big brother picks on the younger one. Then one dark early morning, Claire put together a small bag of clothes, makeup, and supplies, and left the house while Zoë was sleeping. She briefly considered writing D-U-M-P-E-D in backward mirror writing on Zoë's forehead so that when she awoke alone and stumbled crusty and alone into the bathroom to brush her teeth, she'd freak out. But there was already enough drama to make any more, so Claire left quietly, with no note, in the car that brought her there, and headed for the houses of sleeping friends until she found someone who woke up when she knocked.

About that time, she stopped writing and I lost track of her. Her old phone was disconnected. Her parents knew nothing about her whereabouts. Later, I learned that she did a stint as a librarian, a bank teller, and a barista. She put some work in a local art show and published a small book of poems. But that was later.

It'd been almost three years since we met, and next thing I knew I was moving to San Francisco to take a desk job at a small political magazine. I was given my own cubicle, my own computer, and my own bulletin board. Electric pencil sharpeners were at a premium, I was told, so I shared one with the accounts-receivable person in the cubicle next to mine and with the copy-editor nerd in the cube behind me. I could not, however, share my personal code for the copy machine, or else the privilege would be revoked. I might even be fired.

I rented a small, dank studio on the outskirts of a downtown neighbor-

hood. The air quality in my apartment was one or two notches below what you'd expect to find inside a chemical fertilizer plant. Besides the basic locker-room/horse-stable type of odor, the apartment gave me the impression that something very bad had transpired there just before my entering. Consequently, I spent my first weeks wandering friendless around better-smelling parts of the city, returning home only to sleep.

One day I set off like a pilgrim in search of Claire. I wrote the most recent address I had for her on the back of my hand and almost sweated it off before I got there. I said "knock knock" aloud to myself as I hit the door.

"Is Claire home?" I asked, even though I had doubts. The girl who answered shot me a confused look and shook her head. "I'm Jamie, a friend from back East," I said. "Are you Zoë?"

These days, almost no one just knocks on doors. No one that you want to talk to anyway, but she nodded and invited me in. Zoë had been traveling for a year, but the person subletting her house had to leave so she came back. She fixed sandwiches and we sat and ate and talked about Claire—which is how I know the rest—reliving an event that seemed so far from life.

Claire had long since moved out and moved on. She'd been dating and working, Zoë heard, and hadn't been back to pick up the rest of her stuff. I lifted a picture of Claire off a desk. She was a girl in it, with a slash of long dark hair that caught light like water, and deep-blue and black-flecked eyes. She had a cute smile that made her look like some sarcastic bright bird.

"That's not her anymore," Zoë said. "She didn't even lock the door when she left. Her keys were on the table. I didn't hear her get up, but I remember thinking I heard the shower running. Don't know if she used it before she left or not. It was cold in the morning because the door had swung open, so I woke up early, and she was gone. I waited around, thinking she'd gone for breakfast, or for a walk. Then I saw her things were gone and I knew what happened." Zoë rolled her eyes and waved at the air, as if the past was a wasp, and leaned back in her chair. "Claire left everyone; she even warned me of it. Nothing could ever make her stay too long. But no one had ever left me before, so maybe I learned something from it."

I understood Zoë; it was unsettling. Do we all bear a wet seed inside of us dying to split into something new? What young girl carries a man's body

beneath the surface without seeming preposterous? I too couldn't help but feel a bit betrayed.

"Did you see it coming?" I asked, and immediately regretted asking. She shrugged helplessly. Who sees it coming?

Before it got too dark, I got up with a few leads as to where Claire might be. As I left the house, Zoë said, "His name's Jonathan. Don't call him Claire, he hates it. And say hi for me."

A few weeks later, Jonathan and I met for coffee at a café at a crossroads between neighborhoods. We talked a little about the change, much of which was still a work in progress, but there was no sense in going through it all again. Besides, things have a way of returning; there was no need to recall the past with nostalgia.

The day I saw him, he was on his way out of town to his sister's wedding back East. His sister had been nagging him to wear a dress and be a bridesmaid, he said, and he was stressing about it. He looked like the kids I grew up playing sports with in high school. I hadn't seen the slow progression, just the before and after. He actually made a passable boy. A little on the short side. He was nervous about going home; they too hadn't seen him in as long of a time as I had not seen him.

We were sitting there, with the coffee machines thrumming and dripping, and he was saying how maybe he'll come back, or maybe just go south to Louisiana and live with a friend for a while. He wasn't sure.

I nodded. There wasn't much to talk about. It was awkward.

So why all of this now? I don't know. I was new to the city, didn't know anybody. It was right after a terribly long breakup with an ex-girlfriend, which I can't go into now.

There was a long, deep silence. I started to feel like I was annoying him, but then he leveled his blue eyes at me and said, "Remember all those letters I wrote?"

"I remember," I said.

We talked about the letters a while, which somehow grew into discussing his bizarre plot to douse the city water supply with testosterone, because the shots are so expensive. Then out of the blue he said, "I hate my phone number," and leaned his head against the café window and closed his eyes. It was

raining outside, one of those endlessly accumulated days that you know you will always want to go back to, so you concentrate on remembering it. I can still taste the mulch smell coming from the wet park nearby. We got up and took the N Judah back to his neighborhood, where his car was parked. We hugged good-bye, and then Jonathan moved across the pavement to a blue sedan and headed for upstate New York, to the house he grew up in, on a corner lot in the center of the neighborhood, between Euclid and Ostrum Avenues. I asked him why not fly, but he needed the time. He could have made it in three days if he got on 80 East and never looked back, and I like to think he took the direct route. Instead, it's more likely that he weaved slowly through the small roads of the west, roads that are difficult to get off of once you're on, knowing that going home is always hard, and this time would be harder. Right now, he's somewhere between here and there.

Identity

ANDREA GREGG

Until

AYISHA KNIGHT

Until last night
I was missing
the key
to the place
I forgot
existed.
Until last night
I was afraid to
express myself for
fear of rejection,
retribution
from those who say
I'm not deaf enough because
my English is too good,
not Black enough because
my mother is white,
not Jewish enough
because my skin is black,
not Cherokee enough because
each generation gets divided in half.

Some see me as not straight
because I share my life
and love with a woman,
but there are others who
are quick to let me know,
I'm not lesbian enough because
in the past I've loved a man.
Not enough
labels to go around.
Not enough
STRENGTH
to say ENOUGH!!!
Not until last night,
when I raised my hand
and reached through the
looking glass
to touch the
reflection
of she who was me,
a naked girl
running free
loving my body until
drunk uncles
started loving me too.
Believed all women
would stand and walk tall
until I saw my mother
crouched in fear against the wall
searching for protection against
an uncontrolled hurricane
of misunderstood emotions.
Sliding-glass doors
shattered by rage
set the stage

as I moved forward
never looking back,
creating an armor of flesh,
buried memories,
and a silent tongue.
Years disappeared
taking with them
denied emotions,
until I could
no longer
remember,
where this seed
of rage and fear
first appeared.
Until I started
on the path away from
self-destruction
and caught glimpses
of the flame inside,
uncovered when the
masks came off
in games of peekaboo,
I see you.
Grieved for my absent father
until I removed his pedestal,
finally understanding that
he was simply a man.
Believed I was a
rape victim
until I owned the word
SURVIVOR.
Hated my feminine curves,
the roundness of my belly
until I got it pierced

and let myself revel
in its decorated beauty.
Confined myself to an
invisible cage,
until I decided
to move and be free.
Until I left DC
until I moved to JP,
until I met strangers
soon to be friends,
until I met the woman
who loved me
and held me with
open arms,
until I faced the
haunting fears,
until I took a chance,
remembered,
and transformed myself.
Until last night,
when I opened the doors,
and the women said,
"Hey sister,
welcome home."

Juana

MICHAEL ELLSBERG

She came up to me at the party and asked me about the music. I was handling the music for an hour and had just put in some Cuban salsa.

She liked the music. She was Cuban—born in Miami, short with shoulder-length, jet-black hair, and cherry-red lips. She wore a tight black-lace dress.

She was the most beautiful woman I had ever seen.

I realized, while talking with her, that I had seen her a year before, in a play. Then, too, I had thought she was the most beautiful woman I had ever seen. I had thought about how to meet her, but then I had read on the program that she was seven years older than me. I figured there was no way she'd be interested in me, even aside from her looks.

But now here I was, talking to her. I do not think I have ever said more than five words to a woman this beautiful.

She sipped her sangria. "This stuff is disgusting."

I declined to tell her that I helped make it. "There's some nice wine in the pantry," I said. We walked over. The bottles were empty. "I have some Cuban rum in my room," I said.

Her eyes lit up. "I'll trade you some speed for it."

"No, no, that's okay."

All of this flirting at the party may seem like normal behavior for a twenty-two-year-old male, but it was not for me. At that time, my view of the correct male gender role was the "sensitive male"—the open, friendly, supportive man who shares hugs and tears with his group of female friends. I didn't go out and try to "score," because I considered it an expression of predatory male sexuality in a patriarchal culture. I viewed dating as a superficial preoccupation of people who did not understand the urgent attention that the environmental crisis needed.

These are, no doubt, unusual views for a young male. People often wondered how I came to them. The answer is my old high-school English teacher, Frank Adams. Mr. Adams, a Rhodes scholar, was a walking encyclopedia of facts and statistics about the inequalities, violence, and oppression of the modern world. He was not a Marxist but, rather, an ecofeminist. This theory, which emerged from the radical environmental and feminist movements, holds that male oppression of women and human violence toward the environment stem from the same source: patriarchy. Mr. Adams was never as dogmatic about his political views as I became. He had come to his views on his own. He always presented well-supported arguments to support his claims. He was an impressive man. I worshipped him.

As I read more about ecofeminism, it became my dominant philosophical viewpoint. Because ecofeminism posits psychological roots (the ideology of patriarchy) to the problems it addresses, it also posits psychological solutions. The key to undermining patriarchy, according to ecofeminism, is to undermine the patriarchal thought structures within our minds. If I walked down the street and I felt sexual desire for a woman, I felt guilty. After all, I did not even know her. Therefore, my gaze reduced her to a mindless body, an object for my male sexual consumption. I felt that if I eradicated this and other patriarchal thought patterns in my mind, I would contribute to the eventual downfall of patriarchy. It was psycho-therapeutic guerrilla warfare.

Needless to say, I was not very successful with women. I thought if I was a kind, sincere, and supportive male, one who did not "play the game," I

would find an honest, sincere, politically committed woman who would want a relationship with me.

That never happened. I had lots of girl friends, but never any *girlfriends*. I once saw an ad for cologne in *Esquire,* which read, "Do you want to be the man she tells her deep, dark secrets to, or do you want to *be* her deep, dark secret?" I was definitely the man to whom she *told* her deep, dark secrets. "Why don't they ever go for nice, honest guys like me?" I wondered, after being passed over in favor of yet another macho clod.

I wanted sex desperately, yet I felt guilty about even feeling this desire.

"There's something about the word 'fuck' that just isn't okay. It has this tone of violence," Richard said. Richard had been a fellow student of Mr. Adams and my sole comrade in ecofeminism. We had remained good friends ever since. It was a few weeks before I met Juana at the party, and I had used the word "fuck" in some sentence during one of our epic ecofeminist political discussions. Upon hearing this, Richard told me not to use that word anymore.

"What do you mean?" I asked.

"Well, look at how it's used. When guys say 'yeah, I fucked her,' there's this element of conquest, of subduing the feminine body," he said.

"Look, there's a lot to be said for tender lovemaking. But sometimes you just want to *fuck*."

"There's nothing wrong with that kind of sex," he said. "But something about the word 'fuck'—it just adds this tone of rape to it."

"But if *she* wants to fuck? How can it be rape?"

"I'm not saying that 'fucking' is rape. I'm saying that the word itself has a subtle connotation of rape. I think it comes from a word that used to mean 'to kill.' And in some tribal languages, the word that functions for them like 'fuck' is also the word for 'to hunt.'"

"But word meanings can change," I said. "No one means 'to kill' or 'to hunt' anymore. They just mean . . . *to fuck*."

"I'm just saying that the word 'fuck' itself has unhealthy connotations and that I don't think you should use it so much."

I couldn't believe it. How many twenty-two-year-old males have had serious discussions about the appropriateness of using the word "fuck" in light of its perpetuation of patriarchal gender relations? For that matter, how many twenty-two-year-old *females* have had that discussion? I felt like something was out of place. "I think we're not acting like regular twenty-two-year-old guys."

"Well, if we really want to act like regular twenty-two-year-old guys," he said, "we can go out and get drunk and get laid and give up on politics altogether." He had a point. But something seemed wrong about erasing words from my vocabulary because they had subtle etymological associations with the dominant culture that Richard and I hated so much. I guess we already did. I never joked around with the word "nigger." But "fuck" doesn't have all of the immediate negative connotations that "nigger" does. It just means aggressive sex. Meaning is based in use, I tried to convince Richard. Do my political values need to be reflected in every aspect of my daily life, in my every word? Richard would say yes—anything less would be hypocritical.

Later in the same discussion, Richard expressed to me his guilt about liking Led Zeppelin. "I mean, I like the music, but it's so violent. It's definitely part of the culture we're trying to change. I'm sure Mr. Adams doesn't listen to it. I doubt he even wants to."

At that moment, I asked myself: "Does my political orientation need be so all-encompassing that I police what kind of *music* I listen to?" It suddenly seemed totalitarian to me or, more accurately, puritanical—the need for everything to be positive and uplifting, to have a good message; the guilt and self-loathing at pleasure for pleasure's sake. It was like Stalin's state-condoned "Socialist Realism" painting style—facile, didactic, and always with a readily grasped moral, usually concerning the virtue of the proletariat and the glory of cooperation. It was some of the worst painting in the history of art.

"*Screw this,*" I thought. "I'm going to go get laid." It had been two years since I had even touched a woman.

Once we got to my room, Juana sat down on my bed. I found out that she was a Ph.D. student, which added to my nervousness. The phone rang.

It was my friend Kate. I forgot that we had planned to hang out that night. Fuck. I didn't know what to say. If I told my friend that I couldn't hang out with her, I would have to explain why, which would be a thorny path with Juana sitting right there.

"Yeah, I'm hanging out with a friend, drinking, listening to some music. Want to come over?" I said. Great. A gorgeous woman was sitting on my bed, and what did I do? I invited one of my best friends, a "platonic" female friend to whom I always complained about not being able to meet women, to come hang out.

"Who was that?" Juana asked.

"Oh, just a friend. She's coming over."

Juana looked disappointed. Kate came in. I introduced them and put in some music.

We sat around, talking, sipping Cuba Libres, listening to the music. After a while, Juana had to go. I gave her my phone number. She gave me hers. She told me to call.

Should I call? I'm seven years younger than her. . . . She could probably get any guy she wanted in the world. . . . Why would she be interested in me? . . . But, she was flirting with me—I'm sure that was flirting . . . And she did give me her phone number. . . .

"Hello?"

"Hi, Juana?"

"Yeah."

"This is Michael Ellsberg. We met last week."

"Oh, hi, how are you?"

"Good, thanks. Listen, I'm going to this rave thing downtown on Friday. I was wondering if you'd like to join me."

"I'd love to. Where is it?"

"This club called Generation X. I've never been, but it sounds good. It starts at ten, but we should probably get there a little later."

"I'll pick you up at eleven," she said.

Kids dancing to techno music filled the club. *Thump thump thump thump thump thump thump* . . . We went out onto the floor to dance. She wore a short-cut white cotton dress that draped lightly over her body.

Juana was, as far as I could tell, the most gorgeous woman in the room. All the men eyed her. For the first time in my life, I felt envied. She bumped into a few female friends, and we danced together in a circle for a while. Juana grabbed one of these girls and started dancing with her closely. Soon, they were grasping each other, rubbing up against each other, practically making love on the dance floor. *Thump thump thump thump thump thump thump.* The two disentangled, and the girl and her friend went off into the crowd.

"THAT GIRL HAS A CRUSH ON ME," Juana yelled into my ear, leaning into me. I smiled.

It was time to make my move. I have figured out that the only time when neuro-impulses sent by the brain do not translate into movement in an appendage is when the brain is ordering a young man's arm to go around a girl for the first time or to hold her hand. You feel the brain commanding the movement, but the limb just sits there, dead. So, I did what I used to do in middle school: *one, two, three, four, FIVE!*

I reached over and grabbed her hand. She came close to me. I put my hand on her back. She wrapped her arms around me. I felt her chest press into mine. She pulled me tighter. I leaned down and smelled her freshly washed hair.

She stood up and moved her face toward my ear. "LET'S GO GET SOMETHING TO DRINK," she shouted.

"SURE."

She marched me by the hand into the other room. I was nervous—surely every other man in the room thought, "What's a girl like *that* doing with a guy like *that?*" But, she seemed to like me, so I tried to play cool, like I hung out with women like Juana all the time.

She went to the counter and ordered two vodka tonics, then we sat down on a couch in the corner. We small-talked for a while. Then she grabbed an

ice cube out of her glass and started tracing my face with it. I leaned toward her and kissed her on the lips. She kissed back.

Kissing turned to necking. The music went on—*thump thump thump thump thump thump* . . . People standing around us, chatting with their drinks in hand and their cigarettes, eyed us. At every party I've attended, one or two couples always sat in the corner lip-locked the whole time, and everyone around them would make nervous little comments such as "Well, they're getting started early" or "I guess *they* hit it off." Well, for the first time in my life, I was that person in the corner. It felt great.

"Shall we leave?" I asked. She nodded.

She drove a two-door sports car. Nothing too fancy, but certainly classy.

She lived where the "nice" part of town fades into the poorer, more run-down section.

After she showed me around, she poured us some red wine and went to the freezer for a pint of strawberry ice cream. We sat down, close to each other, in front of her television. She put in *Star Wars*. We sat there, feeding each other and drinking wine. Pretty soon, we were feeding each other with our mouths. I turned off the TV.

"Shall we go to my room?" she asked.

I got up and started picking up our things.

"Don't worry about it."

She led me to her room. We kissed in the middle of it. I turned off the light, and we collapsed on her bed.

Diamanda Galás, a vocalist, was giving a solo concert in town. I had never heard of her, but I was drawn to the concert by her picture on the ad—jet-black hair and dangerous eyes. One of the review snippets called her performance "the most harrowing experience in a lifetime of concert going."

A sole piano and microphone stand set the stage. The lights turned off. The room sat pitch black except for a small light on the music stand. After a brief silence, a tall, slim figure in a long black dress came out. Applause. She stood in front of the microphone, silent for at least a minute. Then from

out of the speakers emanated the most spine-wrenching, shattering shriek I have ever heard in my life. About fifteen people got up and exited upon hearing this one note.

I had never experienced such darkness in a work of art. I had seen plenty of art to which the word "depressing" might apply, or anguished, tortured, anxious, apprehensive, cynical, pessimistic, misanthropic. But this music was *dark*. Amidst cries and shrieks, Galás belched out guttural sentences and spoke demonic tongues in a low raspy voice. More shrieks and cries, and then she would dive into what sounded like long passages from biblical liturgy in Romance languages, mumbling in the tone of Catholic priests. Then, shouts of a dialogue with herself: "Shut up! No! Shut up! No!" Then, "Fuck me! Fuck me up the ass! Yeah, up the ass!"

I learned during the intermission that Galás had spent part of her life in a mental institution. Her brother, a gay man, had died of AIDS, and much of her music deals with her institutionalization and her brother's death, the program said. Strangely, I found her cacophony *beautiful*. Not beautiful as in "the opposite of ugly"—the music was quite ugly. But beautiful in that it was perfect—perfectly dark.

Galás made an impression on me. She defied my cherished categories of "political" and "nonpolitical" behavior. She was obviously very political— she had even been arrested for staging a group "Die-In" at St. Patrick's Cathedral to protest the Catholic church's stance toward AIDS in the Third World—but she didn't care much for political piety, especially feminist (or ecofeminist) piety.

The standard ecofeminist line on sadomasochism, for example, is that it represents an extreme internalization of the hierarchical relations of patriarchy, so that individuals living in patriarchy actually come to enjoy the experience of being dominated and controlled, or of dominating and controlling others, and come to experience it as sexually exciting.

In an interview, however, Galás offers a different opinion:

"And this is the domain that people who worry about being politically correct don't address: the realm of exciting, even violent sex between consenting adults. Most people think sex should be gentle and peaceful. But if

sex is merely gentle and peaceful, I'm not even *interested*. Of course, I mean 'play violence'—I'm not interested in ending up with a broken jaw . . . I like the man I'm seeing now because he'll say, 'You filthy fuckin' white whore, that's all you want, you piece o' shit!' and I'll say, 'Listen, you black mother-fucker, I'm gonna take you by the chain and lead you through the streets!' That's the way we'll talk to each other—any way we damn please! Not with this wimpy, politically correct 'discourse.'"[1]

An ecofeminist might say that this attitude merely confirms their inter-pretation of sadomasochism—that Galás possesses the ecofeminist equiva-lent of Marxian "false consciousness" (i.e., that she is completely unaware of her own state of mental subjugation). This may be true. Obviously, Galás does not care. She does not apologize for who she is. She refuses to tailor her psychology to the "correct" standards of feminism. "I like strong women," she says. "Women who aren't ashamed if they *don't* listen to folk music." Her worldview disturbed me, but her honesty impressed me.

I had a date with Juana the next Friday for a costume party the night af-ter Halloween. I didn't have a costume, so I put on all my retro seventies clothes at once—I looked sort of like a cross between a sleazy pool shark and a pimp. She planned to go as a dominatrix. When she arrived, she wore a short black skirt, black boots, and a black overcoat. It looked like her nor-mal clothes to me.

When we got to the party, she took off her dress. Underneath her dress, she wore a black rubber G-string and a whip. We met Marta, who wore a black rubber miniskirt, and Marta's tall boyfriend, Ortíz, with black leather pants, a bare hairy chest, and a spiked dog collar around his neck, connected to Marta by a leash. They were the skimpiest-clad trio in the room. We all danced for a while, and *everyone* watched us. I tried to keep my cool and pretend confidence, like I go to S/M orgies all the time.

[1]Diamanda Galás, interview excerpt from *Angry Women,* ed. Andrea Juno and V. Vale (San Francisco: RE/search Publications, 1991).

The time came for the costume contest. The contestants were a man in a shower curtain, a Brady Bunch group, and a Thor impersonator. And Juana, Marta, and Ortíz. They pushed into the center of the crowd, and Ortíz dropped to the floor. Marta pulled on his leash, and he barked like a dog. She whipped him. He licked her legs up to her inner thigh, and she whipped him again. Then Juana whipped Marta. Then they all came into a pile of whips and chains and orgasmic yelps in the middle of the room. Most of the crowd were stressed-out grad students in their standard grad-student tweeds. They clutched their glasses of wine apprehensively in their fingertips.

Their faces were blank. One male medical student standing next to me turned to his friend and said, "Those aren't grad students like I know!"

After the contest, which they didn't win for some reason, I congratulated Juana. We all left, arm in arm. Marta and Ortíz went their way, and Juana and I went back to her place.

We started seeing each other regularly. On Friday nights, she would pick me up, and we would go out somewhere, then go back to her place and stay up most of the night, then sleep in past brunch hour and spend the afternoon in bed.

We never went out on a Saturday. She reserved Saturday nights for going out and "picking people up," as she put it.

Once, she showed me her closet. She owned a full rack of whips, chains, leather and rubber outfits, and other bondage supplies. She invited me to try a nipple clamp once, but it hurt too much. "Sex without pain is okay," she said, "but to really enjoy it, I need pain."

She went out to bars and parties more nights than she didn't. She also had to read a book every other day for her Ph.D. program. She didn't sleep much. By the time the weekends came, she was so worn out that she had to take drugs to stay awake for more partying, which she could not miss. Aside from a few nights when she looked like a ghost, though, she seemed to manage it all pretty well.

I too started to do more things just for fun, not because they made a political statement. I stopped feeling guilty if my actions did not conform to the correct ecofeminist standards, without abandoning my political commitments entirely. I was becoming and am still trying to work out the par-

ticulars of being political without being a Puritan or a prude—a hedonist with principles. Or, rather, a principled person who knows how to have a good time.

"I've been thinking. I don't think I want to see you anymore," she said.

"What?" It was the week after Thanksgiving, and I had called to make plans for the next night.

"I don't want to see you anymore . . ."

"Why?"

"You're too young for me."

"We don't need to go out in public . . ."

"It's not that. It's just that . . . I want someone more experienced. I need someone darker. And you need someone lighter."

"What's that supposed to mean?"

"I want someone who wears black, who's into S/M. I feel like I always have to be so positive around you. Like your vegetarianism. I just don't give a fuck about that shit. I really don't."

"Can't we at least meet and talk about it?"

"Look, I don't want to see you again, okay?"

"But . . ."

"I hope I didn't hurt you." CLICK.

We had seen each other exactly eight times. Our month-long relationship had been completely meaningless and politically incorrect. The only reason I saw her was that she was gorgeous and willing to see me, and the only reason she saw me was that I was young and she called the shots. There was no emotional attachment at all, no love. Just mutual pleasure.

It had been the happiest month of my life.

Pressure

LEONA GRAHAM

Abrupt Doors

KAREM SAID

A forced sigh emitted. Body knocking against body; standing room only on the 30—caught near Market, wove through Union Square into China Town, but just before North Beach she got a seat. And what a seat . . .

This is the loneliness of our Hollow City pushing me closer to the edge—some brink that has me, can I say enjoying?, the warmth of the leg next to mine. How I love big squishy types, human pillows—the closest I get to touch these days.

And here, miraculously, a seat opens up, almost glowing, angels singing, for just next to it sits a man with good hair and stylish glasses.

I am a self-proclaimed sociologist, of sorts. At least, I believe I can pin 'em down, categorize a given personality on the spot, instantaneously make assumptions about her or his habits, inclinations, sometimes occupation (general field), and tone of voice.

Vibes.

But it's all demeanor and dress. Possibly, some sixth sense? Well, modish glasses, good hair, and reading a book are just what I need now. Calm karma, patience I see, thoughtful. His hair is dark and just long enough. But after the past week of forty- and fifty-year-olds falling all over me, I need some re-

assurance that I am not a dull librarian type, with bookstore work and all. So the best part of this empty seat, besides the man sitting next to it—him with the window, but looking down at book—is the man's age. A mid- to late-twentysomething. I seat myself with grace, with poise (like I never can, because the start and stop of these buses are of earthquake proportion—and who can blame these drivers with torturous jobs, like Sisyphus, like *Ground Hog Day*)—but, my timing is perfect, sitting before the driver slams the pedal, before the bus lurches forth, and immediately I love this seat: He looks good, he reads, but God, he smells good too! I look at his book for title atop page but, seeing none, continue to enjoy his peripheral presence. The fine quality of his camel-colored sweater, seamless stitching, the warmth he emanates. His aura mossy-thick as he grows on me (and he does). I think of the theory that attraction somehow stems from the nose. Pheromones. We find certain body smells more attractive than others, and that is how we primordially seek out mates. The magnetism is more than "Hey, nice glasses," and more guttural, as in "We must create life!" (yet somehow toned down and subconscious, because we live in a society skeptical of love—a place where love and sex are separated in cynical ways).

The air near our seats is taut, scarcely breathing. And it's then that he raises his hand to touch the metal bar directly in front of us—the one that separates our seats from the double doors that open abruptly, always, even when you're impatiently waiting for them, staring just above for a green light, shouting "Back door!" because all but the front doors are back doors. And he just holds his hand there, letting his golden (cycle of life, traditional, I'm-an-adult jewelry commercial with Four Seasons playing in the background) wedding band speak volumes. It's too intentional—(must be uncomfortable)—the closest we've gotten to actual, verbal communication. His statement takes a long time in its utterance: I stare in disbelief, more at his insulting audacity than at the ring. He just holds it there, and so I respond with the cold shoulder. Return to my book, look up toward a window occasionally. Offhandedly.

Did I mention about the book? *Run River*, Joan Didion. Her first novel, my thinking it very impressive in its obscurity, because who reads the fiction of an acclaimed essayist? That was another vibe—his need, like mine, to be

perceived as unique. (Actually more important than his age.) But I gave evidence that I was so disinterested now that maybe it had always been that way. He'd been wrong about my careful posture, and the way I'd pulled my book out, only after looking over at his.

Eventually, I convince myself that it's gotten "old." I'm only dimly aware of who's sitting next to me. It's just me and my novel. And then, he puts away his book—more communication, which of course means, "Heads up, I'm getting off soon." The laborious rustling of papers is clearly meant to alert me to his departure. But I refuse to recognize his effort and continue reading, unfazed. At his stop, he rises; I move over without looking up. He slips past and gets off. It's that simple. If only—and this breaks my heart—he hadn't picked up a portfolio bag on his way out the door.

(Bag: The kind you see in art stores and, if you're like me, wish you'd created enough paintings or drawings to be worthy of such black, nylon, canvassed creativity encasement—like professional instrument cases that sheath silver and gold in definitive black, implying espionage made casual by the shallow undulation of fabric but made elegant by shine and what's inside.)

So he's an artist, I thought. And I couldn't help staring as he walked away in my self-imposed, choreographed slow-mo—he never looked back.

Commitment in the Zeros

HEATHER MAXWELL

Marriage is a sham. I knew it the moment I was conned into the role of flower girl at seven years old. Trotted out as a frothy little love mascot for a happily wedded pair. It turned out they were destined to happily part ways as quickly as you can say "two-car garage." That wedding was just the first in a line of events that would shift my views on nuptial bliss. Along with the years, as ridiculous weddings and crumbled marriages have flowed by, I've decided that society's "sacred institution" is nowhere near sacred.

Lucky for me, my partner shares my admittedly cynical views. The wisest thing to do in our era of divorce court and *Divorce Magazine* is to move in together, try your best, and hope it lasts. There's a fear among many in my generation that once you get married, you've begun the rapid no-turning-back descent into the Gap-shopping, SUV-driving, condo-owning vortex. You might as well go full throttle into mediocrity. Underneath those image-conscious layers, however, is a pure and unadulterated reluctance to make our parents' mistakes.

Like many people my age, my parents have long been divorced. I think that nosh on love's bitter pill was one of the best things that could have happened to me. It was a dose of real life. It helped me clear the fairy tale floating around my brain about being whisked off my feet into some doe-eyed stupor. I ditched the "Love Boat"–inspired daydreams about lasting unions

formed on four-day Caribbean cruises. I saw that people had to work really hard to maintain a satisfying relationship. The concept of healthy love had been introduced.

When I was sixteen, I announced to my family that I was never getting married. My parents told me they respected my decision but secretly smirked at my premature vow. Like most teenagers, I was obnoxious and liked making proclamations that I would forget after a few months. Nearing thirty, after ten years in a steady and loving relationship, I am still obnoxious, still making proclamations, and still set against getting hitched.

I can hear the die-hard traditionalists now, wishing I could see the error of my ways. Well, maybe this will help the purists understand my cynicism: if weddings weren't so boring and predictable, I might be less scornful about the whole marriage package. Creativity and originality are rare at most ceremonies and receptions, and most couples' sense of fun and recklessness gets left behind once they buy into the myth (that myth being that you have to get married in order to be a truly committed couple). Every relationship is unique, nuanced, and complex, but many couples choose to ignore that fact, jumping at the chance to make their weddings safe, predictable, and boring. You get the same conventional displays at every ceremony. Some call it tradition. I call it laziness.

One example of this boring traditionalism is the unbelievably unexceptional wedding I went to last summer. Like so many others before it, the affair was held at a luxury suburban golf course complete with a sweeping vista of teeing-off yuppies in polo shirts. The weepy aunts sniffled, the ceremony script droned, the perky bridesmaids in off-the-shoulder chartreuse frills shifted from foot to blistered foot. At the reception, the newlyweds sat smilingly through cliché toasts that told us little about why they felt ready to commit their lives to adoring, forgiving, tending, and accommodating each other. All the standards were there—the garter belt removal, the uninspired speeches, the gussied-up flower girls. Something was old and something was blue.

During the reception, I dodged nosy questions from strangers about my romantic life as top-forty hits blared. After a couple of martinis and an hour of observation, I came to the conclusion that this particular marriage was an elaborate scheme by the bride and groom to get their greedy mitts on a

mini-deep freeze, new 4 × 4, and a useless glass punch bowl. At some point, my father in (common) law dragged me from my seat onto an empty dance floor. I was confused until I spotted her: the bride, high on champagne mimosas and the pain her high-heel satin shoes and tight dress were inflicting, stood preparing to pass on the baby's breath bouquet to a gaggle of spinsters who reached up with outstretched arms and ringless fingers. I found myself, uncomfortably, in the middle of the melee.

While the tipsy group jostled for position and I tried to quietly find my way out, the coveted flowers whizzed past our heads and landed in the grip of a woman in her late sixties who was busy eating wedding cake but blessed with enough finesse to catch it with one hand and hold it up with a look of surprised triumph. I walked away giggling as my in-laws shook their heads in dejection and tore up petals from the table's flower arrangement. My partner and I just smiled at each other. We'd been there before.

In fact, my boyfriend (better half, s.o., common-law hubby—take your pick) and I have been through a lot in the last ten years. More than many couples go through in the speedy five-year marriages in which 1.5 children and multiple heartaches are bred. We've made it through the seven-year itch (although not in the seventh year), through mistakes large and small, through illnesses and a couple of scary crises. We've had countless fights that involve flying food, and periods of divergent life expectations. We don't require any more confirmation of our commitment to each other—we live it every day.

Despite the objections and clever schemes of my mother ("If you two aren't going to get married, will you at least give me a grandchild? Yes, now!"), we know that traipsing down the aisle won't shine some magical light on us. It won't miraculously give us the wisdom and strength to keep loving each other. It will, however, land us a few fat personal checks and a hutch full of dust-gathering china. But while I'm ignoring nasty looks from pious strangers who think I'm a hopeless fornicator on a bullet train to hell, I consider that maybe, just maybe, I'll eat my words someday. Perhaps I'll eventually be convinced that getting hitched in some weird and truly memorable way is a smart thing to do. Until then, I'll keep ducking the flying bouquets, the leading questions from strangers, and the heavy sighs from my disappointed mother.

The Rules of Rai

VALERIA WEBER

I'm sitting in the cold, hard safety of the bathtub, scribbling on the backs of flyers. No one has yet banged on the door or demanded my exit even though I've been in here for quite a while and have no intention of leaving. This bathroom has become my haven, my place of exile, and people seem to understand intuitively the angst that's bubbling inside. Or maybe they figure that I'm doing what everyone else is doing in all the other locked bathrooms in this rambly old house. Girls have to do their lines, you know. Girls have to fuck. I mean, it is a wedding after all. A joyous occasion that I would rather bomb than attend, but here I am, sitting in a porcelain claw-footed tub, short-panted legs up on the toilet, boots hanging over, the butt of my nicest ruffle tux shirt getting wet.

This moment is the culmination of the last three years of my relationship with Rai. Every deep sigh and misunderstanding, every journalistically catalogued word and every unspoken one, every extra-long look and every time we avoided each other's eyes have led up to this: me locked in the bathroom clutching a scratchy pen and a stack of wedding flyers, lying desolate and boneless in the tub trying to figure out how I got here and how to get out.

The flyers are printed on ripped pieces of paper bags with thick blue ink. On top of the list of bands scheduled to play, there are two stick figures holding hands on the front of each flyer. One has short, spiky green hair and

wears a suit that's too big and a grin that's bigger. That's my girlfriend. The other chick is wearing combat boots, a skirt, and pigtails. That's not me.

That would be Katrina, aka Drummer Girl, aka the Vicious Cunt Who Stole My Girlfriend. If I could, if I had enough energy, I would be less angry at the Cunt and more angry at Rai, who let herself be stolen without so much as an argument. But I'm not. Instead, I amiably agree to Rai's request that I not only attend the wedding, but be in it, stand by her side in her final hour. In a very gracious e-mail (yes, E-MAIL), she added, *Oh yeah and wear whatever you want,* as if my wardrobe would be the most pressing thing on my mind the second after I learn that my nonmonogamous primary partner of three years intends to marry a chick that she met two months before. *I hope you wear your brown seventies suit with the red corset we got at the Folsom Street Fair. That is so hot.*

Oh. Really. What exactly was that supposed to mean? Did she think that we were still going to fuck after she was married? Maybe she was imagining a quickie behind the pulpit as Drummer Girl walked down the aisle. I immediately decided that I would not only be in her wedding, but I would look phenomenal. Fucking fantastic. And that I would never ever again (aside from being in her wedding) do what Rai tells me to do.

One of the most irritating things about the Cunt is that she is a flawlessly wonderful person. She's an incredible drummer and a beautiful femme top completely unaffected by her beauty. I've never met a girl friendlier than her or seen anyone with such a wide repertoire of useless, fun talents—she plays the button accordion, of all things—and she seems truly in love with and devoted to Rai. In short, she is everything that I am, only better, and I hate her. I am a terrible drummer. I am a cute, not beautiful, femme switch, and these days I can barely remember how to smile. My most interesting talent is my comprehensive grasp of all things eighties, which doesn't actually seem to interest anyone except me. And then there's the fact that I was never in love with Rai, much less devoted to her.

Rai is Japanese. Her name means "thunder and lightning." And "trust." She is steadfast, a rocker to the core, and she loved me unconditionally for three years. She wanted monogamy. She lived as if we were monogamous for the first couple of years, stoically listening to my hungover, morning-after

stories of what happened after she left the party. We started a band together; I never came to practice. We signed up for an auto-mechanics course; I didn't show up. I am the shitty girlfriend; she is the long-suffering abused one whose friends have been telling her to leave me for a long time.

On the other hand, my friends have been advising me to leave her for just as long. Rai is demanding and self-centered. She orders for me at restaurants, tells me what to wear, and who not to talk to. In fits of rage, she might either drop her head and cry or start throwing things until something broke. Once, in what I like to call the Amy March Incident, she lit a pile of my manuscripts on fire. Of course, this is the age of technology and of course I had backups, but to me the symbolism was more than I could bear. I doused her with the fire extinguisher more than I doused the blaze; she tackled me, and we fought hard with flat fists and razor words, holding nothing back. We ended up having the most amazing sex of our entire relationship and didn't leave the house for three days.

She stayed with me because she liked the fact that I was such a fuckup. It gave her something real to bitch about. She often told me I was the only thing wrong with her life, the only mistake she ever made. Conversely, I stayed because I fed off her power, mainlining her strength like heroin. It made me feel important, defined me by contrast, kept me grounded. In short, we validated each other's insecurities, and in between we laughed nonstop. We were perfect together.

Rai controls time. She reaches into history and manipulates events to create truth, to support her current whim, to lend credence to her newest determination. The latest version of us is that Rai never really loved me either. She, in fact, had never been in love until she met Katrina. I didn't laugh when I read this in one of her many illuminating e-mails and chalked it up to her invaluable ability to always be right about everything. I clicked on "reply" and wrote: "Of course. I, for one, don't recall you proposing to me once a year on our First-Time-We-Watched-Valley-Girl-Together anniversary. I don't remember either the way that you would whisper into my neck and smooth my hair until I fell asleep every time I crashed at your house at five in the morning, too wasted to move. I agree that showing up to walk someone home from work every day for three years has nothing to do with

love, or kidnapping them in the middle of the night to take them to the mountains, or sending postcards every week even when that someone you don't love lives in the same city." I reread that e-mail twice, deleted everything except "Of course," and clicked "send."

I never lied to Rai. That was one of The Rules. Complete and total honesty. I never gave her any reason to hope for any more labels than what we already had. She was my "girlfriend," my "primary partner," but I never wanted monogamy. In our own way, our intentions toward each other were far-reaching and solid. Occasionally, we even discussed it. We alluded to children, home ownership, and a sedan in conversation the same way we talked about death: it happens to everyone; it will happen to us. But right now we had The Rules, and The Rules specifically stated that at no point was jealousy, pressure, or dishonesty to come between what we treasured most in each other: strong friendship and reliable sex. If she brought it up, I either flattened the conversation immediately or found something else to do right away. She would rarely persist. The quickest way to kill non-monogamous relationships is to throw too much emotion in the face of the other's disinterest. Be strong, honest, detached. These are The Rules.

To further describe the people who are milling around this ancient house, which belongs to a friend's boyfriend's sugar daddy's wife, no one here is sporting a Sinéad cut or leather sandals, androgynous clothes, or angry-victim attitudes. There are almost as many boys present as girls, all gay, few flaming, none of whom follow the Indigo Girls, or have ever protested anything except the No-Smoking rule in bars, or have ever worked for the Green Party. Most of us, in fact, don't even vote. We, for the most part, do a lot of drugs or none at all, play pool, ride skateboards or rebuilt bikes or the bus, drive old cars, and are working to revive speed metal, neo-impressionism, and the art of graffiti while we work construction jobs, wash dishes, or run convenience stores. Most of us used to consider ourselves punk before we got too tired to maintain the lifestyle, but occasionally we still vandalize corporate chain stores and jump in the pit at local shows. Other than that, we attend one another's art openings, film viewings, and readings, and fuck one another and one another's girlfriends when complaining about the gentrification of our neighborhood gets boring. We've al-

ready gone through the head-shaving, obsessive hair-dying routine and now spend that energy on finishing the tattoos that were started by random people who happened to bring india ink and a needle to parties.

These are the people who are roaming around the estate right now. They're drinking malt liquor out of plastic cups. They're doing lines or eating pretzels and talking about what shows are happening this weekend, how that club was last night, what everyone's doing after. Two guys, both named Todd, with matching hearts tattooed on the skin between their thumbs and forefingers, are making industrial-sized panfuls of vegan lasagna in the kitchen. It is probably Marilda, a girl in a boa with clumps of pink feathers sticking out of her hair, who is turning down the music so that the next band can play. Cassie just blew a string tuning her guitar, and her husband, Dex, is laughing about it hysterically with his new boyfriend whose name I can't remember. Rai is out there. With Katrina. They're having a great time, I'm sure. They are establishing themselves, both with each other and in relation to everyone else. They are defining their dynamic. They are beginning their story.

I consider exploding out of the bathroom right now, throwing myself into the middle of everyone and causing a big scene. I could throw over tables, screaming about how long I've loved her, how it was Me who took care of her when she OD'd, ME who made her mixed tapes juxtaposing REO Speedwagon with AC/DC and Team Dresch. ME, ME, ME, not Katrina, who listened to her when she chattered on relentlessly late into the night about ABSOLUTELY NOTHING. I was the one with whom she'd spent the past three years watching reruns of "The Simpsons" and Lifetime TV for Women. I was the one who taught her how to bind herself up to look flatter chested than she already is. I was the girlfriend she brought to dinner to come out to her family. I was the one who helped her discover her predilection for leather and old trucks and Mildred Bailey. ME, not Katrina. Me.

I could also wait a few months, a year, sweep back into her life unexpectedly and slide under her skin again, slowly, surreptitiously, just when things are starting to pale for her and Drummer Girl. I could send her anonymous love letters and regale her inbox with e-mails full of song lyrics and Kathy Acker. I could leave long messages on her voicemail, serenading

her with "Without You" by Mötley Crüe or Bread's "Baby, I'm a Want You." I could spray-paint dramatic poetry on her sidewalk or plaster her gate with photo stickers we had made of us kissing. I could do that.

I could also, I guess, talk to her about what I think of this whole thing. It is technically an option. It's one I've never actually used with her before, in any situation, but it is out there. I could do any of these things. But I won't. There are The Rules that still must be considered, even if the circumstances have been modified. She has chosen someone else. She never really loved anyone until she met Katrina. Monogamy doesn't work for me. I am detached, strong, unemotional. There is to be no pressure or jealousy that threatens the one thing that is most strong between us: our friendship.

I'm going to get up out of the bathtub now. I'm going to rip off the bottom part of my shirt that is completely soaked, wash my face, touch up my lipstick. I'm going to open the door as if I had closed it only five minutes ago. I'm going to go downstairs and be the best man.

X-rays

KIM MAKOI

MISTAKE

DON'T SIT TOO CLOSE

JAKE

FRIENDS

The Unlearning Tree

SAUL WILLIAMS

I was black. After gender, that was the first thing that I learned about myself. Being born in the seventies to parents that had been civil-rights activists and black-power advocates, I was taught that this was my greatest attribute. That I was, indeed, part of a most historic legacy. I remember the sculpted wooden black fist mounted on my father's desk as the first piece of artwork and craftsmanship that I ever admired. From as early as I can remember, I was taught names like Garvey, Hughes, Parks, Dubois, King, Giovanni, Hansberry, Baldwin, Poitier, Brown, Baraka. With these names came a list of accomplishments that served as sources of knowledge as to why we had great reason for pride in being black. I remember sitting in front of the television as a family and watching the miniseries *Roots* when it first aired. I remember the tears, the anger, the conversations that followed, the sense of remembrance, the baby held up to moonlight. All this and more are my earliest memories of being black.

And then there was hip-hop. Through hip-hop I no longer had to look backward in time for pride in being black. My greatest source of pride became the present and the ever-evolving wit of my generation, but now, for some, I may be at wit's end. For despite the depth of my cultural rearing, the pride, the sense of history and connection to Africa, the awareness that came with going to a historic black college, and all of the anger, hate, and pain

that I experienced in the name of maintaining and evolving a sense of cultural consciousness, I have, quite simply, become involved with a white woman.

Of course, she is not simply that, nor are we simply what we have been raised to be proud or less than proud of. We are an ongoing discourse on love and politics. We are a nucleus of heightened awareness in a man-made cell. Cell out? Is it possible? Why would I allow myself to experience the judgment that I once (and sometimes still do) subjected people who I clearly thought knew no better? I cannot say that I have known better, yet I have surely known different, just as surely as I've known rivers. And this winding body of water has led me directly to the source of the unknown, where I have had no other choice but to strip myself of all of my layers of judgment, self-merit, doubt, and fears, and jump in. The water is cold and there is a strong undertow. My head is swirling between two stories: one of a man who walked on water and another of a people who were thrown into its depths while being cargoed to the shores of a new world. It is a new age and there will be many more stories. But will the old ones determine the new ones? Or will the new ones redetermine our understanding of the past?

I don't think that we can talk about interracial relationships without discussing the designs of freedom in a society that has forced us to define ourselves racially in response to oppression, bigotry, and hatred. We learned of our cultural heritage as African-Americans in order to compensate for the greater sense of self and lineage that was stripped from us during times of slavery. So through learning and feeling a sense of connection to our true history we began to acquire a sense of pride as a displaced people. We began to feel connected to a history older than the roots of our oppression and, thus, were able to identify with a greater sense of purpose. The question is, At what point does history, itself, begin to rob us of our freedom? My purpose in writing this is not to justify my choices. It is, rather, an attempt at chronicling an evolution of consciousness.

In the past, African-American men were lynched for the simple act of looking at a white woman. Meanwhile, many slave-owning European Americans carried out their animal-like desires on African-American women, thus giving the white woman an untouchable status in the white male pa-

triarchal setting. As a result, many men of color began to see white women as symbols of the greatest prize or trophy to be had. They simply desired what the men in control had and cherished—their money, their women, their freedom. The idea at its base is problematic considering the fact that women in this setting were seen as the property of the man. Yet the idea has passed down through time that a black man dating a white woman has not learned to value, respect, or find the beauty in black women, and that he is primarily craving after what he sees as the highest European symbol of status. Obviously, this cannot be the case every time, but it offers great psychological insight into the trappings of racial identity and how they manifest in individual pursuits. But who or what does love pursue? Can the love of an individual overrule one's love for "their" people? And if we are truly to dismiss western/European ideals and values, wouldn't we also dismiss their trivial delineations of race as well, along with our reactionary stances? All these questions and many more pass through my head at regular intervals. I find myself torn between that which I would choose to represent to my people, which is a fixed image based on past ideas, yet some still valid, and the freedom to honor my evolving definition of myself beyond our given conceptions. I am thrown into the world of finding myself overly concerned with what others think. As one can see, this may be primarily an issue of self-confidence. We often lack the courage to step out beyond the given norms of our society or culture. We fear the rejection that we often have ourselves imposed on individuals who made similar choices. We prefer the comfort of the collective. But do we experience a collective sense of freedom? An individual must allow their definitions to evolve beyond their misgivings. It often takes courage to shift our perspective, even if our experiences tell us otherwise. We are tied to our mechanical responses and reactions. Thus, in our collective pursuit of freedom, we are often bound from it.

I recently read a story of a man who lives backward in time. The story is based on the idea that time and earth expanded like a yo-yo on a fixed string and when it reached the end of the string it began to retract. What I found interesting in this story was that the people of this retracting earth justified all of their actions as part of their evolving consciousnesses' desires to become closer to the source. Writers would justify going from working on

computers to typewriters for the sake of wanting to rely more on their brains and muscles. People were raised from their graves and lived their lives knowing that their destiny would be to enter their mothers' wombs, becoming one with the primordial waters. A life lived in reverse gave people the clarity of knowing that the purpose of their lives was to return to the essence of their practices, their beliefs, and, ultimately, the source of their being. In this paradigm, for example, black arts activist and poet Imamu Amiri Baraka would at a given point in his life relinquish his chosen African name, retake his birth name (slave name), Leroi Jones, and would find a way to justify returning to his white wife, surrendering his acquired beliefs for so-called lesser perspectives.

I am not a man living backward in time. And although I have surrendered some beliefs over time, I have never in my estimation done this for the sake of embracing lesser perspectives. I have embraced the process of learning and unlearning, realizing that one's perception of reality changes as one's understanding increases. Thus I experience freedom at the rate of my ability to envision it. That is not to say that freedom for me is having a white woman at my side. Rather, it is consistently expressed through the internal challenge of being completely present in a given moment beyond my preconceived notions or expectations and through expressing myself at the heights and depths of my passion. Thanks to the hard work of our ancestors and parents, freedom fighters and martyrs, I have found that freedom, in my life, is to be earned greatly through internal struggle. It is inside. It is immaterial. Thus there is no monetary, skin, or surface value to it. It is metaphysical.

. . . Whereas, the velocity of spinning vinyl
crossfaded, spun backward, and rereleased
at the same given moment of recorded history
yet, at a different moment in time's continuum
has allowed history to catch up with the present . . .

Much of the power of our generation can be understood through the power of hip-hop. The idea of sampling the past, deconstructing it, and realigning it to fit your conception of the present over a drumbeat is no dif-

ferent than studying history and using it to help you shape your conception of the present as is aligned with your heartbeat. But here is my point of interest. In the process of doing this, the DJ makes music of the sound of time (as recorded on vinyl) going backward.

In the Bible, there is a story of a tax collector by the name of Saul who is struck off of his horse while traveling to Damascus and is blinded by the power of God. As the story goes, he becomes a disciple of the teachings of Christ and is henceforth referred to as Paul. This story always interested me because Saul is the name that my parents gave me. And although the name Saul is of Hebrew origin and means "asked for," I often wondered whether at some point I might need to change my name. This, coupled with the fact that I have spent a great deal of my life studying and, in a healthy sense, idolizing singer/actor/activist Paul Robeson, has often made me think deeply on the matter of names. It wasn't until I began meditating that I came to realize that my generation was one that made music of spinning time backward, and, thus, in my time Paul becomes Saul. Interestingly, a year or so after this epiphany I was told by an old scholar that Saul never actually changed his name to Paul. He simply traveled to a region where they spoke another language that used another alphabet and grammatical system, and there the letter "s" was not used at the beginning of words or names; thus it was the pronunciation that changed rather than the name.

I find that this way of thinking and of shifting perspectives complements much of what I've learned through experience, which is that the cycle of learning must be followed by unlearning. To unlearn is not to forget. To unlearn is re-member the source and, perhaps, to dis-member, or separate, the past from the path. What becomes of one who honors their past more than their path?

I have hated white people. I am distrustful of many and often interact with an unuttered belief that they are operating on a lesser level of awareness and little understanding of the insights their so-called privilege has not afforded them. My lessons in history, well beyond any eurocentric curriculum, have seemingly left me with quite a superiority complex. But what place does that have in an ever-evolving consciousness that transcends race and more practically in my current interracial relationship? One of the main

difficulties that I face in this relationship is the question of whether I can ever truly forgive her for being white. Love is expressed through the heart. Yet this relationship often keeps me in my head. I find myself tangled in a web of self-consciousness, individualistic pursuits, and cultural responsibility. I lack the desire or possibly confidence to walk in the blissful oblivion that love affords, yet I refuse to abandon a beautiful relationship because of its political incorrectness or because of the lap of societal judgment that it places me in. Instead I go back and forth between feeling comfortable and completely uncomfortable, compatible and incompatible. This sort of thinking was a no-no in all past relationships, but here I find that a sort of psychological inventory is necessary.

The main difference between this relationship and others I have had has been the ongoing process of communication. Now clearly this principle may have no connection to our racial difference, but is it a very worthy point. In the beginning of our relationship we would, usually under her initiation, sit and discuss the events of the day. Our discussion topics would range from how it may have seemed like I distanced myself from her in a certain crowd (was I embarrassed?) to discussions about why it is that so many white Americans seem to talk from their nose and the repercussions of not speaking from your diaphragm (does it disconnect you from your truth?). These conversations have often grown so interesting or mundanely intense that I have begun to wonder whether we as Americans can ever come to a holistic understanding of the racial paradigm without this level of interaction and confrontation. But then could that make me guilty of the same thing many whites have been accused of in interracial relationships: simply experimenting, in my case, for the sake of challenging myself beyond a point of understanding, yet never truly taking the relationship seriously or as anything more than an experiment? Cree Summer has a song called "Curious White Boy" about a white guy who dates her but never dares take her to meet his family or take her seriously enough to even contemplate such an act. I can admit to part of this idea being true in my case in that I never felt as if this had to be my "final answer," but then I've never allowed myself to feel that in any relationship, even with children involved. Could it be that with this new age our whole sense of relating to other people has evolved?

It seems that we tend to expect a fuller sense of satisfaction from our relationships and are more apt to abandon them if we are not satisfied. No longer does the idea of a couple staying together for the sake of the children seem as wise as it may have sounded in the past. This may sound like I've gone off course a bit, but actually this is easily connected to this idea of evolving consciousness and freedom. I believe that these shifts in relationships have occurred primarily because women have begun to feel a greater sense of independence in our society. And in a system that is perhaps more patriarchal at its core than it is racist, the greater sense of freedom that a woman is able to feel, the more we will all experience a shift in the ideals and values that form the basis of most of our institutions, the institution of marriage being at the top of that list. Thus what some would call "more broken homes," others might call an evolution of the idea of family.

Things do not evolve without affecting other connected entities. As our idea of race evolves, just as the names that we have chosen to refer to ourselves have, our sense of identity and connection to history shifts. I believe that it is important to have strong knowledge of your history and to be able to look at it from shifting perspectives. History is no more one-sided than the earth is flat. And as our understanding increases, we empower ourselves by enhancing our perspectives of ourselves. We begin to understand that we all played key roles in the unfolding of time, and even when things have occurred against our will, we cannot live our lives simply reacting to the past. Are interracial relationships the future? Not necessarily. But as white people begin to see that their privilege in Western society is unearned and as people of color begin to learn that their sense of victimization is uncharacteristic, time will continue to unfold in mysterious ways. Otherwise we will surely reach a very predictable end.

Bi20s-WSM

LOAM AKASHA-BAST

Betty Crocker, kiss my ass! Martha Stewart, bite me! The mask is coming off, girlfriends. I'm not going to be your Lunchbox Bitch. Ain't gonna be no laundry whore. Deadbeat dads? We don't need no stinkin' deadbeat dads. I'm a bisexual, twentysomething, witchy single mama, from here on out referred to as Bi20s-WSM, and while some of the things I say might appall you, I'm here to tell the truth.

I chose to have a baby at age twenty-one and I chose to raise her alone. By the time I'm thirty—if my love life continues its one-act play—I will have spent all but one year of my twenties as a single mama. And let's face it. Exploring your sexual identity while sharing a bedroom with a toddler inevitably stifles one's inherent orgasmic nature.

Bi20s-WSM Personals: Snake-wielding priestess of the kitchen-drain sludge seeks androgynous dishwasher punk for sexual housecleaning experiment. Big plus if naked Barbies in the bathtub turn you on.

Let's assume our twenties are a time to explore our identities, our notions of self in relation to the "rest" of the world. Before we hit our twenties, most

of our social interaction occurred with people within one to five years of our own age. We moved through elementary, high school, and college as a herd. Then we graduated, high-stepped out into the Big World, and suddenly our peers were gone. And if being dropped on the doorstep of this grave new world, swaddled in nothing but a breezy liberal arts degree, wasn't disorienting enough, motherhood severely mutated my connection to other twentysomethings. Because of finances and childcare resources, I usually have one—count it, *one*—chance for a childless social event each month. Talk about putting a damper on spontaneity.

Bi20s-WSM Missed Connections: My dear Spontaneous Interaction, I saw you on the bus today, headed downtown. Where have you been? I miss you. Come back to me. I swear I have no time, but I'll make more time for you. How's Thursday at six a.m.?

No matter how evolved my childless cohorts are, they are afforded an infinitely larger amount of freedom, which creates a gap between our realities. I have loads of young childless friends, some of them partnered, some of them not, who are not only supportive beyond all reasonable question and love playing with my daughter, but who cannot possibly fathom why I never seem to have time to return their phone calls.

And no matter how much I may understand the parenting experience of the dual-income, midlife-baby, suburban mama, our alter-identities are almost always disparate. I know dozens of great moms with whom I can talk for hours about bedtime routine strategies, carseat laws, and hunting for a good kindergarten, but who just don't understand why I pierced my nose.

Bi20s-WSM Approved School: Upon learning that a kindergarten boy was teased by an older student for kissing another boy, the teacher replies: "You can kiss anyone you want to, as long as it is okay with them. It is nobody else's business, and the next time you get teased go find an adult to help you."

I don't fall for all that mother-guilt. Okay, I'm lying. The socialized mother-guilt tape plays in my head almost as often as I find myself humming "I'm a Little Teapot." There is a ridiculous amount of mother-guilt in our culture. Some would have you believe that the entire reason our society is going to hell is because of bad mothers. Let me just say that the pressure of the mother-guilt is even more constipating when you are also presenting yourself as (1) young and single; (2) bisexual; and (3) a witch.

Unfortunately, this identity trial and error is rarely seen as a valuable process in trying to establish a sense of self. Even worse, one is expected to stop all that nonsense upon becoming a parent. The general public does not look kindly upon mothers who experiment with their sexuality or spirituality. Apparently, you are supposed to have the perfect (static) identity before you have children. You should have cultivated all your values with precision and accuracy and expect them to never change. That way you don't mess up the young'uns too much by exposing them to sundry cultures, beliefs, attitudes, and lifestyles.

Being a witch, I'm down with the sacred feminine. The Goddess is all good things, and the Goddess is all bad things. Actually, the Goddess isn't really good or bad at all. She just is. She's that delicious cross between the Marys. She is mother and temptress, creator and destroyer, all rolled into one. If the Goddess can manage to simultaneously be maiden, mother, and crone, I think I can pull off a little identity exploration in between the lunch boxes and laundry.

Who I am today is not necessarily who I'll be tomorrow. I've had to let go of some of my expectations. My inner Mr. Rogers whispers, "The word for the day, dear mommies, is Surrender." Surrender. Give up to someone or something; sign away my rights; acknowledge defeat. My twenties have been a time of little control over anything. No control over job, money, or sense of self. I've been living paycheck to identity paycheck, balancing an emotional budget and a baby on my knee. My sense of self has been eating Ramen for a half-dozen years, but I suspect there is a freezer full of steak in the basement of my psyche, if only I can figure out how to get down there.

Not only am I responsible for the murky task of sorting out my own physical, emotional, intellectual, and spiritual needs, I'm also spearheading an eighteen-year campaign to determine—and supply—those basic needs for another small being. Parenting forces you to relate identity faster than you can dart a sick toddler's projectile vomiting. Figure out what is important to you, and figure it out quick. Assume control, even if it feels like a paradox.

I know that no matter what else I am, I will always be a mother. Exploring my identity while locked into the role of motherhood makes me feel grounded and it makes me feel trapped. The good news is that I have a built-in safety net. I'm probably not going to do anything too life-threatening in the holy sacred name of Exploration. On the other hand, where the hell do I meet people? And when I do, what chance in Hades do I have that they will be even remotely interested in the whole package?

Here I am, legs spread wide, straddling two roles. I've been riding the stiff tension between responsible caretaking and neurotic self-indulgence for almost a whole decade. No wonder I feel exhausted, isolated, and misunderstood. My expectations for life in the Real World, as well as those I had about motherhood, crashed to the ground like a tower of Legos once I moved beyond the theoretical. Stripping away the mask means facing up to the bloody, ugly reality of what lies beneath. It's shocking because it's unknown.

There is no end to this story. The plot is ever evolving, and I'm not sure what comes next. With any luck, your heroine will scuttle through some grand rite of passage and land safely into the next narrative, where Betty and Martha star in a tantric tragicomedy of transformation and rebirth. Until that time, look for me in the Bi20s-WSM Personals, where stretch marks are sexy, the breast milk's on tap, and revolution comes from a small voice crying, "I'm done pooping, Mommy. Come wipe my butt!"

The Quirkyalone

SASHA CAGEN

I am, perhaps, what you might call deeply single. Almost never, ever in a relationship. Until recently, I wondered whether there might be something weird about me. But then lonely romantics began to grace the covers of *TV Guide* and *Mademoiselle*. From "Ally McBeal" to "Sex in the City," a spotlight came to shine on the forever single. If these shows had touched such a nerve in our culture, I began to think, perhaps I was not so alone after all. The morning after New Year's Eve (another kissless one, of course), a certain jumble of syllables came to me. When I told my friends about my idea, their faces lit up with instant recognition: the quirkyalone.

If Jung was right, that people are different in fundamental ways that drive them from within, then the quirkyalone is simply to be added to the pantheon of personality types assembled over the twentieth century. Only now, when the idea of marrying at age twenty has become thoroughly passé, are we quirkyalones emerging in greater numbers.

We are the puzzle pieces who seldom fit with other puzzle pieces. We are romantics, idealists, eccentrics. We inhabit singledom as our natural resting state. In a world where proms and marriage define the social order, we are, by force of our personalities and inner strength, rebels.

For the quirkyalone, there is no patience for dating just for the sake of not being alone. We want a miracle. Out of millions, we have to find the one

who will understand. Better to be untethered and open to possibility: living for the exhilaration of meeting someone new, of not knowing what the night will bring. We quirkyalones seek momentous meetings.

By the same token, being alone is understood as a wellspring of feeling and experience. There is a bittersweet fondness for silence. All those nights alone—they bring insight.

Sometimes, though, we wonder whether we have painted ourselves into a corner. Standards that started out high only become higher once you realize the contours of this existence. When we do find a match, we verge on obsessive—or we resist.

And so, a community of like-minded souls is essential. Since fellow quirkyalones are not abundant (we are probably less than 5 percent of the population), I recommend reading the patron saint of solitude: German poet Rainer Maria Rilke. Even 100 years after its publication, *Letters to a Young Poet* still feels like it was written for us: "You should not let yourself be confused in your solitude by the fact that there is something in you that wants to break out of it," Rilke writes. "People have (with the help of conventions) oriented all their solutions toward the easy and toward the easiest side of easy, but it is clear that we must hold to that which is difficult."

Rilke is right. Being quirkyalone can be difficult. Everyone else is part of a couple! Still, there are advantages. No one can take our lives away by breaking up with us. Instead of sacrificing our social constellation for the one all-consuming individual, we seek empathy from friends. We have significant others.

And so, when my friend asks me whether being quirkyalone is a life sentence, I say, yes, at the core, one is always quirkyalone. But when one quirkyalone finds another, oooh la la. The earth quakes.

Strange Fruit

CHATO ZAPATA

Polygamy is my legacy, says Helen's housemate, Nefi. It's my culture freedom.

What? asks Helen.

It's my culture freedom—men all over Africa have multiple wives; It's in my blood, undeniable and self-evident, won't a thing change it, says Nefi.

Then, says Helen, I must be on some honorary citizenship in that case, because no choice is left to me in a world where not one individual man understands each of my needs. Maybe the best man I know can satisfy my soul in three respects, but that leaves at least seven respects open for two or more people to address. In that sense, being with one man would be like letting so much of who I am go neglected.

A National Public Radio commentator calling himself Weinberg claims that dividing one's attention is like slicing a plum—you lose some of the juice.

So, says Helen, if it's the juice we're after, why not grab three plums and eat them whole, sticking them right into our mouths without slicing anything at all? Just grab one plum with your left hand and while you're popping that into your mouth, grab another plum with your right hand and then another with your left, suggests helpful Helen, and chew with your mouth closed to keep the juice in, and be careful not to swallow any pits, pay attention to the pits too.

But dear Weinberg continues, That's what I'm really afraid of: We'll multitask, attention switch more and more from left hand to right hand to pit from plum and back; We'll engage less and less in eating pleasure plums; We'll care less and less, more concerned with the pit than the pleasure and we'll lose the juice. Instead of having plums of experience, we'll have prunes.

To which Helen replies, Only a sick man would turn plums into prunes like that. I've heard enough.

The music of polygamy begins here, jostled on a street corner, a line of endless embraces in the continual arms of each heart-crushing pedestrian you meet on the sidewalk. On the way to the store Helen meets her sometime lover Chato. He's excited because he's about to visit the check-out girls at Keyfood, mostly the one who looks like she just got off the beach even though it's February in Brooklyn.

Chato, says Helen with the successful exhaustion of having found someone familiar amid the street's rolling engines, footsteps, doorways, and passing murmurs. What's up, you headed somewhere? Helen teaches yoga whenever a customer calls for a class. Chato's buying frozen pizza and tampons for his part-time lover, Beti.

How's your girlfriend? asks Helen. What's her name?

Oh, Beti? She's fine, but things aren't going so well.

What's wrong?

She's mad because I told her two years ago I'm not the marrying type.

Maybe she figures you'll change your mind.

Maybe she figures I'll come around, but I think she suspects I want to get hold of these other honeys for a taste.

You may not believe so, thinks Helen, but I see more than you do, Chato.

There's a lot that Chato doesn't know about his sometime lover, Helen, or his part-time lover, Beti, for that matter.

Why didn't you tell me you taught yoga, Helen, shit, I could call you on Monday for a lesson, right?

You could, Chato.

Don't let me get in your way now though—I know you got people to twist out, I mean, with yoga.

Have you ever done it? asks Helen. It's relaxing.

I need relaxing, but I need to get to the store first, let me call you later.

Can I get a hug?

Shit, you could get 'em in succession, you Siva Yogi.

Helen takes her hugs when she can.

The music of polygamy begins here, jostled on a street corner, a line of endless embraces in the continual arms of each pedestrian on the sidewalk where the content yet tangled strands of our private lives caress one another as we pass. Helen's threads entwine with Chato's, in this case in the form of a departing hug.

All I want is to be happy, thinks Chato. He watches Helen sway off to the train station. A girlfriend, an apartment, a decent pair of shoes, some music, and my health used to be enough. But now that I got this job—there's no time for music, and since my girlfriend can't come to work with me, we hardly see each other. A car passes, its music warping in accordance to its growing proximity and then its increasing distance. Chato looks down at his new shoes. I frequent happy hours with girls from work—the only girls who understand presentable shoes—we flirt in taxis, our present nine-to-five working selves so separate from our previous freelance private selves. I woke up today ready for change: another job, a different woman—in short, another me. Another splintered self full with an endless wanting, an engagement ring in my pocket waiting to roll out onto the next fresh finger, and then the next, and then another. But my polygamous tendency is tender, meant only to nurse each successive personality evolution. Still, this is how we become players.

A few blocks away, waiting for her train, Helen thinks, Yes, at work I spend my time with Chato—sitting in the cubicle opposite him, out to lunch with him, ignoring him in meetings, where he's the most displaced soul. While he stares out the window sipping coffee, I take care of business, keep my mind alert and my tongue sharp to stab at promotions and pay raises. But in the bar after work, I let it all go. I dance with Chato near the table where I drink from Beti's lap. Beti, Chato's part-time girlfriend; Beti, my lover, the incognito Beti

lesbian who I pretend not to remember whenever we meet at the holiday office parties or in the bars after work. But in the bathroom together, in the coatrooms and elevators, we affirm the true strength of our memories, Beti and I, Chato and I, Beti and Chato, Us. And when I finally get home, my boy Nefi leaves food wrapped in foil for me on the kitchen table with a note that reads: "Eat This," heart symbol, Nefi. I'd say I love them all the same, but that would give too much glory to love, which has nothing to do with any of this, and I wouldn't want it otherwise. The only love here is my love for these bodies and these appetites. The love of warmth and the love of soft. Not my mama's love, a newer, bigger love. A love independent, true to itself instead of the law and tradition. A love I can spread and share at will.

If she could hear us, we'd be obliged to tell Helen that her love style resembles something despised, the most acceptable of which is called polygamy, and polygamy is a man's sport. And men, being such spoilsports, frown upon polygamy for women and call it by other names: polyandry, polyfidelity, polyamory—none of them at all biblical. Where polygamy is to have more than one mate, traditionally a man having more than one wife, polyandry is specifically a woman having multiple husbands. Nowhere in any book of laws are women granted such extravagances. But what is afforded us, Helen, is the popular belief that, unlike men, women are capable and even inclined to address multiple tasks simultaneously. Obviously, the discussion is rife with contradiction: If women are more disposed toward multitasking than men are, then why is it that men are awarded the allowance of multiple wives? Such allowances grant men the permission to mismanage their relationships.

A Roman square named Publilius once said that to do two things at once is to do neither. That's right, thinks Helen, if a man can't talk on the phone and balance the checkbook at the same time, then he can't handle two wives. But Helen, being privy to the art of multitasking, tells Publilius that if to do two things at once is to do nothing, then I must do a third in order to appear as though I've done anything at all. Polyandry, polyfidelity, polyamory.

Publilius suspects that the rising popularity of multitasking is unmasking the inevitable North American evolution away from monogamy. Helen smiles. The Internet boom, responsible for a flood of available information,

only accelerates the development of multiple, simultaneous focuses—in short, multitasking—as a means of dealing with information inundation. In this way, to look deeply into the phenomenon of multitasking is to arrive at the conclusion that to multitask is to harbor and nurture a mild, though presently common, schizophrenia.

Perhaps polyamory then—to focus on the most animal-driven aspect of polygamy, the sexual desire of the other—may be viewed as an organic cultural remedy to multitasking's resulting personality schisms, thinks Chato, in that multiple lovers are better able to love multiple personalities. Further, adds Publilius, wondering about the excitement in Chato's eyes, the desire for more than one partner is nurtured by the daily practice of multitasking that occurs in the workplace. People are under siege, really, by this multitasking.

They call it multitasking because simultasking is too strange a word, thinks Chato, who prefers simultasking because of its resemblance to simulcasting (simultaneously broadcasting one program to various receivers—so sterile a transmission, so technical and cold a term), which sheds a more mechanical light on the person in question, a sort of automaton whose work habits are programmed by the larger employment system.

Every morning now, Chato listens to NPR while taking careful time to wipe the sleep from his eyes. Until he returns to bed sometime after midnight, this is the most focused moment of his day: besides yawning, rubbing his eyes, wondering what to wear, and hoping there's something to eat for breakfast, all he's doing is listening to the radio and recollecting his most recent dreams:

That's when I wake up. When all the strange fruit on her head is about to tip. Or when each stack of coins begins collapsing. That's when I wake up. Right before every single thing comes crashing down into the darkness, I wake up. Until then, the mountainous sweaty man stays grinning behind his desk, stacking coin upon heavy coin into towers as high as Babel's. He grins and sweats and breathes heavy as I try to look away, the coin towers swaying, drunk off their own height, each metal disc giggling and ready to crash down. In the other dream, Carmen Miranda beckons me to dance—her *boca de*

sandia, her lustrous mouth smiling and smiling. She swivels and flourishes her long skirt and cha cha chas toward me and dips her head slightly more and more by degrees so that all that waxy fruit begins to quiver atop her head and her wide-eyed posture looms a shadow over me. All that fruit hanging just above me, ready to topple. I want to dance, but not with you, Carmen. That's when I wake up. When all the fruit on her head is about to tip, when each stack of coins begins collapsing. That's when I wake up.

Awake now, Chato turns the radio's volume up, goes to the kitchen and boils water for coffee, throws two frozen waffles into the toaster, goes to the bathroom, and returns to the kitchen table to read from one of the magazines there. The waffles pop up and the water is ready. He pours it over coffee grounds while he reaches for the syrup. He butters his waffles while reading *Talk of the Town.* Wondering if his green sweater is clean, he hears the announcer read the day's weather: cloudy with a chance of rain in the afternoon, clearing up for the evening commute. High of fifty-two today, with winds out of the northwest at five miles per hour. The temperature now is forty-nine degrees.

Pressed for time, Chato brushes his teeth while he's in the shower. He thinks again of the green sweater, remembering that he's let invoices pile up on his desk since he was fired on Monday. Today is Thursday and tomorrow is his last day at work, and he's only got one more check coming to him and that'll be in two weeks. Valentine's Day is coming up and he better save for dinner or flowers or both for his girlfriend Beti, plus save more for her—are you supposed to buy mistresses gifts too? But what? Who knows what these women want. The shower is over and now to dry and dress, but the green sweater smells like smoke, so now what? The telephone rings. (In the back of Chato's mind or, if you prefer, in the corner of the room, Carmen Miranda begins her dance.)

Hello?

Don't go to work today.

Hi, Beti.

Stay home today and make breakfast for me and give me a foot massage.

I already ate.

I want coffee.

I made some—getting his socks out of a drawer, looking for his brown

pants (Carmen tilts her head a bit, the fruit angling) as the phone's second line beeps. Hold on, says Chato. (Carmen's smile brightens.) Click—

Hello?

Good morning, Mr. Big Mouth, you left your glasses and your scarf and your hat in the cab last night, I grabbed 'em for you, do you need them? (Carmen is swiveling her hips; a pineapple begins to quiver.)

Hi, Helen, why you call me big mou—actually let me call you back.

Okay, Bye. Click—

Beti? Breakfast! Okay, I gotta get to work.

Chato, you've been fired since Monday! (Carmen approaches, dancing faster.)

Yeah, but I gotta go turn in some invoices that are still sitting on my desk.

No, me! I'm sitting on your desk! (The fruit begins to topple.)

Okay, I gotta go; I'll see you there.

By this time Chato is half dressed and sweating. Another shoe to put on, and any sweater at this point—there, the black one will do. A jacket and he's out the door, checking to make sure he's remembered his keys. On the subway he reads poems in between watching passengers board and exit, watching the women who no doubt are on their way to work. These women, he wonders, do they have affairs with coworkers? Work. He arrives fifteen minutes late, stopping to buy two large coffees, one with five sugars for Helen and a glazed chocolate donut for himself. In the office he puts the coffee and donuts down on his desk, starts his computer, goes to the bathroom, washes his hands, and says hello to the two out of five people with the courage to look up from their shoes as they walk the hall. At his desk he activates his voice-mail, listening over the speakerphone while typing his password into the server to check his e-mail. While the e-mails upload he searches for the invoices on his desk, stopping to jot down a voice-mail message left so quickly that he listens to it two more times before moving to the next one. A new e-mail arrives. The telephone rings. Helen sips her coffee in the next cubicle. Steam and all, Chato gulps his coffee, his thoughts drifting back to Monday when the boss's secretary interrupted his breakfast at about this same time.

She wants to talk to you, says the secretary, taking one look at pathetic, obedient, task-addicted Chato.

But she's not even here today, says Chato.

She wants you to call her at home. Chato picks up the phone.

But not from your phone, says the secretary. Use Deb's office. Chato hangs up his receiver, knowing he's about to be officially fired. He walks to Deb's office and makes the call.

You're not happy, Chato.

What do you mean, that you're not happy with me?

No, Chato, you're not happy. You're just not present. You come in late everyday. You don't participate in the editorial meetings, even after repeated warnings.

But I get the work done. I stay late every day and get the work done more efficiently when everyone else is gone.

Chato, it's really not working out—you're too distracted, by what I don't know, but I think you'll be happier somewhere else—we'll both be happier. Do this, just write a memo to me as a formality, giving notice of your last two weeks.

A nightmare of menial chores piles up on Chato's desk, as though a sweaty mountain of a man was stacking them there in unmanageable columns. One task takes Chato all day. As he's intermittently interrupted by myriad more tasks, none much more important than its predecessor, none less demeaning for its lack of required skill. Chato's reluctance to perform increases. By day's end, the majority of Chato's time has been spent surfing news websites at the expense of mounting duties. I ignore my job until everyone goes home, thinks Chato, then I concentrate and get things done. This is known as Work.

People in a work setting, says D. E. Meyer, a scientist who studies people in nonwork settings, are banging away on word processors at the same time they have to answer phones and talk to their coworkers or bosses—they're task switching all the time. Meyer says this constant refocusing may be costing companies as much as 20 to 40 percent. If my performance is more efficient after hours, thinks Chato, then it's better that I just stay late and

concentrate. Of course, if Chato could hear us, we'd have to point out that the extra electricity and office refreshments that he consumes after hours actually cut back into the efficiency.

And so, thinks Helen as she reads this news, if constant refocusing may be costing companies 20 to 40 percent of employee productivity, then the same refocusing may be costing lovers 20 to 40 percent of their relationship's success to have to cater to multiple partners. But if Helen could hear us, we'd have to point out that actually, because each lover is comparable to a separate job, each having various needs of their own, then the 20 to 40 percent must be multiplied by the total number of jobs, or partners, on hand. In Helen's case, such multiplication results in 60 to 80 percent of potential love success being lost to the evil that is multitasking.

Such results sound abusive. What partner dares allow a potential 80 percent love loss? A barbarous one, no doubt. But Chato, surfing websites in the wake of his termination, has it from a good source, mainly polygamy.com, that polygamy is not abuse. It is a lifestyle ordained by God for some people. So maybe if you suffer a 60 to 80 percent love loss, thinks Chato after hearing Helen's news, maybe it's because the Great Spirit has it out for you, eh? Polygamy is not for everyone. And perhaps this is where Chato should pay attention—Repeat: "Polygamy is not for everyone. But," reads Chato proudly, as though experiencing an epiphany as to his own saving grace—"for some it is God's calling and God's special blessing." So there. God gave some of us a "special blessing." Who knows it feels it. And if you feel it, please respond:

My name is Chato, a man of 28, and my wives' names are Helen who is 32, Beti who is 27, Chanté who is 24, and Veronica who is 22. We enjoy art, poetry, music, and wholesome home-cooked meals. We like to have popcorn with our movies and mustard with our french fries. We are a loving family seeking another partner to expand our current number of children (seven-year-old Junior, seven-year-old Margo, six-year-old Luis, and seven-year-old Mia). Everything will be legal. You will enjoy both solitude and independence at regular intervals, plus loving arms and private intimacy too, we guarantee. We are all social drinkers and occasional smokers but

aren't looking for anything kinky, just a very, very large family with lots of children. Take a chance; discover the happiness you've been expecting. In this relationship you would be loved much more than anyone could be in a monogamous marriage.

Chato clicks <send>.

In their abstract, entitled "Executive Control of Cognitive Processes in Task Switching," J. S. Rubinstien, D. E. Meyer, and J. E. Evans detail four experiments concerning the efficiency of the human mind in dealing with simultaneous tasks. Daily life—reads the abstract—often requires performing multiple tasks either simultaneously or in rapid alternation, as when people prepare meals while tending to children or drive automobiles while operating cellular telephones. Or, thinks Chato, talk on the cell phone to one woman while going to the store to purchase tampons for another. Or eating a donut while instant messaging the woman who called me big mouth—but this is exactly the variety of real multitasking sequences that scientists fail to mention.

What are scientists fearful of revealing? wonders Chato. Perhaps proof of their own unavoidable polygamous habits? Tendencies so strong that they shape even "objective" experimentation?

I think we'd find clarity in the relationship between multitasking and multiple partners if we spoke with one of these scientists, says Helen.

They decide to speak to Dr. Rubenstien, coauthor of one widely recognized study on multitasking. The good doctor, they learn, used to work for a major university but was recently hired on at the federal level because he studies "how successfully the human brain can be exploited over extended amounts of time," as Chato will soon phrase it. Ring. Ring.

Hello, Rubenstien residence? You'd like to speak to the doctor? I'm sorry, he's not in at the moment, may I take a message?

Well, says Chato, set on speaking to someone about his interests in multitasking, with whom am I speaking?

I'm hired here, answers the unseen voice, to watch the children, sir.

Well what are the children doing?

Knightridder is checking his junior portfolio while he practices his French tape and Miss Tiffany's working on her backhand while approving clowns

for her swim party next Saturday. Nobody's willing to be thrown into the pool every three minutes after each costume change, so it's a bit difficult.

And what are you doing?

I'm flipping Knightridder's pages, waiting to rewind his French tape, lobbing tennis balls at Tiffany, dodging her returns, and sending in the clowns.

Ah, a domestic multitasker.

Excuse me?

What do you think of their father's work? What does he do?

He measures how successfully the human brain can be exploited on multiple tasks over extended amounts of time. Would you like to leave a message, sir?

Well, no, I'll call the school.

He works for the airplane guys now.

Oh, that's right, how's the new job treating him?

I don't know, sir.

Oh well, thanks—oh, one more question.

Yes?

How many wives does he have?

Excuse me?

Never mind.

Well, asks Chato, what now, should we call another scientist? Helen suggests these scientists want nothing more than to identify, manipulate, and implement a new human behavior, as if life were a night of random dice throws on the French Riviera, or Monte Carlo with the Count of Monte Cristo putting it all on six, betting that three out of five times Johnny Aristocrat at the table's end will roll double threes in favor of biting off more than he can chew, after which he goes off onto the terrace to sulk in having bit off too much to chew. Actually—and Chato and Helen suspect this much—life is more like Indian Bingo and instead of the Count of Monte Cristo, it's a head count of turquoise Montezumas, regal in the realization that Johnny Aristocrat throws weighted dice.

They call it multitasking because simultasking is too strange a word, thinks Chato, who prefers simultasking because of its resemblance to simulcasting, which sheds a more mechanical light on the person in question, a sort of

convenient automaton created by bureaucracy's overgrowth—the weighted dice. Helen nods, a splinter of herself full with endless tasks and boundless wanting.

But my polygamous tendency is tender, she whispers, meant only to nurse each successive desire. Still, this is how we become players. The music of polygamy begins here.

part 4

(Amani Willett)

reaming

To: jkarlin@hotmail.com
From: laurenkesner@media.am
Subject: gorillas and curly q's

I forgot to tell you about this art exhibit I saw of a huge watch hung up on a wall. Big
deal, right? But when you look closer, the watch represents the world you and I have
dreamt of: a world where time is longer, the day lasts thirty-two hours or something like
that. We are not alone in a cry for time . . . please, lord above, grant us an extended
day, more sun, more sun! Maybe if we never killed gorillas, god would be more
forgiving. But alas, we will never know and thus are left to relish in the creations of
artists and other visionaries. I am having one of those days when I dream of what
next. I don't know. I can't wait till I move on to another job. But, really I just can't wait
until I have an idea of what next will be.

<l.k.

F eeling rightly distrustful of unified belief systems, these twentysome-
things find strength in connecting fragments and creating dynamic dreams.
Education, media, and marketing make us rightly suspicious of and disillu-
sioned by politics and religion, formerly known to connect people to over-

arching values. Contributors in *Dreaming* show their desire to look out from their personal lives. From the realms of civic duties, ethical quandaries, and spiritual glows, each story shows how twentysomethings nurture hope even as they distrust pieces of their world. Our dreams shape meaning in our lives where contradiction reigns and disenchantment is the easy way out.

Dreaming is in our bloodlines. The United States is based on the idea of an American Dream. Americans look for a yellow brick road and the winning Lotto numbers while the fairy tale remains just beyond their reach. The slim chance for success keeps everyone searching, immigrating, and gambling. Many sports watchers continue to root for and bet on the underdog. Moments such as Buster Douglas knocking out Mike Tyson for the 1989 World Heavyweight Championship make crowds explode in cheers. In their book *The Winner-Take-All Society*, economists Robert H. Frank and Philip J. Cook describe Americans as eternal optimists who believe that all will be fine, even as the economy dives dramatically downward. Frank and Cook cite a study showing that people who have a "clearer view of reality" are more depressed than those who have "an exaggerated opinion of their abilities and social skills."[1] A strange sense of naive optimism—maybe it is escapism—follows all of us, lying like a veil over many of our daily chores. (How can anyone fully contemplate the complexity of the world?)

Our twenties are a time of figuring out how to mesh our dreams with what we can realistically accomplish. We feel something burning inside, and we worry about compromising this passion before we even figure out what it is. We struggle to protect shifting ideals, sure that we do not want to "sell out," but not quite sure what we have to sell out and to whom. Without a clearly defined "The Man" or "black and white," we cannot simply react. A fulcrum of this part, and maybe even the book, is Lee Konstantinou's *The Schrödinger Treatment*. The essay drugs a reader into the familiar dimension where all structures fall away and one is paralyzed about what to do. Konstantinou feels like he can only do absolutely nothing or absolutely everything. He sits in indecision, unable to choose and prioritize—what makes

[1] Frank and Cook quoted in Daniel J. Wakin, "Invisible Hand Now Clamping onto Wallets; Gloomy Economic News Takes a Toll on Optimism," *New York Times*, 12 August 2001, sec. 1, p. 33.

one decision better than the next, one belief system better than any other? By the story's end, Konstantinou figures out a way to act while knowing that every story has another side. Even the version of *The Schrödinger Treatment* that you read here is just one out of thirty that have been written.

Politics is one public structure in which we want to insert our voices, but we are not sure how because there are so many conflicting sides (or lack thereof). Politics oftentimes seems ineffective, overrun with bureaucrats, and awfully expensive. Looking back at our nation's history, we imagine that there was a time when people felt more tied to, and taken care of by their government. Idealists among today's educated group want to believe that we live in a democracy where our concerns are heard and our problems worked out. In a post-Vietnam era, however, the media have changed politics' ability to hide. The government touts one glossy superpower image, while our educations and experiences give us enough information to know that lines bleed. Of course, the dream of democracy is easier than the reality, but many of us do not believe that politics will bring about a better world. Because our educations give us power, we a have responsibility to do something with them.

Humor has always been a way of lightening our disenchantment. And it does seem comical: we grew up hearing Ronald Reagan recite lines from his Hollywood movies in political speeches, watching Jay Leno imitate Barbara Bush, and reading spoofs on Imelda Marcos's shoe fetish. We have seen a politics that weds itself perfectly to money where politicians, like baseball players, get bought and sold. Even though we know that much of politics is a farce, we necessarily participate in it daily. So why not, we ask, continue to make it better? Mark Yokoyama laughs along with us watching election coverage on the comedy channel, but he still participates. Yokoyama accepts that voting in our half-democracy is a joke, but he participates in it anyway. We laugh at ourselves, embrace the laughter, and try to do right by our parents, our parents' parents, and all the unbelievable theoretical freedoms we have long-windedly acquired.

Many young people today are accused of apathy and of focusing too much on the individual self. But we see a different reaction. In this group of contributors, in our peers, an observer will see these young people approaching different aspects of an issue and stretching themselves like taffy

between previously contradictory pulls. It feels sticky and takes a long time to see results. In his essay *Between Us,* Nick Suplina knows that neither activism nor law holds all of the answers, so he takes parts of both to build his beliefs. He is working from inside the United States, but, like many, he identifies not as an American but as a global citizen, bridging between various affiliations. Similarly, Steffie Kinglake explores her relationship to activism by looking at numerous protests that involve international causes. Kinglake comes from a long history of political activists: her grandmother participated in union work activism and in programs that provided services to refugees from Europe, and her father took to the streets to fight against U.S. involvement in Latin America. Today, a clear-cut cause eludes Kinglake. She knows too well that it is difficult to see any issue in isolation and knows that we do not have a solidified target to rally against. She adds to the movement, however, by continuing to attend protests, documenting how the pieces come together into a kind of kaleidoscope added into the national narrative. Both Kinglake and Suplina act when they can piece together activist with lawyer, photographer with protester, partiality with partiality, forming a collective. They involve themselves fully in between, acting as the hyphens.

Religion seems strangely ignored in this collection. Most of us want to be reminded that we are more than micro-specs spinning on one of the nine planets rotating around our sun, just one of the 100 billion stars in our galaxy, among billions of galaxies in our expanding universe. Religion is historically regarded as a structure that can connect a group of people to one another and to dust beyond; but, as cynical, academic types, this sample of people tends to see organized religion at fault for many of the problems unfolding over centuries in the world. The religion that assaults our senses daily has more to do with religious trends based on Madonna—she talks about the Kabbalah, and interest in Jewish mysticism skyrockets.[2] Many churches emulate mega-mall architecture in order to attract large congregations.

In our shifty mistrust of religious institutions, then, do we reject the religion we were raised with, reform it, or find a whole new sense of the di-

[2] Elizabeth Clarke, "Ten Trends in Religion," *Palm Beach Post,* 9 February 2001, sec. E, p. 1.

vine? For those looking for some greater force, a more personal "spirituality" can answer the call rather than an institution. Piecing together beliefs does not mean losing depth; it can mean finding it. Mark Rosal's self-image unravels the Lord's Prayer. In questioning faith, he finds it. George Gallup Jr. and D. Michael Lindsay, authors of *Surveying the Religious Landscape,* write: "More people who say they're exploring one thing are also exploring more unusual religious ideologies. It's like a spiritual salad bar where people can pick and choose their religious practices."[3] A proliferation of Wiccan-Zen-Christians and Hispanic-Jews-for-Jesus lead to more and more hyphenated children of gods. We either skim the surface of it all or delve into new spaces finding the divine while we stand quiet and alone at the edge of the Grand Canyon. For those of us without kids, who feel that church should be more about education and ritual, nature oftentimes serves as our altar. An acknowledgment of all our varied belief systems and an understanding of the problems with institutional religion will help all of us learn to be more accepting and supportive of one another's most intimate concerns.

Some look toward science to seek answers for salvation. With all the environmental and social destruction present in our lives, we place a huge amount of trust in technology to save our souls. As dreams of wirelessness, "better loving through chemistry," and throwing garbage into space dance through our heads, we hope that we will be able to solve all of our problems with switches of buttons, genes, and quantum positioning. We may think we are progressing forward, on the forefront of the new and the next, but new visions are recycled versions of our history. Erik Leavit's poem pulls the past into popular culture in *Taking Socrates to the Movies* and mixes death with life in *On the Death of My Father.* We muddle around in other interesting times knowing that what we have is a now that just passed by the time you get to the end of this sentence. We cannot just focus on the future hoping to develop technology that will save us; instead, we need to focus on how to live responsibly today to create a viable future.

The fin de siècle of the 1900s marked the turn of the last century, another

[3]Ibid.

fulcrum in our collective, spinning mind. Similar to the questions in this anthology, people a century ago were wondering about "the future of the human race, the apocalyptic possibilities opened up by science, the crisis of faith, the mass belief in the paranormal, the future role of women, and the multicultural 'global village.'"[4] This century is different from any other, but, for many, the "big issues" stay the same. David Siegfried in *PomoDad: 2035* is recycling remnants he sees in today's landscape to envision a future that looks much like today. Even forty years from now, imaging himself as a father, he still obsesses about health care, the aging process, and the role of technology. As we age, there is, at times, fear of letting go of our dreams and questions, of falling into complacency.

All of the stories in this part are about finding something bigger than ourselves to connect to. While the stories run the gamut from reflections on politics, religion, past, present, and future, all of the contributors are attempting to turn themselves outward into community hopes, toward a moral, spiritual, participatory gathering. The part opens with Jedediah Purdy's essay *Against Generations and for Memory* about the overall importance of remembering history and larger social and political structures. Purdy argues that we cannot find answers by being forgetful and only looking at ourselves. Nick Suplina then moves us to bridging fragments in order to create change in his essay *Between Us,* and Malka Geffen's poem *While You Sleep* imagines how the process of creating lurid dreams helps us digest the complexity of the world. That in itself is a main purpose of this book: capturing moments in ink and emulsion even while filled with doubt and questions and inspiring others to do the same.

It was Thoreau who told us to build castles in the sky, where they belong, and then to secure a foundation under them. The groundwork is our collective hope for a future of harmony (so what if our cynical attitude guffaws at words like "hope" and "harmony"?); the castles are our individual big dreams. These literary and visual fragments turn outward into community

[4] Mike Jay and Michael Neve, *1900: A Fin-de-Siècle Reader* (New York: Penguin Books, 1999), xi.

goals, toward a socially responsible basis for our lives. Not just for future generations, but so that we can all live meaningfully even with the awareness of all our problems. We can come to terms with our social roles through continually creating, trying, renewing, and trying again. Alix Olson's spoken word poem *Daughter* shouts out the dreams we have for our children, which are really inspiration for us to shape our own reality. Olson believes not in relying on the next generations for answers but in depending on our loud-mouthed, questioning selves to evolve. Our dreams are where fact and fiction conflate: who we want to be and what we wish the world could become.

Against Generations and for Memory

JEDEDIAH PURDY

After my first book came out in 1999, *The New York Times* and other major media briefly described me as a generational spokesperson. I mention this not because I think it makes me cool—I promise it doesn't—but because it convinced me that the idea of a generation is mostly unhelpful. I think it is not one that people should use to talk about themselves these days.

It is a very recent idea that every fifteen to twenty-five years people are entitled to a turnover in generational identity. Before this innovation, it made sense to identify as cohorts—people whose personalities and life paths had been shaped by the same extraordinary experience. There was a generation of American Founders, a generation of the French Revolution, a Depression generation, and a World War II generation. But there was no expectation that being born inside a particular span of years was enough to make a person part of a generation. People whose lives were untouched by the French Revolution in some remote village were not part of the French Revolutionary generation nor were slaves in South Carolina made part of the Founding generation. Being part of that cohort meant being in on its defining experiences.

The idea of a generation reflects the progress of equality in the last few centuries. Slaves and peasants couldn't be part of the same generation as plantation owners, aristocrats, and the Parisian Encyclopedists. Generations

of white people, sometimes restricted to men, became intelligible in the United States sometime around the Civil War. Through the Depression and World War II, it became more likely that Americans from all over would have enough of the same experience to recognize one another as linked by it. The sixties, which competes with World War II in defining today's idea of a generation, was the first period when men and women could have much the same coming-of-age experience. The fact that so many people find "generation" an intuitive idea today means that we think of ourselves as much more equal, or at least much more alike, than people did in the past.

But there is a reason that most of the believable examples of a generation involve war, economic collapse, or something similarly unpleasant. That is what makes such experiences strong enough to bind together those who have also undergone them. Without that sort of episode, what have we got? We have popular culture, the same politics going on in the background, and the same economy doling out chances, albeit in very unequal portions. It is a great thing to have some of these in common with other people. During the scene in *The Fellowship of the Ring* where J. R. R. Tolkien's characters are fleeing goblins single file through the pillared, subterranean halls of Moria, I was glad to be able to whisper to a friend that director Peter Jackson had fallen into an image familiar from nearly every episode of *Scooby-Doo*. When my girlfriend and I discovered that we both shook with delight at certain Pixies songs from high school and college, we picked up a piece of shared language. But there is nothing epochal about any of that. It is episodic, and the delight is in replaying episodes with new people—some of whom we love. Our collective identity has the qualities of the recently fashionable literary, social, political, and aesthetic theory that many of us studied in college: fugitive, multiple, overlapping, perpetually incomplete.

But the idea of a generation as a collective identity is both narcissistic and amnesiac. It is narcissistic because of its relentless focus on us, here and now, neglecting that like Narcissus we gain nothing by staring at our own faces. It is amnesiac because its narcissism comes from forgetting that anyone has lived before us—or before our parents and possibly our grandparents. We try to puzzle out our situation by staring at it until it shifts into some more intelligible shape, rather than by bringing in elements from

other places and times. But narcissism and amnesia are not exactly the right words: they are too high-flown and, in this case, mostly metaphoric. Putting much emphasis on the idea of a generation is lazy.

I am not advocating the policy of early American colonists, that those who do not work should not eat. Laziness has its pleasures. Lolling about delighting in your own particularity, lying in bed for an extra fifteen minutes of that fuzzy, squishy feeling between sleep and waking, watching a fun but insubstantial movie for the fourth time—I would not like life nearly so well without those. Being able to enjoy laziness is a virtue, at least compared to the vices of those high-strung individuals who cannot stand a moment that does not make them harder, faster, or more important.

But it is also important to distinguish among the different virtues that go with different activities. A Sumo wrestler's diet, although good of its kind, will not help a rock climber make it across the lip of an overhang. The pleasurable laziness of self-involvement will not get us very far in making sense of ourselves. This is not because attention to ourselves is somehow trivial or unworthy. Ralph Waldo Emerson, who taught Americans a good deal about how to be forgetful, also taught that the reason to read is to recognize ourselves in the words of others, as we are but also as we could be: quicker, brighter, deeper. The French essayist Michel de Montaigne said much the same thing: he read the authors of ancient Rome not so he could copy their judgments but in order to hone his judgment through theirs. If we are really interested in our situation, we might consider taking it seriously enough to go outside of it.

I suppose that I am talking about reading, or about history, but maybe the better word would be "memory." Memory is not just what is imprinted on our minds by the events we pass through. Memory's treatment of our own, personal experience is a process of composition, retaining some moments, pointedly forgetting others, and highlighting or inventing connections among those it retains. Almost as important as what memory makes of our experience, though, is how it connects us to history. People fight wars over who they take themselves to be, where they believe they come from, and what their identity requires of them. This is the nature of the conflicts between Hindus and Muslims in India, between Muslims and Christians in

Indonesia, and among the religions and nationalities of the Balkans, to name a few. Such ideas of history are also—in exactly the same way—the source of all kinds of solidarity, whether national, racial, religious, or political. What kind of inheritance are you carrying, or, as people ask where I grew up in West Virginia, whose boy are you? We answer that question through the idea we form of our culture's past, which is a work of memory, of weaving personal identity into larger experience.

What should we do with such memory? There have been many answers to that question, almost all of them useful. Emerson thought history a source of personal inspiration: the greatest individuals of the past provided models of human character in which we could recognize our own aspirations. As democracy and individuality progressed, Emerson hoped that more people would match the greatness of the rare few who had lit up the darkness of the past—every man a king, as a later slogan had it. Montaigne, whom Emerson admired but who might have found Emerson's New England high-mindedness a little much, took a different view: for him, history was mainly a pageant of folly, and the foolishness, misjudgment, and cruelty of what our ancestors had done should warn us against confidence in our contemporary opinions. Montaigne studied the past for generals' mistakes, the cruelty of conquerors, the inanity of philosophers, and other reminders that human enterprises tend to be hazardously flawed things. If you ever told him that you were surely right about some question of politics, religion, or morality, he would cite the lessons of centuries to prove that he was speaking with a dangerous person.

We have less of Montaigne's spirit. For him, the folly of the past drew attention to the permanent fact of human imperfection. Remembering others' failings reminded us that we are flawed vessels as much as they were. Our recent debunkers often prefer to point out that the past was less progressive than we are in matters of sex, race, and so on, with the effect of easy self-congratulation. The problem with this sort of moral snobbery is not that it is wrong but that it achieves very little to help us understand the grain and texture of experience in the past, to see what we have in common with it as well as what separates us, and so to appreciate both our persistent

failings and the human aspirations that moved our flawed and sometimes execrable ancestors.

I think of Montaigne when I consider the hazards of a military campaign waged against "evildoers" around the world. Montaigne believed that the most dangerous people were the ones who devoutly believed in their own rightness, because self-righteousness makes us willing to run roughshod over other people and, ultimately, to betray our own humane values. He believed that the Spanish conquest of the Americas and the terribly destructive European Wars of Religion were symptoms of the all-too-human tendency to divide the world into good and evil, with all the good on our side and all the evil on the other. It seems clear to me that a government should protect its people and that this sometimes means using violence. The spirit in which we do so, though, strikes as a very important question. When I look for heroes in history, my thoughts travel to skeptics like Montaigne, who believed that we were morally obliged to doubt our own righteousness.

Another use of memory is the one that Edmund Burke called necessary to civilization: achieving and sustaining a tradition. Burke was a great critic of the French Revolution, defender of the American colonists, and enemy of British imperialism in India. He considered both imperialism and revolution violent ruptures in the unity among the generations. For Burke, the way to turn the violent jumble of history into a human, habitable landscape was to remember the best principles of one's nation and always to act as if in the presence of ancestors who honored those principles and descendants who would judge one by them. Burke admitted that this way of viewing one's nation often amounted to "pleasing illusions" but urged that without such illusions there could be no humane social life. In part of ourselves, we have to believe the best about who we are, so that we can be better than we would otherwise be. Memory makes this possible by the partly deceptive labor of forming a tradition, an idea of who we are that emerges from an idea of who we have been. In the present fight over how to deal with terrorism, the American tradition of constitutional liberty is one of the strongest ways of maintaining liberty in a time of extreme fear. Without believing in that tradition—even though it has often been imperfectly pursued and fre-

quently betrayed—people who want the government to behave wisely would have fewer resources.

There is a darker view of memory, which also deserves attention. The Polish poet Czeslaw Milosz, who won the Nobel Prize for literature in 1980, admitted in his acceptance speech, "It is possible that there exists no other memory than the memory of wounds." Milosz meant that what is scored on our personalities, turned to a scar by constant revisiting, is what makes us suffer. Pain stays with us, and so pain makes the remembered world, the partly artificial personal world of history, present, and prospect in which we live. The memory of wounds is the source of much resentment and violence: nationalism's destructive face emerges from the sense of historical injury, the desire for vindication of old hurts. When the past is made up of fear and humiliation, memory populates the present with the opposite of Burke's pleasing illusions: hostile conspiracies, bigotry, the world against one— the paranoid manner that unites extreme nationalists and fundamentalists everywhere.

But, Milosz suggested, the memory of wounds can also dignify a people. His example was his own region, Eastern Europe, which was then under Soviet occupation. Controlled by a regime that distorted and erased history, the Eastern Europeans held on to their history as an act of defiance, and by remembering, they preserved a tradition that was disappearing in the forgetfulness of Western Europe and the United States. Perhaps it was only the pain of occupation that made memory possible.

What does all of this have to do with young Americans today? Americans in general, and we young ones in particular, are forgetful. We move about, leaving behind places, names, and religious and political beliefs, so that there is hardly a thread linking many of us even to the lives of our great grandparents, let alone to an idea of the nation—which might be praiseful, critical, or, at best, both. The idea of a generation that motivates this book is partly a symptom of our forgetfulness.

The best thing about American forgetfulness is that it opens us to the world. Only cranks now think of the Germans, the Japanese, or even the Vietnamese as enemies—this in a world where thousand-year-old injuries are the ordinary fare of politics in countries as diverse as Serbia, India,

China, and Egypt. In a time of great immigration, Americans are undergoing a great change in the country's racial, linguistic, and religious character, not always easily but with better grace than the Europeans, who otherwise better us in social compassion. Because our previous identity slips away from us, whoever we are at the moment seems what we have always been. This is a passive virtue, requiring no special effort, but it is still a virtue.

The problem with forgetfulness is that it makes us silly, self-important, and ignorant, which are limiting starting points. A curmudgeonly European once remarked that God issues special protections for fools, drunks, and America, and until now that peculiar covenant seems to have held. It is, however, nothing to rely on. People who want to believe in a better version of who they might be do well to begin by reflecting on who they have been, for inspiration and chastisement, but more than that, for a brief and imperfect clarity, an old light shining from behind to turn our eyes outward.

Taking Socrates to the Movies

For being the ugliest man in Athens
he walks shamelessly up to the box office.
He wants to talk to the teen behind the counter
but I pull him past, like a toddler in a grocery store,
telling him the movie's a romantic comedy with Julia Roberts.
"But the boy's hands were so beautiful," he said,
"soft, smooth as two fauns." He stops
at the popcorn machine, crane-bobs around it,
asks me if there is a perfect kernel
in the popper to mold the bursts starch and air from.
I tell him the show is starting.
He complains about the projections as we find our seats,
"fire and shadow," he says, "third-rate forms
with no more soul than a xerox of a xerox."
But when the screen flares with the coming attractions
he folds his hands and watches the previews
because even the man wisest in his not knowing
can sit back and imagine himself as the romantic hero,
common, misunderstood, and at a loss for words.

On the Death of My Father

Clouds devour ocean,
sky swallows clouds,
night opens the belly of sky,
and the stars, like moths,
are ancient with wandering,
thick sirloins sweating years of blood.

From the air
it looks so simple:
great quilts of land,
the flea circuses of pedestrians,
cars blurring the highways.

Maybe like Hemingway said,
the world does break everyone
for bringing so much courage to it,
the cold rains that keep on and kill the spring.
Death's algebra churns on ahead of us
and we are miles past the point
where there was nothing left to say,
our tongues drying like figs,
the cactus-skinned darkness settling.

Between Us

NICK SUPLINA

When at home, the contrast in my life is conspicuous. The room I stay in at my parents' New York apartment has no curtains. I spend most mornings either trying to ignore the sun or surrendering to the sounds of rain. Today, the sprawling northern view of Central Park brings a rest-digesting light. My San Francisco pad offers a partial view of Highway 101 through iron bars. Twenty-one floors above Central Park South, I can see all the way to Yankee Stadium. In San Francisco I have blinds.

I slide to the shower, search for a suitable temperature, and begin my daily watery meditation.

By profession, I'm an activist, a complicated title that usually refers to someone committed to social change and a token salary. I work for the Democracy Action Project, a diverse grassroots coalition formed in response to the 2000 presidential elections, which focuses on voting rights and democracy reform. We view barriers to truly democratic systems as the main obstacle to achieving progressive social change. It is unconventional and wholly fulfilling work.

On this trip home, by comparison, I am spending much of my free time studying for the LSAT. Friends, colleagues, and family all support the idea of law school, though I can't shake the feeling that it will only dilute my values and commitment to activism. The contrast is conspicuous. To be a sheep

or an eccentric? These overstated poles are always battling for position in this Gemini mind of mine, always alternating.

But these poles often serve me well, as my job puts me between straight-laced political types and unswerving radicals. I could, one day, find myself with the former. Work the system from within. Amass respect and power. Compromise often. Or just as easily, I might fully embrace the movement. Dogged commitment. Pumping heart. Pissed-off mother. The slick-suited, loafer-wearing politicos govern the iconography of democracy—the flags and the definitions of patriotism. The grungy-garbed, boot-boasting activists embody the spirit—the heart to get out and speak truth to power. Conspicuous. I try to engage both, which explains my ever-muddled thought process and my ever-befuddled approach to fashion.

And then a knock from outside the bathroom door.

"Nick?" It is my mother. I wholly resent the break in my daily peace. An indignant frustration quickly replaces my reflections.

"Nick, I think you should come out. We're under attack." I wonder if this is a game and contemplate my reprisal. I twist the faucet well past its resting position, wrap a towel around my waist, and bitterly leave the bathroom to confront my mother's face and the television set. Both are broadcasting absolute terror.

Two smoking towers, lower Manhattan in disarray, awestruck television journalists, death everywhere. A fire at the Pentagon? Other planes? And then the collapse. The end of permanence. Clouds of steel and glass billow smoke signals for the world to read. Something essential has begun, only to mark the plain fact that it is all over. In an instant, I'm six years old and my father tears me out of the deepest of dreams. *Grandma's dead and its time for a long, dark drive.* What the hell is going on?

North of the 59th Street apartment, the day that floats over Central Park smiles at the calamity a few miles south. The contrast is conspicuous. It is beautiful: all rich blue with bleached whites. I think that the spirits of those lost in the attack are blanketing New York with serenity. They are saying good-bye to the smoking city with the most extraordinary sky that they can deliver.

All I can see to the south is smoke and sky.

Like so many, I torture myself with the images on screen and then imagine much worse. The double takes from the offices of Tower 1 as the first plane approaches. The heroics of those trapped above the crash point. Phones ringing in flames. I am sick; I am holding my mother; I am making the desperate phone calls. I am part of a collective motion of the day—movements of panic, incapacitating sorrow, and emptiness. "We the people," the victims, the mourners, the witnesses, had a new cohesion: it seemed, we had become American.

The day possessed a saturation of color and pain and fear that was breathtaking. It was undiluted human experience—an honesty that lacked clarity but exemplified sincerity. People spoke to one another with an unusual tone that admitted humility, frailty. Even the television, that vehicle for spin and deception, seemed to glow with well-meaning journalists and humble anchors. In those first twenty-four hours, we mourned the dead with a tribute to real life.

The night after the attack, my mother, my stepfather, and I watch the TelePrompTer-like scrolling news updates on TV with religious vigilance. When the phone rings at 10:30, we are completely entranced by this fact-filled gospel of the moment. Our startled reaction would have made sense had the phone, say, melted. But it is only an out-of-place ring that catches an emotionally exhausted group off guard. I am stunned when the wobbly woman's voice begins with the usual cold-call opening, "Hi, I'm calling from Fort Worth, Texas. Am I speaking with Marc Keller?"

I look to my stepdad and with an instant impatience reply. "No, this is Nick, *can I help you?*" Who is this person? Who has the *nerve?* My vow to be gentle with these people is about to end with the most brutal, curse-heavy indictment of commercialism ever witnessed. That is, until the voice starts up again, this time more unsteady.

"Well, I'm a Keller, too, and I, uh, we, don't know anybody in New York. I mean we have no family there. So I looked Kellers up, you know. I didn't know what else to do."

I am speechless.

"I just thought I'd call some of you in New York, Kellers, somebody who," now sobbing, "oh it is just horrible, horrible what happened to you all. Are you okay? Can we help? We've been praying for you. All of you."

The conversation continues about ten minutes. I try to comfort her by relaying the stories of compassion and generosity in the wake of the tragedy. Most of all, I tell her how much it means to my family that there are people like her thinking about us. It truly meant a lot. "To hear from you," I say, "gives us tremendous hope and strength." My New York–cynic disposition usually has no space for words like "hope and strength" and yet I said them and meant them. It is a warm place, this new sincere America.

The days following the attacks are a blur of emotions, blood donations, family fights, bologna sandwich–making sessions, reunions, and vigils. My parents' apartment is an isolated center of battling facts. I favor television coverage, newspapers, and political e-mails to food. In dizzying and misguided appeals, I'm convinced I can be supportive of my family members while bludgeoning them with apocalyptic predictions of a war-torn future. I leave the apartment from time to time just to see if other people *still do that.*

In the street, looking up, I am dominated by the towering buildings. They were once so *fixed.* Everything is fragile and new.

Union Square is an ad-hoc memorial site, and I spend much of my time there soaking up the messages of peace, the monuments to the victims, and the collective ache that covers the park along with candle wax and tears. It is a strenuous type of mourning that I welcome. I need a place to put my prayers for serenity, and I can't imagine better company.

Rows of people are seated on the ground, many of them clasping hands, some crying, others focused. A northern breeze brings a noxious incense from Ground Zero. With a flash from a police car through the dusty air, I am sent deep into my memory of the April 16 IMF/World Bank protests— my pioneer trip into the world of activism . . .

The mobilization had started at 3 A.M. in the fog and rain. Some of the meeting's delegates joined us at the blockade, and the action, at least at our in-tersection, remained peaceful. I am lying down in the street ready to let the af-

ternoon sun warm my bones, when sirens puncture the calm. A single DC Police car races up the street with a black charter bus close behind. The shift between tranquility and terror is instantaneous as the police form a riot line, charge. Nightsticks come crashing down on the heads of the protestors shattering teeth and uncorking blood from noses and mouths. My composure is lost in circular panics. These are long seconds.

A sergeant whistles the officers back to formation, as hundreds of protesters create a wall between the cops and the injured activists. I find myself in the shadow of the officers as my fear vacillates between the prospects of more police violence and the potential for our ranks to lose their cool and devour the police in a mad rush.

But with an organic choreography, we hold our position as we hold one another. When the police lunge into the crowd swinging at heads and knees, we sit down, absorb their hits, and then rise to march them backward step by step. Euphoria replaces the collective panic, as the riot line gives more ground and the black bus retreats at a steady pace. An honest fear appears on the faces of the officers as their vulnerability betrays their costumes. I can no longer demonize them. As we march forward, it seems like the promise of our vision is being actualized. Might our cheers become prophecies? "Whose Streets? Our Streets!" "This is what democracy looks like!"

But before the conflict closes, one policeman, an absolute thug without badge or apology, strikes the young woman next to me, and she drops without a sound. I and another man cover her with our bodies and deflect further hits while we scream at the cop for mercy. I have never witnessed violence so vivid. "Are-you-okay-Are-you-hurt-Are-you-bleeding?" I ask as I survey her head for injury. A dirty, awestruck face looks up at me, into me, and, with triumphant repose, smiles. A smile in this! In this! It is the melodic face of our crusade—defiant and beautiful. From that point on, my cheers and tears would be for this *humanity, this America, and I vow to call the bluff of any charlatan who would ever try to pass off a counterfeit . . .*

The whisper of mourners calls me back to Union Square where humanity assembles once again. Thousands here share focus and feeling, stories and shoulders. Sirens now wail mourning cries. Loafers, sneakers, and work boots stand side by side, just as they lay side by side in WTC debris. This

group is united by a belief that we might escape the custody of violence by sticking together. Surrounded by candle flames and crayon tributes, I imagine this New York transmitting to the country the powerful lesson of our collective—*another world is possible.* These brief moments—Union Square, the flower-filled firehouses, the vulnerable street-corner conversations, and impromptu memorials—make me a resident of the same country that I was fighting for in Washington. The rumors of our demise have been greatly exaggerated.

As the memorial flowers wilt in the days and weeks that pass, polls supporting "necessary collateral damage" replace notions of collective humanity. America, it seems, is "united" in its readiness to fight and kill anyone associated with these acts, "united" in its eagerness to give up civil liberties in exchange for security, "united" in its willingness to suspend debate and fall in line behind the president. Many friends, usually quick to find fault in majority opinion, view my call for restraint as inflammatory. "Now is not the time," my parents add to the warning chorus. By most standards, it appears, I am not a good American, not the patriot that America is looking for.

All around me, I witness the misuse and abuse of the America that I vowed to protect. Slick and controlled consent-making machines replace the fumbling honesty of news reporters. Union Square was cleaned up, the homemade homage removed, the candles and sincerity extinguished overnight. Commercials and billboards tout the flag and inspirational messages but are stamped with corporate logos and stained by cues to start shopping again. Exercising dissent is traitorous, but using your credit card is now an act of patriotism. Conspicuous. I am disgusted, yet I long to belong just the same. I wonder what Florence Keller down in Fort Worth is thinking. I fear she is maxing out her MasterCard on God Bless America buttons and beating the war drum.

I look for support from my colleagues when we bring our feelings and fears to the table to discuss our coalition's involvement in the coming October IMF/World Bank protests. Our meeting is muted and necessary.

"How is everyone?"

"Okay." "Scared." "Numb."

"Is this it for us, I mean, the movement?"

"No. But I can't fathom marching and dancing in the streets after all this." Protests like these, though serious, are also festive.

"Shit, I'm scared to go outside without a flag, let alone march for global justice. Did you hear that senator say that 'Seattle protestor-types' might be responsible for this? They're going to throw everything they can at us." "They" versus "us" persists in our language. Are "we" outside of this? Hadn't "we" been attacked?

"Fear aside, it just doesn't seem like a great idea to put thousands of protestors in the street right now."

"True."

"But if not now, *when*? If now is a good time for the IMF and World Bank to meet, it's a good time for us to protest. I think we need to be ready to go, to be more committed than ever. Right?"

Sure it's right, except where it's wrong.

"Right."

"Right."

"Right."

"Definitely. Hey guys, did I mention I was applying to law school?"

The IMF and World Bank cancel their meetings. Most actions are cancelled, too, though the week of trainings and teach-ins continues as planned. The peace march that replaces the other legal marches involves thousands. But police violence before and during the event sends a warning message to activists participating in dissent. A demonstration of about twenty-five "counter-protestors" also adds a strange feeling to the day, especially one man who carries a sign that reads: "NO JUSTICE, NO PEACE!" That phrase, more characteristic of social justice protests and union strikes, now holds an uncomfortable irony in its meaning; These are no longer our words. Justice, Freedom, Democracy—ideals at the center of peace—are now part of a cry for war.

My information and outrage are largely secondhand, however. I return to New York before the march, citing other responsibilities and my mom's fear in my excuse. But I am sent home by *my* fear, my unwillingness to com-

bat massive conformity, my unwillingness to make black and white a situation so miserably gray. I no longer fit in either world. The battle between "slick suits" and "grungy garb" has left me naked. Reluctantly, I study for the LSAT hoping one day the ideals that I hold as supremely reasonable will be listened to, if only because of some letters after my name. My heart can wait. Passivity is my patriotism. This is an ugly America.

I am back in front of the television that showed the events that forced us to reconsider everything personal, everything American. Once again the screen shows stunning violence, this time in the form of the HBO World War II miniseries *Band of Brothers*. This is Steven Spielberg's America, and boy is it something. It is humble bravery and American values. It is camaraderie and conflict in the face of brutality. It is, to say nothing of its quality, extremely well timed.

Surely Americans post 9-11 are revisiting, if not actively conjuring, the "Just War" and a Pearl Harbor–style "loss of innocence." But no one conjures like Spielberg. He creates the crisp everyman heroes of Easy Company and the muddy earth tones of blood and war. I trust every wound and mortar blast like facts. On-screen virtues read like a how-to manual for Americans at war, and I feel the need to take notes.

These visuals of "simpler times" are appealing, like war footage shown at movie theaters in the forties accompanied by trumpets blaring in the background and an optimistic narrator drowning out the pain projected on screen. Going to work and being productive were the best things you could do in those days, and it seemed that there was no dissent that needed silencing. Simple.

Everyone needs something simple. These days, some purport to find it in flags and "Osama Bin Laden: Dead or Alive" T-shirts. Others stave off pain with radical rhetoric, "them" versus "us" and the like. I usually stretch my Gemini mind across the void between these worlds, or at least hide in the space between them. But the simple and the overly flexible cannot, will never, last. Sleepless winter nights and a knotted stomach are proof enough of this fact.

I dream a call to Florence Keller. "Florence," I say, "these icons and words, they've let us down. With flags waving and trumpets blaring in the background, we send our young visionaries home, too afraid to speak out for something as virtuous as peace. For peace! Those that do stand up tend to summarily discredit any contrary arguments. It's all too simple to be true.

"And yet we are able to find the saturated slices of life that reconcile chaos, remedy pain. They glow in the somber unity of New York, the transcendent smile in Washington, an unexpected phone call from Fort Worth. These are moments between us that signal our understanding, our strength, *a life that soars*. The rest is artificial, Florence, prepared only for easy and unfulfilling consumption. Left to this, everything turns black and white like old movies, the contrast too conspicuous to ever really trust, to believe in. We're empty then, with nothing in between us, and even less within."

"I know *you* understand, don't you?"

But Florence isn't listening.

On a blustery day at the end of January, I and 15,000 others gather in the streets of New York to protest the elites of the World Economic Forum. The fire at Ground Zero and the flame of vigil candles are now out. An endless war is being waged abroad while recession and defense spending reign at home. Though the political climate is as inhospitable as it was in September, we soar with optimism. As we march, I savor the sight of men and women, fathers, mothers, and children in this crowd, and I am once again reminded of the beautiful side of America that I cherish. In each exchange, truth surges. Life is being lived, though death is not forgotten. A young woman holds the sign "Another World Is Possible." I think I remember her face from Union Square.

Untitled

SARAH GERSBACH

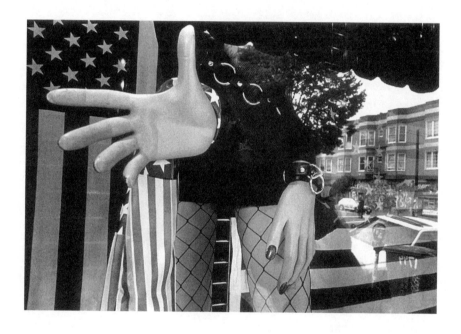

Summer Fruit
—after Bergman

D. C. STONE

If only you could pluck the past
Like summer's wild strawberries
And hold each trembling memory
Between your fingers, then you could dash

Unwanted thoughts against a stone
Or feel them burst between your teeth,
Lob them into neighbors' fields
Or pocket them and bring them home.

If the past lingered in the dust,
A patch of ripened fruit in sun,
If you could harvest and be done
With pain, every regret dismissed,

Then you would welcome your old age
And offer it the rocking chair,
Shaking the tangles from your hair.
And Death, when She stepped to the stage—

A Swedish girl in sheer chiffon—
Would gently gather up your bones
And whisper in white wistful tones,
The wild strawberries are gone.

Political Dissent
and Reflection

STEFFIE KINGLAKE

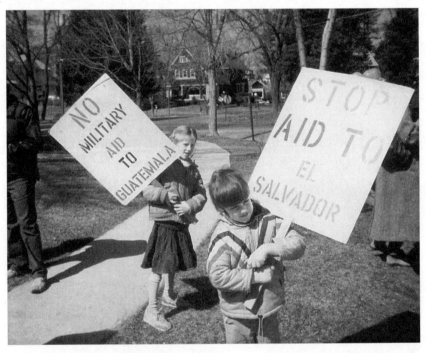

U.S. OUT OF LATIN AMERICA PROTEST, THE COLLEGE OF NEW ROCHELLE, NEW ROCHELLE, NY, 1983
(Basia Kinglake)

NATIONAL DAY OF ACTION FOR PEACE, TIMES SQUARE, NYC, OCTOBER 7, 2001

SEPTEMBER 11TH MEMORIAL, UNION SQUARE, NYC, SEPTEMBER 19, 2001

IMF AND WORLD BANK PROTESTS, WASHINGTON, D.C., APRIL 16, 2000

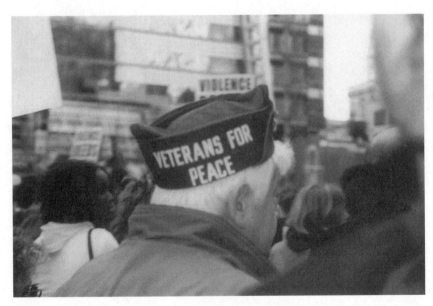

NATIONAL DAY OF ACTION FOR PEACE, TIMES SQUARE, NYC, OCTOBER 7, 2001

IMF AND WORLD BANK PROTESTS, WASHINGTON, D.C., APRIL 16, 2000

NATIONAL DAY OF ACTION FOR PEACE,
UNION SQUARE, NYC, OCTOBER 7, 2001

IMF AND WORLD BANK PROTESTS,
WASHINGTON, D.C., APRIL 16, 2000

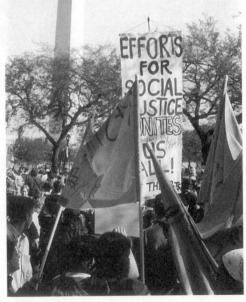

I'm Voting for Me

MARK YOKOYAMA

The first presidential election I remember was Reagan versus Mondale in 1984. I was nine years old and politics didn't mean anything to me. I knew my parents were Republicans, which meant they wanted lower taxes and less charity for lazy people. Over the years, my political opinions changed, but even then I understood that voting was pointless. We lived in Oregon, and the outcome was long decided before our votes were tallied. I saw them call it on TV after school and wondered why they kept the polls open through the evening.

The first time I really cared about an election was in 1992. I was just out of high school and at the peak of my idealism. I was a vegetarian, an Amnesty International supporter, and an environmentalist, aware enough to be passionate about issues I felt were important, but not mature enough to notice my own hypocrisy. I ate a lot of cheese, bought CDs in long boxes, and thought Democrats were much better people than Republicans. I was also about a month too young to vote.

Not being able to vote that year was a real disappointment for me. I felt disenfranchised and I was. It seemed wrong that a lot of stupid people got to vote just because they were older than me. Being a good student and even better test taker, I thought they should base suffrage rights on IQ rather than on age. It didn't occur to me then that replacing one kind of discrimi-

nation with another wasn't going to make things fair. I still love seeing motley groups of teenagers protesting curfew laws or skateboard ordinances. Kids should be allowed to vote. The ones who actually did would probably be among the most conscientious of all voters.

Youth rights movements are, by nature, pretty futile. They're impossible to organize, and by the time anyone has the skills and knowledge to effect change, they lose their primary motivation: youth. Kids don't spend their energy fighting to keep live music venues open once they're old enough to get into bars. They don't realize it's the beginning of the long descent that will eventually turn them into the people who pay $75 to see Van Morrison. Will I be buying Dave Matthews tickets when I'm fifty? I don't like him now, but age does strange things. At any rate, four years later I had long since forgotten my righteous indignation about not getting to vote as a teenager.

In 1996, I didn't vote since my vote didn't matter. I was at the apex of my anti-political swing. It wasn't apathy. I hated politics. I still believed in plenty of causes, but it was obvious to me that the political machinery was in complete disarray and incapable of helping in any way. Disheartened, I refused to play a hopeless game. Hell, Clinton had been in office for four years and pot was still illegal.

It was about me, too. I did not have time for politics. I wanted to have a good time and didn't bother with things like registering to vote. I wasn't spending my time teaching children how to recycle either, but those two things aren't the same. I blame myself for losing interest in making a difference, but I don't blame myself for not voting. A can gets recycled or thrown away. Voting was like separating the trash and sending it all to the dump.

One can't blame voters for their apathy if they aren't at least offered the illusion that their votes make a difference. In theory, the right to vote is the coolest thing we have. It is the fundamental and essential part of democracy. Even if in real life it can seem worthless, especially when choosing between two increasingly similar candidates.

Over the next election cycle, I changed again. I had to start working for a living. Having a job to pay rent is different from selling pot to buy pizza. No matter how much you don't want to admit you are now one of the mil-

lions of people who goes into an office every morning and stays there all day, you are, and it changes you. I became more citizen than student, and the government reminded me of it with every paycheck. I didn't become an activist, but I did start to grudgingly accept politics as a reality that affects me, like it or not.

I moved to Portland, Oregon, and found myself interested in local politics, which seemed more manageable. On a local level, candidates are more like real people, and the distinctions between their views are more apparent. Party distinctions are less important, and sometimes there are even more parties. Sure, there's still that sense of total futility sometimes, but a lot of the time the votes and ballot measures do matter. That's all I ask for from democracy. I don't mind if my candidate doesn't always win; I just want the chance to make a meaningful decision.

I was primed for being interested in voting by the time election fever (a pretty mild syndrome these days) hit the country again. My political perspectives were more mature and informed. I was ready to take politics seriously and make the best decisions I could under the circumstances. I guess I set myself up for disappointment.

I was almost in stitches watching the Republican convention. I could barely believe my eyes as token minorities (even a homosexual!) gave cute speeches supporting Bush, and the loving arms of the GOP welcomed them. As cameras zoomed in on the few African-Americans in the crowd during Colin Powell's speech, I was taken aback by how ridiculous it was. When I noticed the cameras repeatedly showing the four or five African-Americans at the convention, I did briefly consider the possibility that NBC was deliberately pointing out their token nature out of some sense of self-respect or for comic relief.

Comedy Central's *The Daily Show* was living high on the hog. They didn't really have to make any jokes. I'm not sure what percentage of election coverage I got from *The Daily Show*, but it was pretty high. I found this both inspiring and discouraging. Our country still supported enough freedom of the press to be brutally honest about how crippled our democracy had become but accepted it so completely that the act of pointing it out was funny. Which, of course, isn't really funny. The fact that G.W. would prob-

ably be a funnier *Daily Show* host and Jon Stewart a better president isn't really funny, either. Don't get me wrong, I love Jon Stewart, but I'm not sure he has enough foreign-policy experience.

Bush's grammar may have been the most entertaining part of politics in 2000, but Nader was, to me, the best thing happening. I was too young to remember his "Unsafe at Any Speed" years, but I still knew that he cared and that he had been fighting for the good of the little guy for a long time. Nader was intelligent, articulate, and, aside from Pat Robertson, the only candidate who wouldn't compromise his values. His only real drawback: he didn't have a chance at winning.

The practical aspect of voting is important to me, but being able to vote for someone or something you really believe in makes voting satisfying. Voting for Gore would have been practical, perhaps, but voting for Nader meant voting for the way democracy should be. Growing up in an age when there's no God and everything we do is evil, destructive, and controlled by giant corporations sucks. Being aware of it is even worse. Our only defenses are Prozac and irony. Having Nader as an option was the one reminder that hope still existed.

Actually, to be fair, there were others. I don't know if history will save a place for online vote trading, but to me, that was a quintessential example of Internet boom idealism. (In case future readers have absolutely no idea, several websites had trading venues where people could exchange Gore votes in close states for Nader votes in firmly decided states so Gore could win and Nader could get the 5 percent needed for the Green Party to receive federal campaign money.) As foolish as it may sound, to many people my age (at least educated, middle-class people) the Internet represented the possible democratization of knowledge and opportunity. It even offered the chance to subvert outdated social and political institutions simply by moving faster than they could catch up. Even putting ridiculous sums of money into the hands of young Web entrepreneurs seemed hopeful to me. Young people never had the money to buy their way into politics before, and I honestly thought it could be a good thing.

At any rate, as online vote trading went from a crackpot idea to some-

thing some perceived as a legitimate threat to the electoral college, the Internet hit a high watermark of sorts. The Internet changed how we communicated, invested, and rented videos. These things are impressive, but if it had changed how our country elected a president, that would have been awesome. Of course, it didn't have any impact. Within a few months, Aeron chair–seated entrepreneurs would realize, like the rest of us, that buying our groceries online wasn't that great either.

I actually discussed swapping my vote with friends in other states, but when it came down to the wire, I couldn't do it. Call me old-fashioned if you want, but there was something about the actual act of voting that seemed so important I had to vote for what I believed in. Perhaps it was self-ish, but something in me wanted to be satisfied rather than just virtually satisfied.

Watching the election results come in reminded me a lot of the first election I ever watched sixteen years ago. Except it was a lot more exciting. The 2000 election had everything: it was a tight race, there was the shocking and controversial reversal of Florida, and, best of all, there were moments late that night when, desperate for something to talk about, the news networks even came up with scenarios in which Oregon would decide the election. On the national news, even I was actually excited. About politics. I had finally voted, and it might have even mattered somehow.

Or not. I mean, votes don't count if they aren't counted. If there's something more discouraging than thinking your vote doesn't make a difference, it's realizing that no one's vote made a difference (except if you were a Supreme Court Justice, but it isn't supposed to be that way). Great. Another soul-crushing confirmation that reality is worse than ever. If there's anything worse than electing an idiot president who wants to execute retarded people, burn more coal, and start wars to beef up the military, it's getting one you didn't elect.

In one way, I'm back to where I was at nine years old when I first realized that voting doesn't make a difference. On a practical level, that has been proven to me beyond a shadow of a doubt. The one thing that is different now is that I have voted, and I understand why people still vote even when

they know it won't decide the election. I understand why I will always vote no matter how hopeless it seems, whether they count it or not. It's still a chance for me to say what I want, no matter who isn't listening. Even if I'm just voting for me, I'm going to do it. It's the least I can do. In some ways it may be depressing, but I'm not going to stop believing in democracy even if my country has.

Holy Trinity

MARK ROSAL

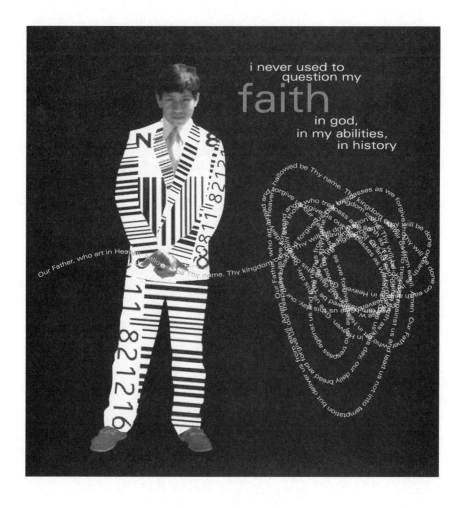

PomoDad: 2035

DAVID SIEGFRIED

I always believed that the year 2000 represented another point on a chart illustrating order and progression. Maybe that idea was a result of the popular notion that time follows a linear path and that hysteria is part of the nature of things. But when I heard Rabbi Soebal say *the nature of things,* I assumed he was just trying to confuse me. In hindsight, the year 2000 was simply another moment.

I graduated college five months after the new millennium began. There was this guy I knew who wrote his philosophy thesis on "What's Going On." I never read it, but I heard it was interesting. I heard my thesis was interesting, too, but I never read it in full. My thesis was on Zimbabwean stone sculptures, but my memory tells me it was about much more. I never knew how much more because I never read it in full.

Back when I graduated, my parents were big on health care. Now that I'm a parent, I too have to be big on health care. In the thirty-five years since I graduated college, trends have come and gone; fashions have thrived and died; nations have been terrorized and subsequently globalized; and economies have crashed, boomed, and folded in on themselves. Yet not once have the powers that be considered health care a universal human right. I used to argue with my father about it all the time. Our arguments weren't political,

but, rather, he wanted me to be protected, and I resented that I needed to be protected. Now I want my son to be protected, and now he resents me, too.

My son graduated college this year with a degree in socio-cultural artistic philosophy. He is finally prepared for the world. I, of course, am very proud. He wrote an exemplary thesis on something about the structural-postmodernists and their attacks on more traditional forms of postmodern thought. It was quite an accomplishment, but, I must admit, I never read it in full. I don't think his teachers did either, for they said that he said it all, that he really understood the need to add an abstract structure to postmodern theory, and that, despite the paradox, it provides a nice crutch for the postmodernists who, without the aforementioned abstract structure, would be abandoned and stranded on their makeshift, academic rafts. Hearing that made me remember how thirty-five years ago, I just wanted to be getting out of school.

I remember being shocked by the speed of life. When I graduated from college, I maybe checked my e-mail two, possibly three times a day. Never did I imagine they would develop those Palm-vibes that made your palms buzz whenever you received an incoming message. I'm relieved that those finally got recalled, and I still feel just terrible for that sixteen-year-old. When I went off into the world, people called me young and naive. Yet now that I'm not young, I guess that would make me not naive, although not much has really changed. Marijuana twisted up in idealism was my drug of choice, and through its haze I could envision a world that respected more and defecated on less. But when I graduated college, brilliant skepticism and unquestioned innocence sparked flares of sight through society's thick walls of wool and provided my brain with a release in which I could feel as though I were cut free from the dark, elusive spins that attempted to define my existence. Today, idealism and pot are still my drugs of choice, but now I can't help wishing my son would get a job that covers health care. I'm not sure why I feel that way; perhaps it is because the world forces compromises. But were my ideals compromised by experience and emotion, or did I just sell out? Maybe life moves too fast to even address that question. Someone told me that at a party about twenty-five years ago—that wherever you might be, doing

whatever you might be doing, feeling whatever it is you are feeling, there is bound to be a reason for it all. It's in the nature of things. While that insight was hardly revealing, something about it was encouraging and made sense. I have not thought about that guy and his reflections until right this moment.

It seems I have forgotten many memories, or at least rearranged them, patching bits of my past together with sticky nostalgia. But that is why, if you ask me to talk about youth, you better plan on staying awhile. I get excited thinking about it, maybe because I got old. I know many people my age who don't think about youth because they never got old. When I was young, I thought moving to California would prevent me from aging. I would go and start a timeless artistic revolution aimed at saving the planet from itself. Through art, I would present to the world a field of its own illusions. You see, I had thought about it! California was the place to go. After all, no seasons, no time, no limits or boundaries for production. California—a playground for subversion! The streets of the entire state submerged in dot-com glory, drinking overpriced organic juice and rejoicing in the year 2000's first newspaper headline: "Computers Prevail in Millenniums First Hours!!"

With that prophetic headline, YourWorld.com was spawned. The bright young PR Stars hailed the coming of the information era. It was time for all them liberals to get rich quick, dot-com style, and getting rich could be more "conscientious" than in the 1980s. At that time they had the rationalizing spin of progress to justify their actions. Some companies even had pinball machines and espresso carts in their offices! And the beauty of it was that nothing physical was ever being produced; people were not making money through creation—simply the provision of information. The "providing of services and progress" replaced the passé capitalist anthem of "rape the poor and pillage the people of color." It seemed people realized that to steal and oppress with style involved tact, and who better to provide tact but the PR Stars. Everything had to be a tad more discreet, and the advertisers and PR Stars became one in the creation of a wool so thick that even if you knew it was being pulled over your eyes, you still could do nothing about it. It was and is everywhere. *Here at YourWorld.com we believe in the progress of humankind. We believe that there should be no difference between the First World and Third Worlds. There should be no separation between the developed*

*and the underdeveloped. We aim to make every society and every individual of society equal and one. That is why for a mere expense, as well as some minor import taxes, all former Third Worlds can increase their speed of development to catch up with the mighty Northern Nations, by investing in YourWorld.com to provide everything from staple foods, to culture, and medicine generously distributed by Pfizer and Procter & Gamble. Thanks to the Monoculture Globalization Act of 2008 passed unanimously by all the members of NATO, the Group of Eight, and the mighty W.T.O., now all developing nations must turn to YourWorld.com for all their development needs.**

Further, as we all know, the Swiss were supposed to be cloned. Yet some scientist found a single southern African component to the Swiss DNA, and he declared it a virus, and the project was swiftly abandoned. Later that scientist, I forget his name, was given a Nobel Prize. The significance of his discovery, however, was not just simply the recognition of a potential virus-causing agent. Socially, somehow, the idea of race just seemed to vanish. I even remember a straight white fellow who often declared he was a gay black man. Scientists, the PR Stars, and civil-rights leaders couldn't necessarily explain; they just told people to roll with it. But no one knew how to judge. Since the fear of suddenly becoming "the other" threatened everyone's sense of identity, a wave of fear swelled upon our shores and crashed down catastrophically, submerging the human existence under a sea of doubt and debris. For the next fifteen years, during a period history has dubbed as "The Lost Night," chaos and disorder entered the world. But then science found a solution in the form of a vaccination. The vaccine was developed by the daughter of the same Nobel Prize–winning scientist who had discovered Sub-Saharan DNA in the Swiss genetic code, and, just like her father, she too won a Nobel Prize. Once again, order, coupled by a secure sense of self, was restored. This Nobel Prize–winning scientist spoke at my son's graduation. It was a thrilling speech, although I didn't hear it in full. I fell asleep half way through. All I remember is something about scientists needing to be more moralistic in their endeavors. I was very proud of my son.

*DISCLAIMER: Delivery of Northern Nation culture to developing nations may take six to ten years due to high consumer demand and backlogged lists.

My son doesn't have a clue about what he wants to do with his life. I try to tell him that the decisions he makes now will affect him in the future, but he wants to "discover things for himself." He should listen to me. I didn't listen to my father, but I also never made it to California.

A few months after I graduated, one of my best friends was killed in a fire that burned down his house. He had no idea what he wanted to do, but he said that his mom wanted him to do something that provided health care. No one knew that in two days his body would be taken over by flames, leaving him dead and me with horrible visions for years to come. I remember feeling that his fate proved that the only definite health-care plan was life itself. There was no health-care plan in existence that was going to give him his life back, and I cried that we should all just live and not ever think about the *what ifs*. Nothing, not even full coverage with dental and vision, was going to save him or make the reality of that explosive night promise him one more morning for him to wake up to. He felt eternal sleep, and it ended his physical existence like switching off the TV too fast—one lone line of rainbowed pixellation remains but then, poof—blackness.

Through his death, however, I gained an odd sense of belonging. It was one that was not confined to a certain town, street, drink, or place. It was simply a sense of belonging to the moment and the moment only. His death taught me of the necessity to weave and bob my way through the world and not to let the world move through me. To not let the world move through me was to see the present as simply being a moment, and only when the present gets linked to the past or shackled to the future does the moment die. When I would be swept away by a social current, all I had to do was find myself where I could, stand up, and force myself to realize that I could get out of the river if I so desired. Yet, still, the pressure of having to define yourself or even to locate yourself in a world that swallows you is inescapable. Was I my father's son, or the son of my father? Was I the romanticized, literary, beatnik, rude boy out of control and racing a mad dash to win Kerouacian ecstasy? Was I me? Or someone else, and is it ok to shop at this store, or do they buy products from sweatshop labor too? Do I need to buy a cell phone, or can you be in New York without one? In addition, at this point I still had no health care, and my father was nagging me about mak-

ing sure that whatever job I took, it had to provide health care. He sounded so draconian every time he'd start up on the great Siegfried job search . . . I wonder if that is how I sound to my son . . . Naaa . . . I'm cool, I'm hip. But maybe that's what my father thought about himself, and now I have rationalized my way into his skin, and my son, will he do the same? It makes me wonder that the times can change, technology will progress, but can time, progress, and technology change our basic concerns and insecurities as social beings? I'm ashamed that I want my son to get health care, but I don't want to worry about him. It's not that I'm selling out to YourWorld.com; it's just that I love him dearly.

Eventually I got a health-care plan, not because my father made me but because I got older, and, without it, medical visits can dump you into the bottomless pit of debt. Health care should be a universal right, but it's not. Maybe someday we can force ourselves to change that around. But for now, I'm glad I have it, because the other day I cut my chin with my SHAVEBUDDY 2030®, and I had to go to the hospital. While my lovely partner-in-life-and-parenting was driving me to the hospital, she e-mailed the emergency room my entire medical history, including all my health-insurance information. When I arrived everything was all ready to go. I was in and out of the hospital in ten minutes, and I didn't even have to explain to the doctor what was wrong. I have full medical coverage, and in fact it's so full that it entitles me to priority attention over others. That means I get to go on in ahead of everyone else, even if someone has a gunshot wound. As the doctors were mending me, I looked down at my insurance cards and sighed. I don't understand why my son is so "anti." I mean, when I was young, it was all right to be against health care because socialism provided a better alternative. I miss socialism. I wished it hadn't been thrown away. My son yells at me and calls me an ignorant pig for not seeing the reductionary nature of socialist thought. I ask him what he means by "reductionary" and he throws up his arms in intellectual disgust. I should have never paid for that damn college. He, like me, wants to move to California, but I want him to get health care. When *I* eventually did, my father finally relaxed. I also would like a deep breath too.

daughter

ALIX OLSON

I'll teach my daughter to bang on anything that makes a beat,
she'll shake-a-boom, she'll quake a room
she'll paint her cheeks warrior-style, then smile,
beguile you, turn you inside out til your guts plead guilty.

She'll be built like a truck, built to work you down
as she works herself up.
She'll make holes in the streets in her ten-inch spiked heels,
in combat boots, stilts, on roller wheels,
she'll stroll through Male Pride,
Amazon Babes at her side.

She'll relinquish White Privilege
observe, be wise, she'll compromise
when the fire is stoked by other womyn's desires,
but she'll never leave the flame.

All the same she'll crave what makes her burn,
she'll learn her Cunt's good name—
the thick red lips, the small hot tip,

no more of this cryptic shit.
This Vagina will be known.
She'll park in all the wrong places,
make faces at police cars,
wind up behind bars, bust out big before serving her time,
fingernails full of this grime we call

Reality,
She'll dig her way through.

She'll pick her nose when she has to,
she'll scratch her ass,
she'll be a crass medusa child,
a wild healthy fiend,
she'll live in all fonts and all sizes
curly q's, caps, italics, and Bold.

She'll fold airplanes out of shredded Cosmos and Mademoiselles,
then pilot them to Never-Say-Never Land,
where Peter Pan's gay and Wendy's
ok with it.

She'll wear thick braids, she'll shave her head,
she'll eat thick breads, she'll let her breasts flop,
she'll mop the floor like Cinderella, then with
Rebellion-Prowess,
she'll unionize daughters for a higher allowance.
She'll be male and female and
in-between.
She'll preen, then crack her mirror, crack a beer,
and watch Love Connection.
She'll go for days without taking a shower
just to feel unchained ivory-slave power.

She'll want more than what she's "entitled to"
she'll watch through Nike commercials, and she'll
 Just Un-Do It,
ask who's making that shit, who's breakin' their backs
keeping her breaking that
glass ceiling.

she'll do all of this.

and she'll do none of this.

and it's funny how we hide behind these daughters,
hide ahead of our own Herstories
scared of ourselves,
scared of the world,
scared of someone who made us
one way
or another.

Well, this time around, I'll be bound to my own
mind womb
in my own birthing room,
I'll squeeze out, squeeze out
each crimson thick belief,
then eat each pungent, sweet placenta
and relieved,

I'll tear up this country's
"Welcome to the World" certificate,
tear off my father's
father's father's father's
name,
I'll legitimate my own entrance into a
Thinking Existence,

I will birth myself towards
Resistance.

But no frantic tick-tock of this Biological Clock.
On my own time, Foremothers at my sides,
Sisters as midwives,
I'll cut my cord, head for that War,
I will mother myself into my own grown daughter
and I will call myself
a home-grown
woman.

The Schrödinger Treatment

LEE KONSTANTINOU

The lure of success had drawn my friends away from Cornell University, but I somehow found myself left behind. It wasn't that I had no options. Indeed, I had too many. With a double major in English and biology, I got lots of offers, but I didn't take the corporate job, didn't go to grad school, didn't travel abroad to teach in some impoverished nation. I had too many interests, I told myself. I couldn't rightly commit to any one path. The thought of locking my future on to a single target and giving up all others terrified me. In school I could pretend to do everything, wedge myself between science and literature, take whatever classes piqued my interest. Now I had to choose, to be either this or that. I often recalled my third-grade teacher Miss Glass saying:

You can live your dreams and change the world, class, if only you're true to your heart.

This is the right thing to say in a democratic society, but it's not actually true. Miss Glass's loving reassurance now resonated with irony. School loans forced me to defer thinking about life and to accept a job at a used bookstore in Ithaca. A year after graduation, I still hadn't left the dead-end job or thought about the future. I lived my life one paralyzed day after another. In limbo. Hardly made enough to pay my bills.

Then one day in July, Professor Martin Salazar sent an e-mail to his former students offering $40 to participate in a fifteen-minute experiment. I needed the money so I signed up. After a day of shelving dusty books, I left work and reentered Uris Hall, the cube-shaped psych building, for the first time in more than a year. It seemed different now, like a catacomb, as if the very walls and doors constituted a diabolical experiment on human bodies. Surprisingly, a graduate student, not the professor, met me at the lab. I recognized her. As an undergraduate I had lusted after her from across a lecture hall of five hundred students. For an entire semester I watched her, but we never did meet. *Another person doing something with her life* was what I thought now. I introduced myself and followed her into the lab. She wore jeans, a tank top that was tight (but not distastefully so), and stylish narrow glasses. Her straight dark hair framed her face beautifully. I became aware of my soft belly, poor posture, and slovenliness. Food-stained shorts, half-tucked T-shirt. I sucked in my gut, brushed my hair into shape. The room was small and windowless. Three computers hummed on a long table against one wall. A single sputtering fan swiveled back and forth on the floor, intermittently cutting the humidity.

What's your name? I asked.

Minnie.

Minnie, like the mouse?

Minnie, like Minerva, the Roman goddess of wisdom.

Oh.

Minnie's first impression of me gelled. My friend Kerry, who at the time worked as a wealth analyst for J. P. Morgan, had explained the way such impression making worked:

Women decide if they'll sleep with a man immediately, Lee. They close the deal within the first thirty seconds of contact. Click, click. Just like that.

And so had Minnie clicked with me.

Before we begin, she said coolly, read and sign these forms.

She presented her clipboard. I signed my name blindly. Minnie's cool hands brushed against my face as she fastened an eye-tracking apparatus to my head, securing the straps tightly against my skull.

Read the sentences that appear on the screen, she said. Select your choice with the mouse to fill each blank with a word. There isn't a right or wrong answer.

The experiment began. I answered thirty fill-in-the-blank questions on the computer. Afterward, Minnie explained the purpose of the experiment:

Martin studies artificial intelligence, tries to create neural networks that simulate how we make choices when presented with ambiguous cues. He thinks quantum-mechanical processes are involved. Some in the department frown on his work. You know, non-computational Platonist types. They believe the mind is impossible to know and worship Roger Penrose, but for all the wrong reasons, of course.

Of course, I said. Having nothing remotely intelligent to add, I said, Um, well, see you around campus, Minnie. How much do I get paid?

Forty dollars.

Minnie paid me and, turning her attention to a computer, replayed a slow-motion recording of my blinking eyes. My irises seemed large and alien in the open window. I inched toward the door. Before I closed it behind me, Minnie said, Wait, Don't go yet, Lee.

What?

How'd you like to make $100?

What would I have to do?

Another experiment. These results look promising.

I liked the idea that my results looked promising. I could also use the $100.

I'd love to follow up, I said. I looked at Minnie's perfectly proportioned face. Her eyes wide with eager intensity. Maybe Kerry isn't right, I thought. Maybe I still had a chance. Minnie took a small box from a shelf. Inside the box: tiny blue pills.

You'll need to take a pill, she said. But first you must sign more forms.

What's it do?

It's just a harmless isotope that'll get into your bloodstream for tracking purposes. The real experiment happens tomorrow. Take one and come back tomorrow afternoon at five.

It all happened so fast. I wanted to make a good impression so I signed

her forms and swallowed the pill. Going home to my apartment in the Commons, wondering what I'd committed myself to, my thoughts scattered in a million directions and grew increasingly disoriented. The treetops blurred together, the pavement seemed incoherent, the sky bubbled a shocking fauvist blue. When I walked down the hill I couldn't remember if I'd taken Buffalo Street or Seneca Street. Somehow I remembered walking each street, as though I'd walked down both. I couldn't even remember if I'd walked on the left or right side of the street. As I concentrated I lost my sense of where I was. A couple inches ahead, a couple inches behind, all together, all at once around a central locus of me. Hands rose above my head to touch the sky; grasped my hips as I flexed my spine; searched for keys in pockets; thumbed the new money in my wallet. I let my instincts guide me home, tried not to think too hard. I unlocked the door to my apartment. My senses still felt flooded, but better now. I microwaved a dinner, read part of a novel, dabbled with a short story that I couldn't get off the ground, then prepared to sleep. Brushing my teeth, I noticed another strange occurrence: my reflection seemed multiple in the bathroom mirror, simultaneously in many slightly different places, fuzzy. The mirror was like a multifaceted gem, breaking my face into pieces, a cubist face. Did I need glasses?

The next day at work my boss, Jill, said I seemed distracted. I'm fine, I reassured her as I shelved books. Of course, I wasn't fine: I couldn't get Minnie off my mind. Why couldn't I date a girl like her? I was as smart as the next guy. I just lacked confidence. I could snag her if I were more decisive, I decided, as I picked up a book to shelve, Graves's *The White Goddess.* I'd always wanted to read it; now that I had money I could even buy the old tome, but I had more books on my bookshelf than I could ever commit time to. I leafed through the yellowed stale-smelling pages of Graves's history and realized that I'd already read it. I turned to random pages, remembered his prose very vividly. As if I'd just read the whole damn book cover to cover. I felt dizzy, confused. Throughout my shift, every time I'd select a book I recalled reading it, even though I never remembered *actually reading* it. Something felt very wrong. Although I couldn't quite articulate what.

After work I tried to focus on which street I took up the hill. At the top of the hill I recalled walking three paths. Weird. When I got to the lab it

took a few minutes to feel like I'd fully arrived, as if I'd left a wake behind me I needed to recollect. Minnie opened the door. Professor Salazar hunched in front of a computer playing a game.

How was your day? asked Minnie.

Fine, but a little strange I guess.

Minnie smiled mysteriously, and asked, How strange was it?

I don't know, I said. I found myself remembering books I've never actually read. Does that make sense? Like my memories are incomplete or too complete or not real.

Professor Salazar swiveled in his chair. He had on shorts, a T-shirt, and sandals. His ponytail and goatee mismatched the austerity of the label professor.

Your memory is fine, Lee.

I asked him what he meant. Salazar shut down his game and brought out a sealed bag.

Sit down. Let me show you what I mean. Do you know the contents of this bag?

Well, no.

Neither do I, and neither does Minnie. We only know that ten slips of paper with information are in this bag. You'll pull one at random. I'll read it and that's it. Easy, right?

Yeah, I said. Easy.

Salazar unsealed the bag. I drew a slip of paper.

Lily's mother is named Susanne Walker, Salazar read.

What now?

Now we ask you some questions, said Minnie. She looked down at her clipboard. What kind of dog does Thomas own?

A Labrador retriever, I answered.

When was Peter born?

On February twentieth, nineteen seventy-eight.

I answered all nine questions. I remembered Salazar's voice reading each slip of paper. I had ten memories, quite distinct, equally vivid. Salazar reviewed the slips of paper.

You answered every question correctly.

How could I know the answers?

You know the answers because in parallel universes you selected different slips of paper.

What? I don't understand what you mean.

I call it the Schrödinger treatment, he said. Have you heard of Schrödinger's cat? You took Cognitive Studies 101.

I searched my memory, and said: It's an experiment where physicists kill cats, right?

Minnie giggled. Professor Salazar smiled elfishly.

No cats are killed, Lee. It's a simple thought experiment. You must first understand that physicists describe the tiniest aspects of reality, like atoms and electrons, not as solid objects but in terms of wave functions. The wave function doesn't say that an electron is here or there, but most likely here or there. To figure out where the electron actually is, an observer must measure it. For example, if an electron has a fifty-fifty chance of spinning up or down, both realities are simultaneously true until we measure the spin of that electron. Make sense?

No, I admitted. Not really.

Of course it doesn't make sense. People don't experience the world like electrons do. Let's not dwell on the details. Imagine a microscopic switch— let's call this a quantum switch. This quantum switch has a fifty-fifty chance of being either in the on-position or the off-position. The wave function says the small switch is both on and off at the same time, that the two states coexist in superposition.

I suddenly started to understand Salazar's explanation.

The switch is on and off until we measure it, I said. And then it has to be either on or off. Still, what's this have to do with a dead cat?

Imagine a quantum switch connected to a cyanide capsule. If the switch is on, the capsule breaks. For a cat sealed in a box with this capsule, the capsule determines its survival.

Does the box have air holes?

That's irrelevant detail. Try to image what would happen.

I tried to imagine such a switch, and said, When the switch is in superposition, the capsule with poison gas is both broken and unbroken, and the

cat in the box is both alive and dead until someone looks inside the box. But a cat being alive and dead at the same time? That's ridiculous.

Ridiculous, but real.

I don't understand what this has to do with me.

There's an interpretation that accounts for the ridiculous called the Many Worlds interpretation of quantum mechanics. If the wave equations are literally true, then for every discrete quantum outcome, our universe, which seems singular, splits into an exact replica of itself with minor differences. In one universe we open the box and see a dead cat. In another we find it alive. Reality—the multiverse—effectively contains an infinite set of such parallel universes, each with slightly different versions of you, of me, of Minnie. I want to enable subjects to access information from their own minds across different universes to experience the world a little more like an electron than a person so we can learn more about human consciousness. Unless you take more pills you'll decohere into the universes you've experienced by the end of the day. For coming this far, let me give you this $100 bill. Decide if you want to continue with the experiment, Lee. You're under no obligation.

I didn't know how to respond at first. But as I concentrated I could recall multiple memories of our conversation. Within each distinct memory Salazar had said more or less the same words, but the details of his explanation were indeterminate, cloudy, contingent on my reaction, my responses. I realized Salazar stood neither here nor there. I could linger on one image of him, live within a particular perception, with a particular set of memories, while simultaneously aware of others pressing against my consciousness. Like being cross-eyed, except each of my dozen crossed eyes observed a different reality, all the images somehow recombining in my mind. For every meaningfully different universe, an infinite number were minutely, mundanely altered.

Guess the pills aren't harmless isotopes, eh? How do they work?

Salazar smiled, and said, You don't need to know. My work's classified, of course.

Of course. Are you allowed to do these experiments? Is it safe?

It is now.

Now?

Animal trials helped perfect the pills. You'll need to take one every twenty-four hours. Otherwise, the effect will subside. Minnie will give you seven each week. I'm busy working on a grant proposal. It's been hard to focus on, you know.

He pointed to the computer where he'd been playing, as if to say he was having trouble finding time with these neat games tempting him.

I need to think about it, I said. It's so much to swallow.

I understand, Lee, said Salazar, smiling. Take the next pill, experiment with your power. Let us know by tomorrow.

After I swallowed the next pill, my awareness of different universes amplified. I wandered around campus, eventually settled on a couch in the undergraduate library to watch the sun approach the horizon. Could I resolve my plague of indecision with a little pill? Maybe seeing myself traverse every possible path would finally appease my restlessness. As the library clock tower chimed the hour, a thought struck me. I was in a library. It would be open for another hour. In the stacks, I chose a novel, processed the entire book in about three minutes, knew it more thoroughly than I'd ever known any book. I selected a second book, a third, a fourth. Before closing, I'd perused dozens: books of mathematics, metaphysics, medieval hermeneutics, books I never had the time to read before. There was no excuse not to learn about anything that even casually sparked my curiosity. I could master everything within the scope of human understanding. How could I turn down Salazar's offer? I left the library reluctantly and that evening read every book in my apartment, books I thought I wouldn't get to for years.

I called in sick to work the next day. I couldn't wait to return to the lab. Every moment waiting increased my anticipation; I tried to go early but the lab was locked. No sign of Salazar or Minnie. I spent the rest of the day reading, wandering the campus. I managed to read hundreds of books, lifetimes of knowledge transmitted directly into my mind. I could be the greatest novelist who ever lived, the greatest scientist. I could compensate for any lack of analytical and creative ability with a breadth of knowledge. *Now that I can do anything, what do I want to do?* I wondered. The answer was, of course, everything, which used to be a silly answer, but now I could consider it seriously. I went to the lab at 5 P.M.

I definitely want to do this, I said.

That's wonderful, said Minnie.

I told you he'd agree, said Salazar, not turning from his game.

Minnie made me sign some more forms, complete some more tests on the computer, then gave me a packet of seven pills. Afterward she returned to writing the grant proposal while Salazar played his game. She seemed to be his support structure, his safety net. She looked so beautiful. I was ready to ask her out for dinner when she curtly said, Come back tomorrow, Lee. Martin and I have a lot of work to do.

I didn't like how she called him Martin. Were they together? I felt jealous. Her gaze seemed distant, mysterious. She had no reason to think of me as anything more than her subject, but I wanted more. I wanted her to consider me worth dating, worthy of her precious attention.

I turned to her and said:

[SCENARIO A: P = 80%]

I was actually wondering if we could, um, have dinner tonight. I've really enjoyed working with you, even though it's only been a couple days, you know.

Oh, how sweet, but I can't do dinner. I have to get back to this grant proposal, OK?

[SCENARIO B: P = 19%]

I know you're really busy, but I really need to talk to you about something important related to the experiment. Could you spare about half an hour to talk?

I'm sorry but I can't—I have to get back to this proposal. Would tomorrow work?

[SCENARIO C: P = 1%]

Is your grant proposal more important than me? Are you so eager to get back to fucking Salazar?

What the hell is wrong with you, Lee? she asked, appalled.

In the small fraction of universes where I attacked Minnie, Salazar coolly attributed my outburst to psychological instability and removed me from the experiment. I felt so humiliated I didn't protest. Soon after I stopped taking the pills in those universes, my awareness of them tapered to nothing. Memories of them became inaccessible. A dozen books fragmented into pieces, hundreds of pages gone missing. I realized I couldn't sustain my new-found knowledge if I kept losing memories. I had to avoid offending Minnie or Salazar. I also felt terrible for yelling at Minnie, even if only in a few universes. *How could I lose control,* I kept wondering. *Am I determined by laws of probability, ready to explode anytime?* The more I avoided these negative impulses, the more inevitable it seemed that I'd succumb to them in at least one or two realities. I soon bore guilt for all my dishonorable thoughts and feelings, for couldn't imagining a possibility be as foul as living it in the multiverse?

I skipped work again the next day, immediately (obsessively) patched the holes in my memories, rereading splintered books. Then I added a thousand new books, realized if I continued to become aware of new universes so quickly I might soon run out of books to read. I could now read books almost as quickly as I picked them up, two or three simultaneously. I might apply this power to learning languages, mathematics, physics, everything— although even the world had only so much in it to learn. That night while being tested at the lab, I told Minnie about all the books I'd read that day, trying to impress her.

What do you recommend? she asked.

I don't understand, I said.

I'm looking for a good book to read in my spare time.

Well, I said, stumped. I don't know.

Had I actually enjoyed any of the books I'd read? I just sort of knew them—plot, characters, setting. The pleasure of reading came from spending time with books, which I hadn't done. Leaving the lab, I decided to try living linearly a little, to spend some time doing one thing in every universe, but while visiting the Art Museum I saw paintings from many slightly different angles: Picasso seemed infused with new meaning, but Matisse made

me light-headed. My favorite Monet became a muddy mess. Going home, despite my strongest efforts, my Walkman played at different instants, blurring each song into inchoate sound. At home, I opened *The Great Gatsby* for comfort. As I read, Fitzgerald's gorgeous prose overlapping impressions overwhelmed me. I just couldn't follow the same book in every universe. In some I read page seven, in another page eight, in another page twenty. How could I enjoy the novel without a linear sense of its story? I felt mortified. I turned over the words of Nick Carraway, the narrator of the book, who suggests personality is "an unbroken series of successful gestures." If I had to pick from different series of gestures across universes, which would I pick? Which sequence of moments was truly me? Was berating Minnie a success? Was it me? I tried to write my impressions in my journal, but in each sentence I saw subtle differences in syntax and intention across realities. A million different texts of me. Which was real? Damn it all, I had to know, to establish some new standard of beauty for my life, a new aesthetic. Compounding my despair, I realized I couldn't keep taking days off from work. I'd eventually have to return to the bookstore. The mundane facts of my daily life anchored my personal Argo in its port. Even self-anointed Argonauts of the multiverse must eat, pay the rent, and scrub the toilet clean. But no! I couldn't accept such limitations.

The next morning I woke just after sunrise. From the university entrance I simultaneously stepped in a hundred different directions. Toward the Arts Quad, the Ag Quad, the Engineering Quad. Inside every building. Into gorges and onto hills. The clock tower chimed the Alma Mater over the morning mist, which broke as if in response to the sound, in anticipation of my apotheosis. The bell vibrations resounded in my bones. I pushed, split universes into finer gradations, rotated my body to random angles so that everywhere I stood I perceived a panoramic perspective of my location. I strained to maintain awareness. My head hurt. I took another pill now, early, waiting for its power. And I pushed. Soon I sat in every seat of the football stadium, looking down at the empty field where in some universes I also stood. In front of the Hotel School by the statue of Hercules, a man approached. A homeless man, well known around town. Old, fat, endur-

ingly strange, almost part of the landscape. He stank. He wore black sunglasses. I saw my fragmented reflection in them.

You see it, can't you? I see it in your eyes. You see it too.

I held my ground. I wouldn't let him destroy this perfect moment.

I see today's a beautiful day, I said. I offered $10, hoping to satisfy him. He wouldn't take it. The bill fell softly into the street.

I thought you saw, he said. Am I the only one?

Please, go away.

I wondered about what Salazar had said about the test trials of the Schrödinger treatment, trials conducted on what he called animals. In one universe, despite my better judgment, I asked, What's your name?

Sorry, he said, even in universes where I didn't ask the question. I thought you saw. My name is Harold T. Hogarth.

And he left. Now I felt ready. I let the campus rush my senses. I coexisted on every quad, in every building, everywhere. I saw the campus from every perspective, simultaneously. Cornell in early morning superposition. Overwhelmed, I lost consciousness.

I woke up at home; in a grassy field; on a park bench. When I went to work, five hours late, Linda fired me on the spot. When I told Salazar I'd been fired, he told me not to worry.

Stage One has gone phenomenally well, he said. My sponsors want to accelerate the treatment schedule. We'll provide for your basic needs as long as you stay with us.

They'd provide me with a life on a platter. I said I needed time to consider the offer. The next morning, in one subset of universes, the *Ithaca Times* announced the death of a local homeless man, found in the gorge. These were the universes where I met the man; I still could smell his reek on me, the residue of our encounter. Suddenly terrified, I wondered: *Did my being in a random place at a random time change some vital flow in his life in a way that caused his death? Did my coldness drive him off the bridge in despair?* To allay my growing anxiety, I did nothing but read for days. After several days I started to notice inconsistencies across universes. Newspaper headlines mostly stayed the same but back pages diverged, differences creep-

ing closer and closer to the front page. Had my behavior subtly changed the course of history after only five days? More likely, I realized, I could sense not only variations in my life but in the lives of others as well, different possible decisions people made in parallel universes. Soon, if I wanted to know what was true of the worlds I lived in, I'd have to take a whole hour for each paper. I'd soon be back to square one, living in universes that changed faster than I could master them. I used to dwell in physical moments, between the Commons and the University. Now I dwelt completely in my tortured head, my consciousness surfing a tenuous wavefront of possibility, in perpetual liminality. I felt like the solipsistic narrator of an essentially masturbatory story. Where were the other people in my life? The only common element across universes, across each lifeline, was my subjectivity. Me. My life seemed meaningless now, fundamentally inhuman. I was nothing but a subject. One of Salazar's fucking electrons. I could only choose to continue with the study, but then making my own so-called choices had felt empty when I couldn't contrast them against choices unmade. I wanted more than anything to tell a simple story of my life with a beginning, middle, and end. I wanted my life to make sense again, even if it were all a big lie. I wanted to be free.

Are you doing Stage Two? Minnie asked one evening after testing me. I really hope so.

I looked at Minnie. She wore a different outfit in every universe. She must be thinking different thoughts in each one, a slightly different Minnie in each.

Probably, I said. I'm not sure.

Are you feeling OK, Lee? You look uneasy, Lee.

In most universes I said I was fine. In one, despite myself, I asked, Do you love me, Minnie?

Do I *what*?

I don't mean are you *in love* with me, but am I important to you as an individual?

That's kind of a strange question.

Why?

Because I don't really know you. You seem like a nice guy, but how do I know?

298

Seeing you in these alternate universes, I realize now that I'll never know you.

I only know this one Lee who I'm looking at.

There are a million more where I came from.

That's true.

How long do you think it'll take you to know the real me?

I feel kind of uncomfortable having this conversation.

I'm sorry, I said. Before I leave, I wanted to tell you I think you're beautiful.

Well, thanks, said Minnie, blushing, embarrassed for me.

And so—now unemployed and soon to be homeless—I exited the lab, left Ithaca, eventually lost all my newfound knowledge and power. The books I'd read shattered into noise, into vestigial déjà vu. Somewhere in the multiverse live other Lees, billions of variations, who embraced Salazar's offer and still take the Schrödinger treatment. Sometimes I can sense them, brooding beneath my conscious mind, but I stopped caring about them long ago. They couldn't have written this story, I think, because they all still live in Schrödinger's little box.

While You Sleep

MALKA GEFFEN

I.
All around the world tonight
people are torturing their enemies;
they are tying them to train tracks,
sticking their tongues to frozen poles,
laughing maniacally at the close
of their one-hour dramatic monologues.

They are hiding bombs in rescue vehicles
to disseminate when least expected,
conducting mail fraud in their names,
trying to remember why they started this,
posting tales of illegitimate children
on the world wide web.

They are tucking them in and kissing
their foreheads,
fixing them a drink at the end of their first dates,
sketching their portraits by the Spanish Steps
and placing their noses a little off center.

They are signing the guestbooks
at their weddings,
laughing maniacally at their ill-timed jokes,
saving up for their college tuitions,
thinking of ways to negate them.

I am painting stars and little darts
around your head,

brick and mortaring you into
a comfortable nook in my heart,
brass knuckling the wind away
from your perfectly styled hair,
bicycle chaining your leg to mine
for the race,
bringing back the dead who harass you
only to kill them again.

II.

All around the world tonight
people are lying with their lovers;
they are racing their heartbeats
to sleep, remembering
forgotten grocery-list items,
turning to change the direction
their colds drain through
their nasal passages,
simulating and making love
up like the directions were lost.

They are counting the days 'til Christmas,
switching the flat pillow for the fluffier one,
caving in and repeating "Sweet dreams,"
chanting their mothers' lullabies
under their breaths to themselves
with their lips closed.

They are wishing they had used
the fabric softener, rolling over
the idea of marriage in their minds,
saying, for the sake of argument,
that there is no tooth fairy,
watching the blinds
cast shadows from the moon.

They are counting their lovers'
chin hairs, laying blame
where blame is due,
thinking of the ten thousand things
they would do with a million dollars,

thinking of a thousand things
they would say to their moms.

I am painting hearts and little question marks
around your head,

wondering where you are
most ticklish, riding your chest
with my eyes as it rises
and falls, listening to your breath
as it changes from day in
to day out, hoping that you will do
the same.

III.

All around the world tonight
people are writing poetry;
they are selling out their dreams,
crashing headfirst
into walls to catch the bleed,
spilling their guts through Pilot
onto Mead.

They are consulting the muses
like oracles, painting images
in words that look like tarot cards,
looking back far enough to find blame
with their parents, dunking coffee cake
into coffee because it sounds like
a good idea.

They are considering their odor
because everyone has got one,
listening to Mozart and thinking
about child development, closing
their blinds because it's that time
of night.

They are working through some
issues, hearing their voices
for the first time, tensing up
their shoulders to feel
the difference when they're down,
wondering whether to hang
loose or force the rhyme.

I am painting little cars and spaceships
around your head,

hoping this inspires you,
hoping that you'll board one
and get the hell out of here,
hoping that the place it takes you
makes you comfortable in your
skin, wanting so much for you
to write again.

ORPHEUS IN TAURUS RISING, 1999 *(Michael McConnell)*

I guess that's the way the whole darn human comedy
keeps perpetuating itself . . . down through the
generations . . . westward the wagons . . . across the
sands of time . . .
—THE COEN BROTHERS, *The Big Lebowski*

BUT

To risk this multiplicity is to risk unstringing the world.
—MICHAEL POLLAN, *The Botany of Desire*

It is 4:49 in the morning and we sit awake at the computer, percolating in one-hundred degree New York City heat. Our hands drip sweat as words flow out in a slow stream across the computer screen. Our fingers tapping on the keyboard break up the constant humming noise of our machines. We remember that the steady background hum is really overlapping pulses of vibration.

We want to finish this book, which will never really be complete. We want to turn off our computers for a little while. Amelia wants to return to Hawai'i to start a radio station as a first step in creating a new nation called Oceania, a loose conglomerate of Pacific Islands. Jen wants to intertwine medicine, law, and journalism to work toward a multimedia conglomerate

that calls attention to the constructions of science and the necessity for a national health-care system. These are certainly big expectations that we will most probably never achieve. And these ideas are likely to change. We leave our computers behind for a few minutes to walk out onto the concrete streets to find out what is growing within the cracks of the sidewalk.

Outside, fingers are wrapping around the edges of the pavement; nails scratching the surface, knuckles strained. Cracks. Wounds. Offbeats. We notice others much like us, who are pulling themselves through openings in the concrete world. Alert and mutable, these hybrids are scanning the horizon for clues about how to live in between named categories and still fit in. These are people who live conflicting lives, who have to cut and paste from different theories in order to create meaning that they can believe in. Adept at technology and information synthesis, these agile bodies have educations, big thinking, and timing that have made them global and critical. If they are none of these things, then they are resting, gaining strength for another day.

We are especially unstable in our twenties because we lack fixed structures and routines. We blur our sense of placement. Why bother trying to organize our lives in nice, clean shapes and sizes in times like these? When we look around and try to take it all in, read the newspaper cover to cover without skimming, splinter our thoughts in all the multiple directions and imagined possibility, everything can be bewildering. All around us, we choose to see truths being questioned. We question the idea of home as a single location while we immigrate, migrate, and look for a sense of place. We question work, trying to make our ideals real while resisting the predilection to define and limit ourselves. We question our relationships, divorce rates, and our tendency toward individuality. We question our beliefs and larger structures of meaning. The rigid boundaries that traditionally categorize relationships and social roles are disappearing, opening up the hope for growth, for regeneration.

Regeneration can be dangerous because we do not know what will come next. Everything falls away, and in front lies only possibility. It is difficult, sometimes, to let go of the old, the established, the smooth skin. Contributor Josh Krist sees regeneration as coming out of liminal states: "I felt invisible in London, and I ran across the idea of liminality in a book during this

time. The liminal state is when someone is between two worlds where they are both more insightful and more dangerous to existing orders. The material world and the spiritual world, say, or the junkie world and the straight world. I liked the whole liminality thing because it made me feel my perpetual sense of not fitting in could be a strength, not a weakness."[1] Rather than feeling powerless because we are between categories, we gain vigor from the possibility and creativity there. The liminal state is where we slip in to question, where we gain perspective about the categories around us. We can see from where we have come and develop new ideas about where to go next. Out of the liminality, the questioning, the mush, the changing self, whatever you want to call it, comes danger, excitement, and new definitions. The scars and bruises we acquire through the process remind us of the progress made.

Although liminality is precisely where change and transformation occur, it can often be a difficult state to exist in for very long because one is so vulnerable there. Much of our culture revolves around pretending that we are invincible and that we do not die. We can see this in our medical technologies, in our antiaging creams, in our hiding of death and sickness behind sterile walls, all permitting the facade of control. Western medicine may be successful at warding off infectious diseases, but we have a long, long way to go to learn how to live with chronic illness. As Western thinkers, we like to categorize transitions to mark off what we are and what we are not. We are not quite sure what to do about the states in between, the most difficult and transformative periods of our lives.

Some of us desire something ancient and singular instead of this continual movement. Overwhelming change can cause many to crave a structured, settled whole. After the Internet boom, wearing a suit to work is coming back into vogue. There are those who wish they could marry their high-school sweetheart, if they had one (and some of us certainly did). In her photo statement *1999–2000*, Lauren Kesner explains her desire for a tie to history as a way to place her. Jedediah Purdy, in *Against Generations and for Memory*, asks us to look past episodic trivialities to connect ourselves to a

[1]Josh Krist, "Cocaine, The Learning Aid."

larger political and less self-righteous history. D. C. Stone's poetic mission to bring formalism back into poetry is yet another example. Many crave community, history, formalism, high art, and for the progress train to move a little slower. Sometimes many of us cannot deal with the awareness of everything being so uncontrollable, and we get prescribed medications to help deal with the world that we have created. These anti-anxious, pro-positive, and focus-inducing aids help us resist tendencies toward flux. But the desire to go back to something with more weight, meaning, history, and seeming simplicity, while prevalent, is almost impossible to fulfill in today's hyper-mutable landscape.

Many of the answers are right here before us, not in some distant future or in some historical continuum, but right here if we keep our eyes open. We cannot only look toward traditional answers to today's questions; we must use the power of our multiplicity to allow for new meanings to arise. As Saul Williams asks in his essay, "The question is, at what point does history, itself, begin to rob us of our freedom?" Marco Villalobos, aka Chato Zapata, answers a similar question in his essay *Strange Fruit,* which wonders how today's predisposition to multitasking contributes to our new abilities to love in various, fulfilling ways. Catherine Black in her essay *The Joy of Mud* learns to live in multiple places in order to answer her desire to help foster growth in her childhood home and to satiate her need to be living in other places. We can do better than revert to complacency. We can do better than navel-gaze. We can dig into the past to find some solutions and then use today's tendency toward change to create answers in the present; we can reach out from ourselves and regenerate through our multiple interactions.

Because we now have the ability to regenerate, to become who we want to be, in ways that we could not before today, we have the responsibility to do so. Today's twentysomethings are young adults living in a young country, trying their best to find solutions to complex global problems. These problems may not be more grave than at any other time in history, but we are certainly more aware of the critical circumstances that we find ourselves in today. This can be overwhelming. In trying to do everything, be everything to everyone, unrealistic expectations can get the better of us as we look for more, more, more. We are constantly disappointed. Of course we wanted

more for and from this book: we wanted more diversity among contributors, cameras at bookstore counters to take pictures of our book buyers, kid scissors shrink-wrapped inside every book so that you could cut out stories that you do and do not like and thereby change the way you want to read the book, paper dolls to dissemble and glue back together for your own miniature regeneration project, and a CD of people reading their stories and describing their art in the perfect tempo for slow dancing just to calm things down. Of course, these were unrealistic expectations. For those of us in the educated elite, we have power, but often not as much as we think we have. The difficult task we have before us is to compromise into contentment without slipping into complacency.

Creating this book has been our own regeneration project. It started with a conversation walking across a bridge. We felt tired of looking inward and having the same discussions with friends about the heavy decisions and pressures to figure out when, with whom, where, what, and how we wanted to lead our lives. Although these conversations were interesting, we wanted to do something with all the uncertainty. We could not just sit around; we were anxious to produce something that could offer tools to inspire thoughtful action. We wanted to document the questioning, the moments when everything falls away, and then the moments of regeneration. We knew that we would not find the answers in any singular theory; we had to overlap individuals' creations by means of an anthology so that patterns could be seen and individual voices would not be muted through generalizing or defining.

From that conversation, this project has morphed thousands of times. There are hundreds of pages of our writing that you will never see, thousands of ideas and people's stories in a recycling bin. We had to make choices. We had to decide what we could not include. There were many times over three years that we almost dropped the project. We spent time anticipating criticisms: that it's sophomoric, that it's self-centered, that it's too self-help positive. Sometimes we felt paralyzed. How could we write something about a group of people, knowing that we could disagree with every statement we were uttering? We realized that we could move ahead only by turning to the voices in our book. The contributors started living in our heads and became reference points for what we were thinking about

both in the book and in our own lives. The stories come alive, not by mirroring or defining but through interacting with one another. We persisted on behalf of these voices because we wanted to share them. We had a responsibility to our contributors and to ourselves. We could not sit and wallow in questions; we had to create something that showed how meaning is made through the juxtapositions, that we survive through action. This project became our practical expression of how to live within boundaries without closing ourselves off to mutability.

The morning that we woke up to write the first conclusion to this book (there have been twenty-one different conclusions since then), we watched the World Trade Center collapse. Regeneration, ha, we thought. In the aftermath we felt: forget this project, we have warplanes overhead, a biochemical anthrax scare outside our window, and tanks on the streets. Wandering around dazed, we picked up pieces of conversations around us. At the ferry building we overheard older professionals saying, "I just do not know if my work is very meaningful." Or "I want to give back somehow, I just don't know how." Or "Is this really where I want to be living?" The moments when our sense of stability is disrupted are when we start asking ourselves new questions that challenge us in different ways. Maybe we never thought of the questions before, or maybe we never had the opportunity to act on the questions because everything around us was always tying us to our routines. These are the moments that are oftentimes the most profound because they give way to our regrowth and connect us across previously defined borders.

We may want the calm of knowing that we will be okay and that the world will be okay and stable, but that calm is an impossible conclusion to ever hold on to. Regeneration has been imbued with different meanings through time. In the Bible, "the regeneration of the earth" is the time in the future when the "golden age will come. . . . Peace, prosperity, social justice, and equality will prevail." Regeneration was used in the early 1900s to mean a "template for the renewal of humanity." It all sounds so dramatic, but what choice do we have but to keep regenerating ourselves again and again, replacing parts that were lost to us with new pieces? To keep redoing and trying to make better what was there before us? It is not that we see regeneration as good or bad; it just is. Many aspects of the way history has un-

folded lead us to despair. But we have to believe that in between the cracks and rubble of all that has passed before and will pass after us, new hybrids are budding.

It is our hope that in reading this anthology you are inspired to continue questioning while awakening the transformations that may be hibernating inside you. Spending three years creating, collecting, editing, writing, and promoting this anthology has been our regeneration project. Readers, we hope, will run, laugh, and regenerate right through these pages and on into their own multidimensional lives.

Work is love made visible.

—KAHLIL GIBRAN

May 1999: Amelia and Jen graduate from Wesleyan University. Neither one knows what to do; they were too busy living in the present and writing theses at school. Now they have student loans, lovers, and job rejection letters on their hands.

December 1999: Amelia and Jen separately make their way to the San Francisco Bay Area via Hawai'i and New York City. After a walk across the Golden Gate Bridge one day, Amelia tells Jen (and Diana) about an idea to collect stories and artwork from peers because (a) there are lots of people creating artwork and writing who are struggling to have it seen/heard, (b) this is a volatile time full of questions, and (c) something must be going on when we keep having and hearing the same conversations over and over and over again. This is the gist of the event we now call "The Golden Gate Bridge Walk" even though Amelia remembers that the conversation happened in a car in the Presidio.

Late December 1999: Amelia is in Hawai'i and Jen is in New Jersey, both visiting family. Amelia sends an e-mail to all of her friends asking if anyone is interested in sending in their personal stories to her. Jen responds, saying that she thinks it is a great idea and wants to work on it together to make an anthology.

January–February 2000: Below is a miniature version of our first call for submissions. We post this flier at coffee houses, bookstores, and send it to friends in every major city where we know people: Boston, New York City, Chicago, Portland, Tucson, and Atlanta, to name a few. We make a shorter version, print it in *Poets & Writers Magazine,* and post it on various community websites, including our most successful on www.craigslist.org.

Attention 20–30 Year Olds!

"What is unpronounced tends to nonexistence."
—Czeslaw Milosz

CALLING FOR
SUBMISSIONS

For: An edited book of personal stories

Topic: How Are You Negotiating Identity, Values, and Passions in a Boundless World?

Tell a story about jobs (or lack thereof), relationships, America (or travels abroad), technology, art, race, sex(uality), "God," and/or dreams for a possible future. Please pick a detailed, specific experience that deals with these themes, or just comment about what you are currently up to and how/why. Submissions may include creative non-fiction, poetry, photography, collage, photojournalism, etc. We are looking for creativity, honesty, and depth.

This is a project initiated by two 23-year-olds to provide a public forum for impassioned young writers and artists who are too often unheard. This collection is meant to draw together and disseminate a diverse group of voices in order to share, inspire, and speak truth to (em)power. The final product will interweave personal stories through literature, art, and theory.

Although intended for professional publication, we cannot guarantee contributor fees. I accepted, however, financial compensation is a possibility. This project is a grassroots effort. Its success depends on the quality of the contributions.

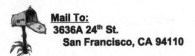

Mail To:
3636A 24th St.
San Francisco, CA 94110

Specifics: 3–15 typed pages;
slides/graphics welcomed
Due: July 1, 2000

Questions??? Please email aborofsky@hotmail.com –or– jkarlin@mail.wesleyan.edu

April 2000: We research starfish, earnestness, and Internet links. Our friend helps us make a website on his Web page that was located somewhere like www. regeneration.grandmas.org.

May 2000: We contact the *Wesleyan Alumni Magazine* and more than 150 universities and college alumni, and other writing programs asking them to post our call for submissions.

August 2000: We receive approximately 250 submissions. We decide we have enough material to write a book proposal.

September 2000: www.grandmas.org is not such a perfect fit. Jen's cousin Frank makes us a new website at www.regenproject.com.

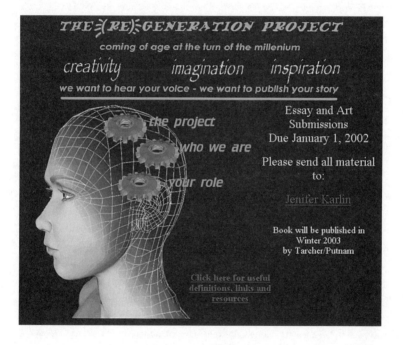

October 2000: Jen meets with Danielle who works at a literary agency to talk about how to write a proposal and query letter. We buy *The Writer's Market.*

November 2000: We start feeling confused about what we want to say/collect and need outside perspective. We send an e-mail to all of our friends:

Hello guys. I am sending you a mass e-mail on behalf of The (Re)generation Project. You see, Amelia Borofsky and I have been working to create a book of collected

personal stories written by 20–30-year-olds about "coming-of-age" issues. We are now selling the book to agents and publishers, but have become a bit stuck in our own heads, or just writing the same thoughts over and over. I am simply asking you all to write back your ideas on the question we are going to pose to you. Feel free to interpret it as you will and go off on anything you want to in relation to the question because we are not even sure at this point what we are trying to get at, and that is why we need your help. Anyway, we only need a few seconds of your time for you to just shit your mind out of a few sentences. Thank you in advance, and check out our project at: http://www.regenproject.com.

The question:

What is distinct about our culture of being young and twentysomething? What is making it that way?

-or- Why was/is it so difficult (or not) to be our age and to participate in the world right now?

-or- Is there anything specific that our generation is going through, or that you are?

-or- What makes a generation? It's a bullshit phrase, right?

December–February 2001: We narrow down submissions and edit them. We finalize the proposal and query. We called upon our friends to help us again:

Hello again. We have finalized the query and proposal. Could you look at it for us one last time please? Your comments so far have been very helpful. We also have a few more questions:

(1) Do we generalize too much? How do we get around this? (2) How much specific detail should we give? (3) What would you reply if you were a publisher? (4) Is it too long? (5) Should we keep in the online component in the market section? (6) Do we need to show how we tie all the stories together? (7) Do the descriptions of the stories make sense (we have read the stories and know what they say, do you get it?) (8) Are we too repetitive?

And then, any other general or specific changes (i.e., grammar)

Finally, add any humor you can. Please make any changes and send it back, or answer the questions. Do what you can and what your expertise allows. Thank you, thank you, thank you. We look forward to reading your comments and (again) thank you for all of your support.

We would love to take you out to dinner or something for all of your help, and I would just love to see you again . . .

We look forward to your response. Please be brutally honest because this is our first crack at this.

Love,

Jen and Amelia

February–April 2001: We receive welcomed interest from Lawrence, a writer living in Spain. We have both read some of his anthologies. He is very supportive and gives us a needed ego boost. We make more edits and send out query letters. Here is a sample:

March 29, 2001

Acquisitions Department:

We are two editors, both graduates of Wesleyan University, who have created an anthology of contemporary coming-of-age stories entitled *The (Re)generation Project: Personal Stories from Twentysomethings.* This book draws together stories and narrative artwork from twenty-four new, exciting writers and artists. As editors, we weave history, cultural anecdotes, and philosophy into chapter introductions that tie the stories together and situate them within a larger social context.

These stories explore common themes that are unique to our age group at this particular time in history. Concerns include the changing nature of work, the lack of spiritual guidance, the irony of politics, the global economy, and the race for new technologies. Pop-culture, dot.com industry, and instant America are not satisfying us. As we yearn to discover our place in the world, this book will serve as a resource to develop a discursive forum for our generation.

As 24-year-old freelance writers, we are well positioned to write and edit this book. Collectively, we have worked for Wesleyan Press, Mother Jones, and Lonely Planet Publications. We currently have a website (www.regenproject.com) and are connected to an extensive network of young writers and artists. This has helped us amass a variety of submissions, from both well-known and emerging artists.

Thank you in advance for your consideration. If you have any questions, or would like to see a proposal and/or sample chapters, please contact us.

We look forward to further discussing this project with you.

Best regards,

Amelia Borofsky and Jennifer Karlin

Amelia Borofsky and Jennifer Karlin

Sometimes, we had to had to send follow-up letters:

April 10, 2001

Dear Agent:

Thank you for your interest in our book. Included is the requested proposal. Both Amelia and I are familiar with Sara Shandler and her book—its success has inspired us throughout this project. *The (Re)generation Project: Personal Stories from Twentysomethings* is a bit different for it is directed toward an older audience and contains social commentary that ties the personal stories together. Our anthology gives voice to a variety of experiences and ruminations that a generation is producing with art, poetry, and stories that testify to the importance of creativity during the difficult process of coming of age. As twentysomethings passionately wander through contemporary hinterlands, readers travel around the globe from China to cyberspace, Antarctica to alienation, and Memphis to metamorphosis. We hope you enjoy our proposal and we look forward to possibly working with you.

Sincerely,

Jennifer Karlin and Amelia Borofsky

Jennifer Karlin and Amelia Borofsky

In total, we send out forty query letters and twenty proposals.

April 2001: Carol, a writer in Venice, California, meets with Jen and gives the project another well-needed ego boost.

May–August 2001: We receive about thirty rejection letters. At some point, we send out another round of queries and proposals, this time aimed specifically at literary agents because publishing houses are "not responding to unsolicited material." Jen's mom gets sick and Jen moves back to New Jersey.

June 2001: Jen's Aunt Ethel calls to tell her to watch Oprah because there are some girls on TV who have written a book about twentysomethings. *Quarterlife Crisis* is published. Jen and Amelia poll their friends about its effect on the sale of their book. The results are 50/50: some think it will help, other think it will be passé.

August–September 2001: Amelia moves to New Jersey to finish up the manuscript. We hear back from three interested literary agents and one publishing house.

August 21, 2001: We send out a bound packet of the proposal (edited again), a sample chapter, and seven additional sample pieces. A friend gives us feedback on the rough draft of the manuscript. Amelia leaves because she is sick and tired of the book. She tells Jen that she can finish it without her (actually, this is said more than once).

September 20, 2001: Amelia moves to Mexico. Jen is working full-time for the Legal Aid Society in New York City.

October 6, 2001: Jeremy P. Tarcher offers us a publishing contract.

October–December 2001: We recall for submissions with a publisher secured. Amelia sits in cybercafes in Mexico calling for more submissions; Jen tries to call Amelia while in NYC hospitals and on subways.

December 2001: Laura and Ammon compose a new call for submissions for us. (This one does a lot better than our previous ones):

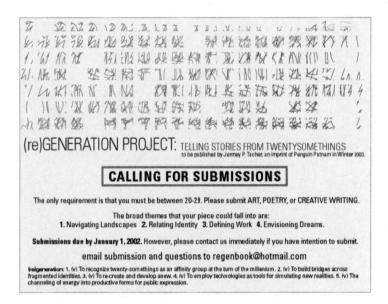

(re)GENERATION PROJECT: TELLING STORIES FROM TWENTYSOMETHINGS
to be published by Jermey P. Tacher, an imprint of Penguin Putnam in Winter 2003.

CALLING FOR SUBMISSIONS

The only requirement is that you must be between 20-29. Please submit ART, POETRY, or CREATIVE WRITING.

The broad themes that your piece could fall into are:
1. Navigating Landscapes **2.** Relating Identity **3.** Defining Work **4.** Envisioning Dreams.

Submissions due by January 1, 2002. However, please contact us immediately if you have intention to submit.

email submission and questions to regenbook@hotmail.com

(re)generation: 1. (v) To recognize twenty-somethings as an affinity group at the turn of the millenium. 2. (v) To build bridges across fragmented identities. 3. (v) To re-create and develop anew. 4. (v) To employ technologies as tools for simulating new realities. 5. (v) The channeling of energy into productive forms for public expression.

January–March 2002: We receive about 200 additional submissions. We agonizingly narrow down the pieces based on instinct, if it offers a new perspective, and how it fits into the slowly emerging pattern of the book.

April–June 1, 2002: We finalize the pieces and our own writing for the introductions. We have written three hundred pages of gobbledygook that we pare down through many revisions. We have regenerated into a third person to write the book—taking away our individuality. We would write and rewrite back and forth, spending hours on individual words, each one of us adopting parts of the other.

Loam Akasha-Bast, 27, is an MFA student in creative writing who lives in Oakland, California, with her daughter. She is the publications coordinator for the Northern California Recycling Association. In her alleged spare time, she organizes family witch camps.

Reza Assemi, 26, finds himself in Fresno, California. Aside from painting, he is currently revitalizing the old Red Cross building in downtown Fresno converting it into four separate artist live/work/gallery spaces. More of his work can be seen at www.rezaassemi.com.

Marcelo Ballvé, 25, was born in Buenos Aires, Argentina, and grew up in Atlanta, Mexico City, and Caracas. After graduating from journalism school, he worked for the Associated Press as a reporter in Brazil and as a Caribbean desk editor in Puerto Rico. As a freelancer, he has published articles in *The Christian Science Monitor, Latin Trade* magazine, and *The New York Times.*

Catherine Black, 25, works at *Pacific News Service,* a media/communications nonprofit in Oakland, California, but flies back to Hawai'i regularly. She hopes to

facilitate more exchange between the Islands and the outside world. Her favorite food is raw fish straight out of the Pacific Ocean, and her pastime is kung fu.

Courtney Booker, 27, lives in the San Francisco Bay area and works at Pixar Studios as an after-effects artist. She claims that she has survived thus far because of art. A great deal of her work is portraiture, mostly of people who have crossed her path and have made an impact on her in one way or another.

Pat Boyer, 26, runs his own new media design company, Urban Cowboy, in Montreal, Canada. Mix this with tango lessons, mad amounts of coffee, and Black Russians, and his creativity and ulcers are fashioned.

Sasha Cagen, 28, a San Francisco resident, edits and publishes *To-Do List* (www.todolistmagazine.com), a magazine of meaningful minutiae that uses the idea of a to-do list to explore the details of modern life. Her own to-do list includes items such as "proofread" (her day job), "laundry," and "QA focus group." She is at work on a book about singledom, tentatively titled *Quirkyalone: A New Idea about Being Single.*

Emmeline Chang, 29, spent two years living in Taiwan and traveling in Asia before she landed in New York. She teaches creative writing at Gotham Writers' Workshop, freelance writes and edits, dances tango, and eats long meals with friends. She is currently working on numerous projects, including a collection of stories about tea, tentatively titled *The Agony of the Leaves.* Her website is www.emmelinechang.com.

Keina Davis, 28, is a self-employed artist/entrepreneur working at her studio SIVADART in San Francisco. Painting since the age of seven, she focuses her art on visual narratives depicting the stories and essence of everyday people. World renowned, Davis sometimes feels that she is telling stories that her ancestors could not. See more of her work and learn more about her at www.sivadart.com.

Amanda DeWald, 25, going on 49, lived and taught middle school in the Bronx, New York, for two years. She has a master's degree in education and is now working on education policy on the Navajo reservation in New Mexico.

Michael Ellsberg, 25, lives and works in New York City, where he raised funds to start Green Planet Venture Capital, LLC, www.greenplanetvc.com, a small venture-capital firm focused on environmental technology and alternative energy. He also teaches salsa dancing.

Malka Geffen, 26, is a recent graduate of the MFA program at Mills College in Oakland, California. She moved to the Bay Area in 1997 from Tucson, Arizona. Besides writing poetry and enjoying the "lifestyle," Malka plays drums in a few bands and considers her future unemployment with a furrowed brow.

Sarah Gersbach, 28, is a photo assistant and does digital retouching. A new arrival to Los Angeles, Gersbach does not know what she will be doing next. She works hard, plays hard, and never stops. Visit more of her work at www.supersarahonline.com.

Bayne Gibby, 25, is a writer/comedian. She has performed improv, sketch, stand-up and theater all over New York City. Most recently she produced a live CD of her original comedic songs that can be found at www.baynegibby.com. She has had many day jobs, none of which has ever been as much fun as making people laugh.

Leona Graham, 28, presently resides in Santa Fe, New Mexico, where she is a painter, sculptor, and graphic designer. She is currently at work on a series of earthbound angels, invoking the contemplation of societal constructs and the feelings of frustration they can create. To see more of her artwork, go to www.home.earthlink.net/~leonamae/leona.html.

Andrea Gregg, 23, is a printmaker, book artist, and professionally, a graphic designer. Her artwork has been exhibited in galleries and libraries along the California coast. After returning from London, Andrea has started freelancing out of her own design studio, a gregg design, located in San Diego, California.

Rachel Hutton, 24, is a Minneapolis-based designer/writer working to increase the social capital in her community. She co-edited *Before the Mortgage,* antidotes from the school-to-work transition, with Christina Amini.

Andy Isaacson, 25, was born and raised in Brooklyn, and currently resides in San Francisco, where he worked for a public relations agency helping corporate clients communicate their brand essences and company messages while at the same time making the world a better place by explaining to the general public its need for their products and services. Only the world isn't any better, and he had a hunch that his day job might have had something to do with it. Eventually, he hopes to learn how to intertwine urban planning with international relations.

Elsie Kagan, 24, makes a living as a painter, creating images on canvas and on formerly familiar objects. Living in Oakland, California, but moving back East, she also coordinates and paints murals for private commissions and community projects. Her dream is to synthesize her interest for creating art with her commitment to community development. In her free time she follows her love of West African drumming and currently plays in the only all-woman Sabar group.

Lauren Kesner, 25, lives in Yerevan, Armenia, where she works at a documentary film company, Bars Media, making films about human rights, post-Soviet realities, and humanity. She does her best to surround herself with foreign cultures, philosophies, and tongues, and spends her free time taking walks.

Steffie Kinglake, 25, lives in Brooklyn and works as a benefits paralegal for the Legal Aid Society in the Bronx Neighborhood Office providing legal services to low-income people. She is looking to further explore the world of photography. Her most recent work is a project documenting the community of the Southeast Bronx. Traveling is her passion, and she hopes to someday get to all the places she has dreamed of and return to those she has loved.

Ayisha Knight, 29, lives in Salem, Massachusetts, where she is a photographer, ASL teacher, and ASL story-teller. She is the deaf daughter of a white Jewish woman and a Black Cherokee father by birth and grew up in a community of single mothers. At last count, fifteen mothers, three fathers, and numerous brothers and sisters all form part of a happily unconventional family. Her poetry CD, the first ever by a deaf artist, will be out this year. See more of her art and poetry at www.aboutayisha.com.

Lee Konstantinou, 24, spends his days reading, writing fiction, and toiling as a technical writer in the fun-filled Silicon Valley. He is enrolled in an English Ph.D. program at Stanford, working on his first novel, and waiting to be discovered as a famous novelist (any day now).

Erik Leavit, 23, is a recent migrant to Duluth, Minnesota, where he works as a night auditor at a local motel. Currently, he hosts a reading series and polishes his writing for the eventual move toward a graduate degree.

Dr. Kim Makoi, 25, knows exactly what to do when your first practice is about to go under and they're about to repo your x-ray machine: quick—make art! These

days, she lives in San Francisco, where she is building a chiropractic practice, learning to surf, training capoeira, and making art without an x-ray machine.

Heather Maxwell, 28, lives in Vancouver, British Columbia, and makes her living as a freelance writer and editor. She was one of the founding managing editors of the SXSW-nominated online magazine *Tales of Slacker Bonding.* Her current projects include content creation for a global information service provider, and serving as editor for the West Coast's New Forms Festival, which converges art, music, and multimedia.

Jamie McCallum, 24, is a freelance journalist, apprentice tile setter, and carpenter living in San Francisco. This leaves ample time for touring in a punk rock band and participating in social justice activism against war and for workers' rights. Currently, he's focusing on plans to establish the School for Bread and Roses, an institute to train community, union, and environmental organizers.

Michael McConnell, 23, was born in Garden City, Michigan, and now lives in San Francisco. He is an artist, nanny, and owner of a small coffee/video store called Faye's Video and Espresso Bar. His art is represented by Braunstein/Quay Gallery, Art Farm, and the "Story without a name" project.

David and Gabriel Montero, 25-year-old identical twins, are both living in New York City, and are not the same person despite their appearance. David is a journalist focusing on urban development, human rights, and social movements. Gabriel is a research scientist who studies the growth of global cities and public health at NYU's Wagner School of Public Service.

Justin Moyer, 25, lives in Washington, D.C., and works as a case manager for formerly homeless, HIV-positive clients at a local nonprofit. He writes poems and has been tinkering with a novel for over two years. *El Guapo,* his band of more than six years, recently began work on a CD with the independent label Dischord Records and hopes to tour the United States extensively this year.

Paul Ohan, 25, lives in New York and works freelance jobs that vary from styling mannequins to reporting on the decor of special events. He also writes letters to the government on behalf of immigrants. He is trying to find his audience.

Alix Olson, 26, is a Brooklyn-based spoken word artist/activist who treks across the country year-round, performing at colleges, clubs, and festivals. She is a 2002 OutMusic Award triple-nominee.

Radames Ortiz, 23, Houston, Texas, works as a marketing associate for Arte Publico Press. He is the founding editor of *Coyote Magazine: Bringing Literature and Art Across Borders,* the former editor of the *Bayou Review,* the literary journal for the University of Houston Downtown, and his work has appeared in numerous publications. He is at work on his first collection of poetry entitled *Barefoot & Ugly.*

Shannon Peach, 27, dreams of writing and starring in a rock opera. Currently, she spends her days in Alaska, where she can be heard on public radio at KTOO FM. Her other passions include puppets and poetry.

Laura Plageman, 25, is a photographer who hates writing bios. Her inspirations include the antics of family and friends and self, the curiosities of the past and the future, and the infinite potential of right now.

Jedediah Purdy, 27, is a native of West Virginia. He is the author of *For Common Things* and *Being America,* and since college he has worked as a journalist and a lawyer. In 2001–2002, he was a fellow at the New America Foundation. He has lived most recently in Washington, D.C., and New York City.

Mark Rosal, 28, is an art director by trade but balances his commercial art with his insatiable craving for experimentation in fine art. By day he works in a design studio in central New Jersey and keeps a fine arts studio in Trenton, New Jersey, under the name www.gomarky.com.

Karem Said, 22, has worked in a bookstore and at *Mother Jones* magazine and is now planning to escape San Francisco's dust bowl of a job market for newspaper work in any other city that will have her. Although she will miss the metropolitan love of her life, greener pastures beckon with quirky American secrets and stories yet untold.

David Siegfried, 23, lives in Cornwallville and Brooklyn and writes plays and short stories. For subsistence, he serves as a youth outreach center supervisor and HIV/AIDS prevention educator. He co-authored and collaborated on the play/art/sound installation called *If You Go in Here You Must Come Back,* which premiered at the 2001 Long Island City Art Frenzy in Queens, New York.

Taigi Smith, 29, is a network news producer and freelance writer. She's a graduate of Mills College and the mother of Moxie, the world's cutest Yorkshire terrier. She currently resides in Brooklyn, and her essays have been published in *New York Newsday,* the *San Francisco Chronicle, Testimony: Young African-Americans on Race and Identity,* and *Step into a World: An Anthology of the New Black Literature.*

D. C. Stone, 25, spent his early years in the Arizona desert making forts out of saguaro skeletons, then moved to northern New York at age ten. Dan now lives in the Bay Area, where he writes poetry and criticism, teaches, coaches basketball, and runs the nonprofit corporation *Speakeasy Literary Audio.*

Nick Suplina, 24, lives in Washington, D.C. He is cofounder and coordinator of the Democracy Action Project, www.democracysummer.org, attends law school, is actively trying to change the world, and occasionally changes his mind. Nick has good ideas like *Baby Rebellions: No mas lagrimas,* poetry for children with vision.

Valeria Weber, 26, is currently backpacking across Canada to spend the winter in Alaska, where she will finish writing the great American novel. Teaching at a girls' reform school in upstate New York, waiting tables in the Castro, roaming aimlessly around Costa Rica, and trailblazing in the south, led her back to school. She wrote her essay both to piss off Rai and to get over her. It worked.

Jig Wiley, 28, grew up in Las Vegas, the son of a casino pit boss and a blackjack dealer. Desperate to escape the physical and cultural desert, he sailed the earth, cast anchor in many places for several years, and is now harbored in Seattle. After years of leaving Las Vegas, he's at work on a book about, you guessed it, that city. He avoids hunger by working as a writer and content creator for a finance firm.

Amani Willet, 26, is working on a project about life in the drug- and HIV-ridden neighborhood of Coney Island, Brooklyn. His photographs have been featured in *Take It from Me,* a documentary film about the effects of welfare reform in New York City. His photos from Brazil, Tanzania, Cuba, and South Africa have appeared in George Soros's Open Society Institute's annual reports. Other photographs have been published in *The New York Times, Glamour, Popular Photography,* and *People,* among others.

Saul Williams, 30, co-wrote and starred in the independent film *Slam,* the winner of the 1998 Sundance Film Festival grand jury prize and the Camera d'or at the Cannes Film Festival. He has written two books of poetry, *The Seventh Octave* (Moore Black Press) and *S/he* (MTV/Pocket Books), and has been included in several anthologies. His album, *Amethyst Rock Star,* was critically acclaimed and named Album of the Year by the *London Times.* He currently resides in Los Angeles where he is working on his new book and album, both due for release in 2003.

Mark Yokoyama, 26, recently moved from Portland, Oregon, to New York City. He is a marketing manager at an Internet startup that turned into a more traditional gift wholesaler. He spends his spare time playing music at The Action Items. This is his first published writing since having a poem published in the magazine *Highlights for Children* (Age: 6).

Jessica Yorke, 25, is currently living in Kenya, East Africa. She has moved on from typing for a medical journal, cutting press stories in Glasgow, clubbing, and slugging flavored vodkas on Haight Street to volunteering as an art and French teacher. Although many of the issues have not changed, she has wised up, relatively.

Chato Zapata (Marco Villalobos), 29, a Brooklyn resident, enjoys popcorn with his movies and mustard with his french fries. He is a self-employed writer who, along with his four wives, is currently seeking another partner. They are all social drinkers and occasional smokers but aren't looking for anything kinky.

JENNIFER KARLIN, 25, works at the Legal Aid Society's health law unit in New York City, getting more and more people health-care coverage every day even while knowing that it might take an earthquake to inspire long-due implementation plans for a national health-care system in the United States. She has written and lectured on a variety of topics including rheumatoid arthritis, Quichua midwifery, and U.S. campaign finance. She also makes broken mirror art, convinces her friends to live with her, hangs out with her family, and is always at work on a project of some sort.

AMELIA BOROFSKY, 25, works as a teacher with *Kama'aina Kids* in Hawai'i, running around and getting dirty. She specializes in working with autistic children and has freelanced for publications such as *Lonely Planet, Girlfriends,* and the *Honolulu Weekly.* She is currently at work on a children's book entitled *Oceania* and spends her free time surfing the small waves while avoiding sharks.